About the Authors

Pete Carr is a commercial and editorial photographer with a passion
for documenting street life, architecture, and incredible scenery. He
publishes his photographs on his award-winning daily photo blog (www.
littletimemachine.com) and some of the highlights are featured in this
book. His work can also be seen in his 2008 book about Liverpool, *Port of
Culture*. He is one of the most prominent photographers in the Merseyside
area today, described as "the 21st century Chambré Hardman" in a review
of his first solo exhibition.

Pete's work has been exhibited widely at venues including the Tate, Open
Eye Gallery, St. George's Hall, the Anglican Cathedral in Liverpool, the
National Media Museum in Bradford, and the Museum of Liverpool. His commercial work is extremely
sought after, with one of his iconic shots of the Liverpool waterfront used as the key image in a major
campaign by the Mersey Partnership promoting the city across the United Kingdom in 2010. His pho-
tographs have also been featured in the *Guardian*, *The Times*, the *Liverpool Daily Post*, and the *Liverpool
Echo*. You can visit his website at: www.petecarr.net.

Robert Correll is the author of a number of books about digital photogra-
phy, including camera-specific titles, digital cameras and technologies, gen-
eral and specific digital photography techniques, and photo editing.

His latest titles include: *Canon EOS Rebel T3/1110D For Dummies* and
Canon EOS 60D For Dummies (both written with Julie Adair King), *Digital
SLR Photography All-in-One For Dummies*, *High Dynamic Range Digital
Photography For Dummies*, *HDR Photography Photo Workshop* (written with Pete Carr), and *Photo
Retouching and Restoration Using Corel PaintShop Pro, Third Edition*. When not writing, Robert enjoys
family life, photography, playing guitar, and recording music. Robert is a graduate of the United States
Air Force Academy and resides in Indiana.

Credits

Senior Acquisitions Editor
Stephanie McComb

Project Editor
Amanda Gambill

Technical Editor
Haje Jan Kamps

Senior Copy Editor
Kim Heusel

Editorial Director
Robyn Siesky

Business Manager
Amy Knies

Senior Marketing Manager
Sandy Smith

Vice President and Executive Group Publisher
Richard Swadley

Vice President and Executive Publisher
Barry Pruett

Project Coordinator
Patrick Redmond

Graphics and Production Specialists
Jennifer Henry
Andrea Hornberger
Jennifer Mayberry
Heather Pope

Quality Control Technicians
Laura Albert
Susan Moritz

Proofreading and Indexing
Betty Kish
Estalita Slivoskey

HDR PHOTOGRAPHY
PHOTO WORKSHOP

SECOND EDITION

Pete Carr and Robert Correll

WILEY

John Wiley & Sons, Inc.

HDR Photography Photo Workshop, Second Edition

Published by
John Wiley & Sons, Inc.
10475 Crosspoint Boulevard
Indianapolis, IN 46256
www.wiley.com

Copyright © 2012 by John Wiley & Sons, Inc., Indianapolis, Indiana

Published simultaneously in Canada

ISBN: 978-1-118-09383-2

Manufactured in the United States of America

10 9 8 7 6 5 4 3 2 1

For general information on our other products and services or to obtain technical support, please contact our Customer Care Department within the U.S. at (877) 762-2974, outside the U.S. at (317) 572-3993 or fax (317) 572-4002.

Wiley also publishes its books in a variety of electronic formats and by print-on-demand. Some content that appears in standard print versions of this book may not be available in other formats. For more information about Wiley products, visit us at www.wiley.com.

Library of Congress Control Number: 2011937919

Acknowledgments

Pete Carr and Robert Correll would like to thank the team at John Wiley & Sons, Inc., including Stephanie McComb, Amanda Gambill, and Kim Heusel. Special thanks to Haje Jan Kamps for reviewing the book for technical accuracy.

We would like to voice our deep appreciation to David Fugate for representing us and for introducing us to each other.

Pete would like to personally thank Arundel Cathedral, National Museums Liverpool, Liverpool City Council, and everyone else who helped make this book possible.

Robert would like to thank The Chapel and Tower Bank (both of Fort Wayne, Indiana), New Castle High School of New Castle, Indiana, and the Kruse Automotive & Carriage Museum and National Military History Center (both of Auburn, Indiana).

Pete Carr:

To Mum, Dad, and Sam. Thank you. :)

Robert Correll:

To Anne, Ben, Jake, Grace, and Sam.

Contents

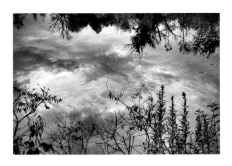

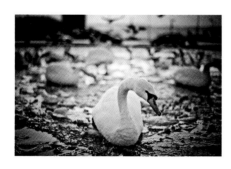

CHAPTER **4** Generating and Tone Mapping HDR Images 80

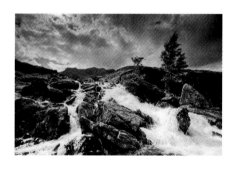

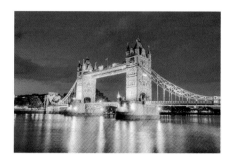

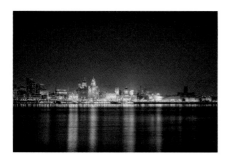

CHAPTER 8 Interiors 212

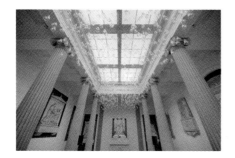

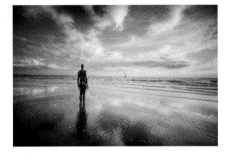

Introduction

HDR photography has become incredibly popular over the past few years. Forums and photo-sharing sites like Flickr have a number of groups and followers who constantly post HDR photos.

This popularity brings people looking for answers. They want to know how HDR works, how to shoot it, how much it costs, what kind of software it requires, and whether any special cameras or lenses are necessary.

That's what this book is for: HDR answers and examples. It focuses on answering the key questions that enable you to shoot and process HDR, such as what type of camera, lens, and tripod you need. It also covers how to set up and shoot exposure brackets to create your HDR images. Following that, you learn how to tone map and edit your HDR images to create a finished product.

In addition, this book also covers several genres and shows you what is possible with HDR. It covers how to shoot land- and cityscapes, buildings, interiors, and other subjects for HDR, as well as how to look for high-contrast scenes, how to frame your subjects, and what lighting is best. The possibilities are endless and the results can be stunning.

However, this book isn't a Ph.D. on HDR — it's for photographers and artists, not scientists. While there is enough depth to challenge you, it's not supposed to be a physics lesson. Ideally, anyone should be able to pick up this book and learn how to shoot HDR, even those who have never used a camera.

Along those same lines, this book doesn't rely on (nor does it suggest you depend on) the most expensive gear available. The photographs within these pages were taken with a variety of cameras — new and old, entry-level and professional. A few shots were even taken with a couple of inexpensive compact digital cameras that cost about $120. If you understand the concept and how to use your camera, you can shoot HDR.

Although there are a number of HDR applications on the market, this book uses a single application called Photomatix Pro (www.hdrsoft.com). It's impossible to show you anything meaningful by switching applications every other image. If you like, search the Internet, read software reviews, download and try out any that you want, and keep the one that makes the most sense for you.

HDR photography enables you to push past the limitations of your camera. With HDR, you can tame bright skies and peer into dark corners. HDR also helps you get more out of your camera than you might have thought possible. That fact alone makes HDR brilliant, but there's much more! You don't have to live in the Swiss Alps to shoot brilliant landscapes, nor do you have to live in New York City to take breathtaking cityscapes. You can be anywhere. Look for light and beauty around you, wherever you are. Use HDR as a tool to translate what you see into something you want to share with the rest of us.

© Pete Carr

On the surface, High Dynamic Range (HDR) photography is about overcoming technological limitations. Cameras, whether film-based or digital, don't perform as well as eyes and brains when it comes to collecting and interpreting light. You don't even have to think about it — your eyes adjust to the ever-changing amount of light around you, and you're able to discern details in deep shadows and bright highlights automatically.

When you take a photograph, however, you have one fleeting chance to collect what details the camera can capture. You must learn to deal with its limitations as you try to balance shadows and light in a single exposure. Many photographers spend their lives working to achieve this balance.

HDR photography is a relatively new technique that overcomes the limitations of a single photo by using multiple exposures to produce an image that illustrates a high dynamic range scene (reality) with low dynamic range data. It is a powerful way to extend the camera's responsiveness to light. You find out how to do that in this book, beginning with this chapter.

Digging deeper, HDR photography is an exciting avenue of artistic expression. Many choose to push the limits of photography with HDR, while others prefer to present their subjects very naturally. There is no absolute right or wrong approach — it's up to you and your audience.

DYNAMIC RANGE

Within the context of photography, *dynamic range* refers to the range of brightness (from very little to a lot or from a lot to even more) in the scene to be photographed.

This property is also known as the contrast ratio of the scene. Dynamic range can be characterized by the terms of exposure value (EV) levels, zones, levels, or stops of range.

First, look at a scene with a reasonably low dynamic range, as shown in Figure 1-1. Here, you see a winter scene looking down a lane bordered on both sides by ice-covered trees, some of which have been damaged by a recent ice storm. The

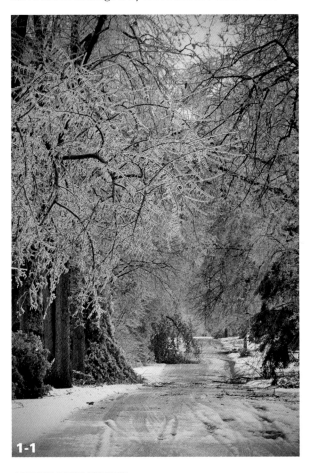

1-1

ABOUT THIS PHOTO *An example of a scene with a smaller dynamic range. (ISO 160, f/8.0, 1/100 second, Sony 18-70mm f/3.5-5.6 at 60mm) © Robert Correll*

light-gray sky is barely visible. The street, trees, and sky are all fairly light, but there are no intense highlights. Dark tones are represented by a bit of foliage and tree branches. All in all, this scene was easily captured by the camera. In fact, contrast was enhanced during RAW file processing to balance the highs and lows.

Some scenes, such as that shown in 1-2, clearly have a greater contrast ratio, or dynamic range, than others. Shooting during midday, into the sun during the Golden Hour, around bright

lights, or with reflections pushes highlights to the extreme. Anchoring the low end of the spectrum are shadows and other less well-lit areas in the scene.

The exposure challenge in a scene like that shown in 1-2 is to rein in the highlights in the sky and clouds while exposing the rest of the scene well enough so that it can be seen. Careful RAW file processing was essential to presenting this photo. The clouds and other highlights were protected and the foliage on the riverbanks was

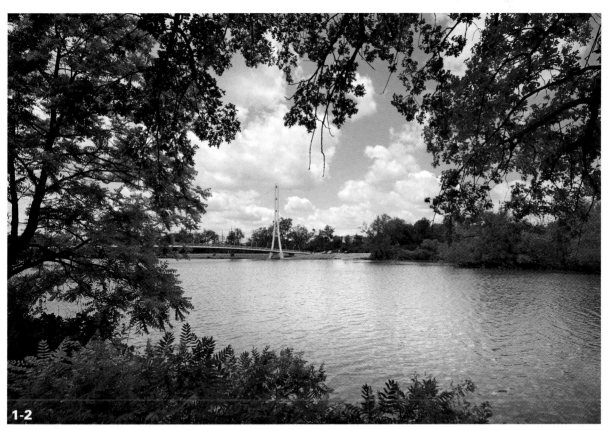

1-2

ABOUT THIS PHOTO *Scenes such as this one push the dynamic range of your camera and require careful processing. (ISO 100, f/8.0, 1/250 second, Sigma 10-20mm f/4-5.6 at 14mm) © Robert Correll*

brightened. In other words, the dynamic range of the scene was captured reasonably well by the camera raw exposure, but these highs and lows had to be squeezed to fit into the file format required for viewing and printing.

The challenge when shooting in shadow, such as inside a building, on a cloudy day, or during either predawn or dusk, is to capture details in low light, as shown in 1-3. The underside of the bridge is in shadow, which presents an exposure dilemma. You must capture darker details by increasing ISO, aperture, or slowing the shutter, all without causing the scene outside the bridge to be overexposed. Quite often, this is impossible in a single photograph without resorting to flash or extra lighting.

The dynamic range of a camera tells you how many stops of brightness it can capture in a single exposure. For example, can it capture the sun and shadows in one photo? In the case of 1-4 and 1-5, the answer is no. The photo in 1-4 was underexposed by four stops in order to capture the sun, and reduce or eliminate detail-hiding glare. This photo illustrates the peak of the upper end of this scene's dynamic range. The next exposure, 1-5, captures the opposite end of the scene's dynamic range. In this case, the bridge and other dark elements in the foreground and in the distance are visible, but the sun and sky are washed out by glare. This is closer to how the scene looked in person, although the meter indicated the photo was overexposed by 4 stops (+4 EV).

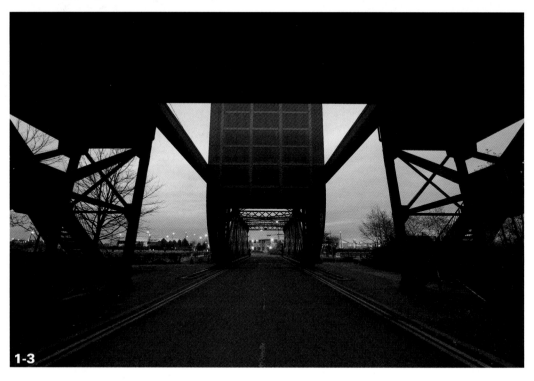

ABOUT THIS PHOTO *Standing under a bridge, the outside is perfectly exposed, but the image lacks detail inside the bridge. (ISO 200, f/13, 3 seconds, Nikon 14-24mm f/2.8 at 14mm) © Pete Carr*

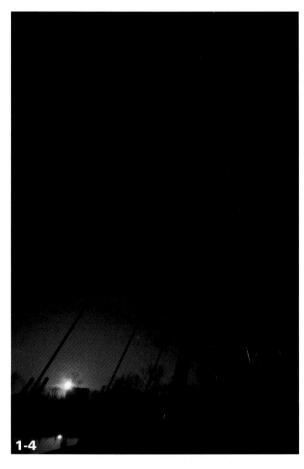

1-4

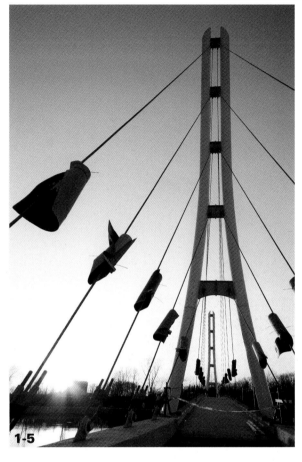

1-5

ABOUT THIS PHOTO *One photo isn't enough to capture this range of light. Compare this version, underexposed by four stops, with 1-5. (ISO 100, f/8.0, 1/4000 second, Sigma 10-20mm f/4-5.6 at 18mm)* © Robert Correll

ABOUT THIS PHOTO *This photo and 1-4 illustrate the large dynamic range of this scene. Compare details in the sun, sky, and bridge. (ISO 100, f/8.0, 1/60 second, Sigma 10-20mm f/4-5.6 at 18mm)* © Robert Correll

PRACTICAL EFFECTS OF LIMITED DYNAMIC RANGE

HDR is not meant to replace, nor is it always a good substitute for, the single-exposure photography that we're all used to. However, the fact that

your camera has a dynamic range often inadequate to the task at hand can have undesirable effects on your photos.

This section briefly illustrates what happens when highlights are too bright, shadows are too dark, or both.

BLOWN-OUT HIGHLIGHTS

Blown-out details, quite often skies, are the result of limited dynamic range. Too much light overexposes parts of the scene and the camera literally cannot measure any more light. The resulting image has no details in the overexposed areas.

A bright sky is notoriously hard to capture well and not ruin the rest of the photo. For example, when given a choice between capturing a nice building at the cost of a blown-out sky or capturing a building that is too dark but has a nice exposed sky, most photographers (and their cameras) choose a blown-out sky. Why? Because, although blowing out a sky runs contrary to most digital photography guidelines, the building is the subject of the photo.

This dilemma is illustrated in 1-6. The cathedral is the subject of the photo and, as such, deserves to be well exposed. The sky, however, limits the amount that you can raise the exposure without blowing it out. The camera does not have enough dynamic range to capture both at the same time. Notice that the ISO was raised to capture details on the darker building. Although you could choose to lengthen the exposure time, that was impractical in this case due to people moving around next to the building.

When you know you can't expose both the building and the sky correctly, you have a choice: Shoot for the building or shoot for the sky, and if necessary, try to fix the problems in processing. HDR, however, presents another way. The point of HDR is to enable you to bring out more detail in scenes that demand more dynamic range than your camera has, as shown in 1-7.

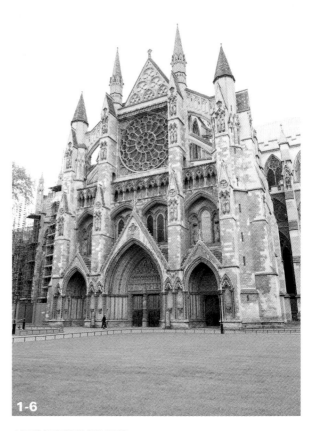

1-6

ABOUT THIS PHOTO *An example of a blown-out sky. The building is nicely exposed but the background is completely lost, or blown out. (ISO 640, f/8.0, 1/100 second, Nikon 24-70mm f/2.8 at 29mm)* © Pete Carr

Notice that the sky in 1-7 is not blown out at all. In fact, it has a wealth of details. Clouds that were not visible before (that's what happens when the sky blows out) are clearly present and add to the character of the photo.

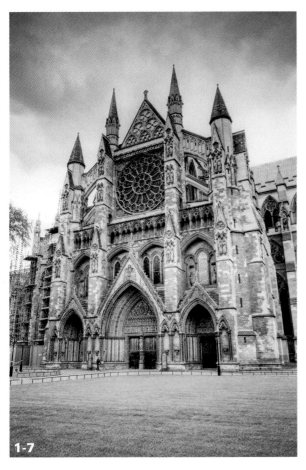

1-7

ABOUT THIS PHOTO *HDR brings the sky back into this image and emphasizes other details in the foreground. HDR exposures bracketed at -1/0/+1 EV. (ISO 640, f/8.0, 1/100 second, Nikon 24-70mm f/2.8 at 29mm) © Pete Carr*

DETAILS LOST IN SHADOW

At the opposite end of the scale is when you lose details in the shadows or the dark areas of your photos. Silhouettes caused by sunsets are the usual cause when shooting land- and cityscapes, although you also run into this problem when shooting indoors in dark spaces or any other time your subject is backlit.

What happens in this case is the camera (or the photographer) decides to expose for the bright areas of the scene, underexposing everything else. This protects the sky but turns the foreground to silhouette and shadow. In the case of 1-8, the ship and quay in the foreground, plus the ships and buildings across the water, have turned to black shapes.

Although this is often aesthetically pleasing, there are times when you want to be able to capture details in the shadows without blowing out the sky. HDR offers a viable alternative (see 1-9) by enabling you to capture the bright sky and a well-lit foreground in separate exposures. Notice that everything that was in shadow in 1-8 (the normal exposure) is visible in 1-9.

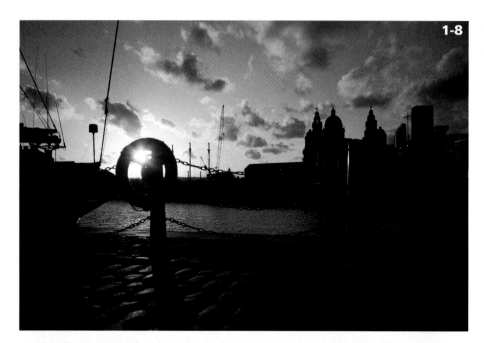

ABOUT THIS PHOTO
This image intentionally shows huge areas in silhouette. (ISO 200, f/8.0, 1/200 second, Sigma 10-20 f/4-5.6 at 18mm)
© Pete Carr

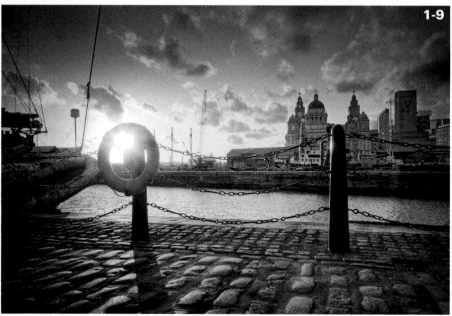

ABOUT THIS PHOTO
The same scene after three bracketed exposures are merged to HDR and processed. HDR from three exposures bracketed at -2/0/+2 EV. (ISO 200, f/8.0, 1/200 second, Sigma 10-20 f/4-5.6 at 18mm)
© Pete Carr

TRADITIONAL SOLUTIONS

Over the years, photographers have developed quite a few solutions for getting around the limited dynamic range of their cameras — both film and digital. This section gives you a taste of more traditional methods so you can see how they compare to the HDR examples shown in this chapter and throughout the book.

ADDING LIGHTING

Additional lighting helps you bypass the dynamic range issue altogether. By controlling the light differences between subject and background, you can manage the overall contrast ratio so that it falls within your camera's capabilities. For example, if you are a studio photographer, you essentially have complete control over a scene's lighting and background environment to achieve whatever artistic effect you desire, such as that shown in 1-10.

ABOUT THIS PHOTO
The lighting in this standard studio shot has been carefully manipulated to precisely create this crafted look. (ISO 100, f/13, 1/125 second, Nikon 85mm f/1.8) © Pete Carr

If you need less light, you can dim it, block out windows, bounce it, or move it back. If you want more light, you can add it, use reflectors, or move it closer to the subject. If you want more contrast, you can choose a different background or turn it white, and remove shadows for a *high-key* effect (that is, intentionally lowering the overall contrast ratio of a scene, most often resulting in a very bright-looking photo). You can put lights above, behind, below, or to the side of the subject. You can modify the light by adding reflectors, brollies, softboxes, snoots (if you don't know what these are, check out a lighting or camera sales website), and more.

Whatever your artistic goal, the point is to manage the scene so that you have total control over the contrast and overall dynamic range. Lighting on location is far trickier because you lose some of this control. You may have no choice when it comes to background lighting, which is often up to nature. However, you can control how bright the model is and, therefore, balance that with the background. If you have a few lamps, strobes, or reflectors, you can illuminate the model nicely. Again, this reduces the contrast between your subject and the background, which in turn reduces the dynamic range of the image.

USING FILTERS

Filters are also a tried-and-true method of controlling exposure. There are two main types of Neutral Density (ND) filters: Graduated (ND grad) and nongraduated. Both types come in various strengths. Unlike software solutions to exposure, you can see the effect before you take the photo and adjust your settings on location.

Landscape photographers use ND filters to darken their photos (most often, because they can't select a low enough ISO and fast enough shutter

speed given a wide aperture). ND filters filter out all wavelengths of light equally, resulting in an evenly reduced exposure.

ND grad filters are particularly well suited to scenes with simple horizons, such as beaches and long-distance landscapes, where the sky is very

bright and has to be toned down dramatically compared to the foreground. ND grad filters are perfect solutions for these types of scenes, as they keep the sky from being blown out.

ND grad filters can also be used in more complicated scenes, such as that shown in 1-11. In this case, the end of the street and sky may look uneven, but the horizon line between the road and buildings is straight enough to make an ND grad filter a viable option. Beside this, the bright building at the end of the street dominates your attention. It wasn't as important that the buildings beside it be brightened. The ND grad filter helped brighten and balance the light of the road leading away with the brighter building, which was darkened by the filter.

ND filters are not without their problems, however. If the horizon is not perfectly straight (trees, hills, buildings, and mountains get in the way and complicate things) and you use a graduated filter, details on the intervening scenery are likely to be underexposed. Additionally, mountains or other objects may look like they have halos around their tops.

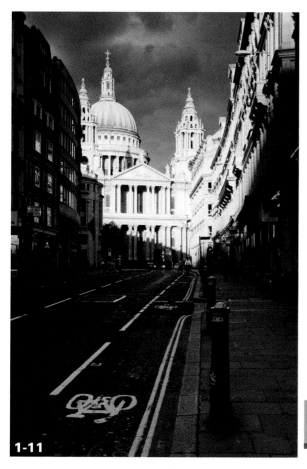

1-11

ABOUT THIS PHOTO *This scene illustrates an ND grad filter in action with minimal processing applied. It helped retain detail in the brightest area of the photo while brightening the road. (ISO 800, f/8.0, 1/160 second, Nikon 24-70 f/2.8 at 45mm) © Pete Carr*

In short, ND filters can be used at any time, but ND grad filters are best used when the landscape is neat and tidy. HDR works in any of these situations because it is not dependant on the horizon line being level.

CONTRAST MASKING

Contrast masking is a software technique that evens the contrast of an image. The idea is to use a new layer to bring out details in the shadows or darker areas, and tone down highlights in others.

In 1-12, the sky is a bit washed out and the details are unimpressive in the shadows, particularly the monument.

In brief, contrast masking involves duplicating the photo layer in your favorite photo-editing software (from the *layers* panel); *desaturating* (reducing the color intensity to zero, resulting in a grayscale image) that duplicate layer; and then *inverting* it (inverting the brightness of each pixel of an image, resulting in something that looks like a black and white negative). Desaturating the duplicate layer focuses the end result on brightness rather than color. Inverting the layer pushes the original highs and lows in the opposite direction.

At that point, apply a *Gaussian Blur* (a sophisticated blurring algorithm that blurs each pixel) to the layer to soften the effect a bit. The final steps are changing the blend mode of the duplicated, desaturated, inverted layer to Overlay. This lightens dark areas and darkens bright areas of the lower layer.

note A lot of Photoshop jargon is used in this section (contrast masking is probably the most intense). Photo editing techniques often rely on sophisticated tools and methods, for which full explanations are beyond the scope of these examples. For further information, please consult your photo editor's help file.

You can also selectively erase portions of the contrast masking layer to help restrict the effect to specific areas. For example, portions of the building might look fine without contrast making, so just erase (or mask out) those areas of the contrast mask.

The effect of contrast masking on the photo in 1-12 is illustrated in 1-13. It brings out more detail, but in some ways it looks a little off. The right side of the building looks weird compared to the left.

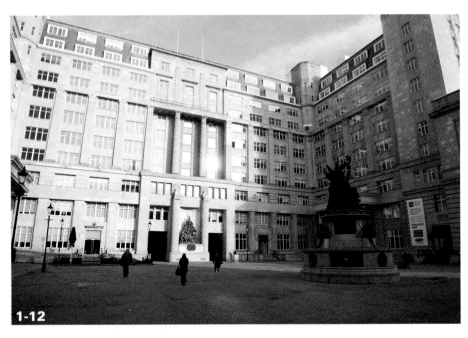

ABOUT THIS PHOTO *Exchange Flags in Liverpool. This scene includes a loss of detail in shadow areas. (ISO 800, f/8.0, 1/800 second, Nikon 24-70mm f/2.8 at 24mm) © Pete Carr*

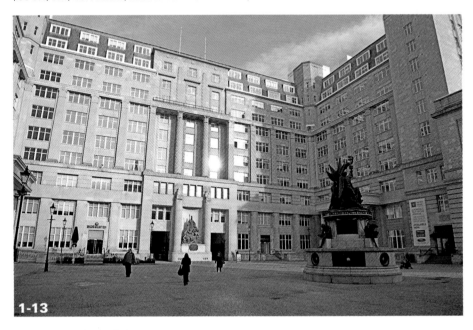

ABOUT THIS PHOTO *Exchange Flags in Liverpool. This scene includes more detail in the shadow areas. Contrast masking may work in some situations, but it can be an inelegant solution. (ISO 800, f/8.0, 1/800 second, Nikon 24-70mm f/2.8 at 24mm). © Pete Carr*

EXPOSURE BLENDING

You could call exposure blending an early form of HDR. In fact, it began (as many software techniques have) in the darkroom. The idea was to take more than one photo and blend them while making the print. Today, exposure blending is predominately a software process, and (as with HDR) begins with taking more than one photograph.

For example, to photograph a landscape with a bright sky, you take one photo of the land properly exposed, then take another and set the exposure for the lighter sky. You can take as many photos as you want, each differently exposed, as long as you use a tripod and keep the scene composed identically between exposures. Later, blend them in Photoshop as different layers (see 1-14).

There are several ways to perform exposure blending in software. You can change blending modes from soft light to pin light or erase (or mask) parts of the image you don't need, and then work them until they blend together. Ultimately, this can be a tricky and time-consuming process.

HDR photography is very similar to this on the front end (taking the exposure-bracketed photos), but is vastly different in software. HDR software such as Photomatix automates blending and other aspects of this task.

TWEAKING SHADOWS AND HIGHLIGHTS

Another reasonably simple solution to overcoming your camera's limited dynamic range is to tweak the shadows and highlights of your photo in your favorite image-processing application.

You can recover some detail from a JPEG using this technique in a standard graphics program, such as Photoshop Elements. However, it is easy to ruin the image if you try and push too hard. JPEGs have only a stop or so of enhancement in them before they are ruined by noise and color banding. You can also use this technique on previously processed camera raw exposures that have been saved as TIFFs.

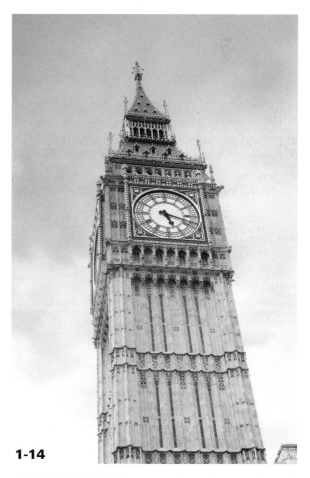

1-14

ABOUT THIS PHOTO *Two exposures are merged together in Photoshop to create a balanced photo of the Clock Tower that holds Big Ben. (ISO 640, f/16, 1/100 second, Nikon 24-70mm f/2.8 at 58mm) © Pete Carr*

This technique is illustrated in 1-15 and 1-16, which show a mastodon sculpture in the grass. In the before shot (1-15), the sky is on the verge of blowing out. At the same time, the mastodon is in darkness. After applying a moderate Shadows/Highlights adjustment in Photoshop Elements,

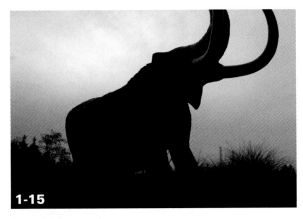

1-15

ABOUT THIS PHOTO *A mastodon sculpture in shadow. Notice that the sky is on the verge of blowing out. (ISO 100, f/8.0, 1/200 second, Sigma 10-20mm f/4-5.6 at 20mm) © Robert Correll*

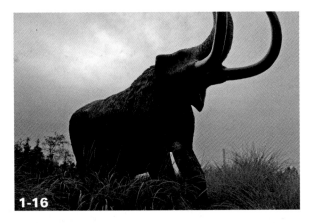

1-16

ABOUT THIS PHOTO *The same image after a Shadows/Highlights adjustment in Photoshop Elements to recover detail. (ISO 100, f/8.0, 1/200 second, Sigma 10-20mm f/4-5.6 at 20mm) © Robert Correll*

the mastodon is lightened and the bright area of the sky has been toned down a bit (see 1-16). Afterward, both photos were converted to black and white with a hint of sepia toning to age them.

Although you may still want to use this technique, properly shot HDR reduces the need for most shadow and highlight tweaking for anything but aesthetic reasons.

DODGING AND BURNING

Dodging and burning are two techniques that also have their roots in the darkroom. *Dodging* involves lightening specific areas of a photo. For example, if someone's face is a bit too dark, you can dodge to lighten it and make the person stand out more. *Burning* darkens areas of the photo. If, for example, the sky is too light, a small amount of burning can bring it back in line with the rest of the photo. In these ways, different areas can be exposed with different amounts of light, resulting in customized exposure levels across the photo.

In theory, dodging and burning are simple. However, the default exposure strengths in Photoshop and other applications are set so high that it's almost impossible to get good results without a good deal of tweaking. The key is to take it easy and set the strengths correctly. If necessary, apply evenly over more than one application. Using a pen tablet helps tremendously.

The Dodge and Burn tools are located together on the Tools palette of Photoshop. The Dodge tool looks like a small paddle that holds back light and the Burn tool is a small hand. Here are some tips to help you dodge and burn:

■ After selecting the Dodge tool, set the Painting Mode range to Shadows to bring details out of darker areas.

- Start with the Exposure between 10 and 20 percent when dodging and then alter it as needed.

- Set the Painting Mode range for the Burn tool to Highlights to darken overly bright areas or Shadows to deepen existing dark areas.

- When burning, set Exposure under 10 percent to start and alter as needed.

Doing a poor job with the Dodging and Burning tools can create halos around the areas you manipulated, so be prepared to experiment and start over. It's also possible to increase noise levels in areas as you dodge. Additional noise may not be a problem, especially if you're working with black-and-white photos (see 1-17). In those cases, a little extra noise looks like film grain and is aesthetically pleasing.

On the whole, even when shooting HDR, you should be prepared to continue dodging and burning. However, your attention should be much more focused on subtle details, rather than trying to rescue a photograph.

FILL LIGHT AND RECOVERY

If you use Adobe Lightroom or Adobe Camera Raw (available within many Adobe products, including Photoshop Elements), there are two quick and easy ways to rescue hidden details from standard photos: Fill Light and Recovery.

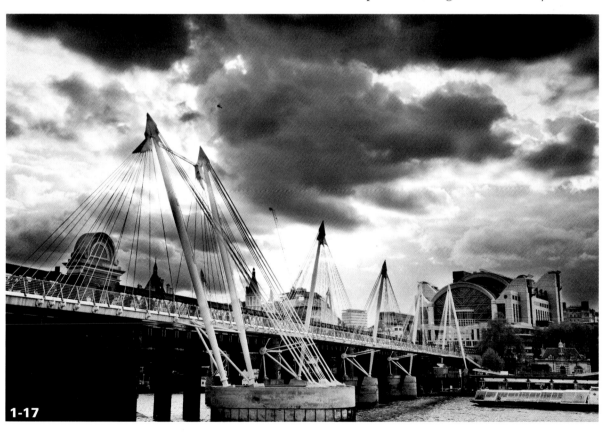

1-17

ABOUT THIS PHOTO *This classic black-and-white photo has been enhanced with dodging and burning.
(ISO 250, f/6.3, 1/800 second, Sigma 10-20mm f/4-5.6 at 10mm) © Pete Carr*

Details get lost in shadow because the limited dynamic range of the camera forces the photo to be underexposed in darker areas to avoid clipping the highlights (see 1-18). Fill Light selectively brightens the dark and midtones of a photo, moving them toward the lighter end of the histogram. If you're using HDR, the multiple exposures capture these details more suitably in the first place, so you don't have to resort to using Fill Light to bring them out.

Overexposed highs normally happen with skies and other bright objects, again, due to the limited dynamic range of the camera. In this scenario, if the subject is exposed correctly, it leaves the sky white or blown out. To fix this, Recovery does the opposite of Fill Light. Recovery takes the highs of a photo and brings them down into a reasonable balance with the rest of the photo.

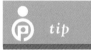

tip | Generally speaking, it is not wise to overdo Fill Light or Recovery as you may lose contrast and tone, or elevate noise.

Both techniques are illustrated in 1-18 and 1-19. The shadows in the street were brightened with Fill Light and the sky was protected from being blown out by Recovery. As you can see, the trouble with this technique is that it doesn't increase the dynamic range of the scene. It only helps you bring out or protect the data that is already there.

PROCESSING CAMERA RAW EXPOSURES

Processing RAW photo files (which includes Fill Light and Recovery) is a very good technique for increasing exposure flexibility because, unlike 8-bit JPEGs, camera raw images contain the full dynamic range of the original photograph as

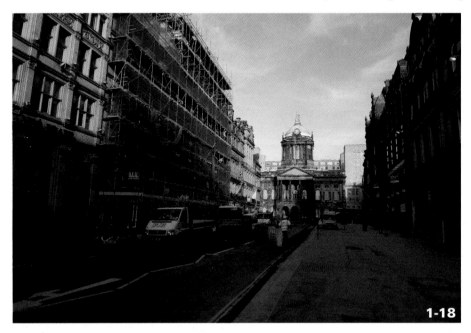

1-18

ABOUT THIS PHOTO
Castle Street in Liverpool. This image has a lot of shadow in the foreground. (ISO 800, f/8.0, 1/1600 second, Nikon 24-70mm f/2.8 at 24mm) © Pete Carr

ABOUT THIS PHOTO
Castle Street in Liverpool. Fill Light and Recovery can be used to bring out the detail in the shadows while retaining detail in the highlights. (ISO 800, f/8.0, 1/1600 second, Nikon 24-70mm f/2.8 at 24mm) © Pete Carr

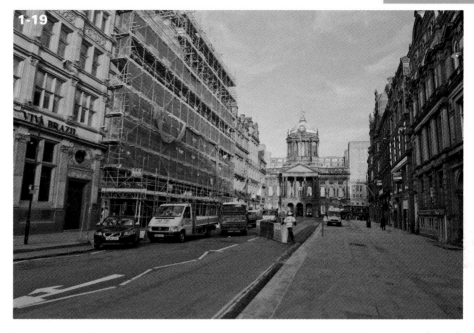

1-19

captured by the camera. In other words, when a camera converts sensor data to a JPEG file, it reduces the dynamic range of the photo in order to fit within the 8-bit-per-channel restriction of the JPEG file format. Cameras often let you choose an artistic style (such as portrait, landscape, or vibrant) for it to use when it converts from RAW files to JPEGs. However, when you convert the file yourself, you control the process. The trade-off for this control, though, is an altered workflow, increased time spent processing, and space.

In the end, working directly with camera raw photos is a step toward HDR, but still stops short of it. A camera raw photo has more dynamic range compared to a JPEG, but you're still limited by the processing options of the RAW file editor. Current RAW file editors reveal a traditional, single-exposure mind-set that excludes some techniques unique to HDR applications. For example, you cannot blend or merge exposures, generate HDR, or tone map a 32-bits-per-channel HDR image.

THE HDR SOLUTION

To sum up, you've discovered the problem — your camera has a limited dynamic range. As a result, it's easy to lose details (especially when photographing high-contrast scenes) by blowing out highlights and leaving shadows in the dark. There are a number of traditional measures that photographers have come up with over the years to try and overcome or correct these problems. Although these techniques are successful to varying degrees, there is finally a technique that allows more light to be captured with the same camera.

That technique is HDR photography. It increases your camera's dynamic range by using more than one photo — each with a different exposure — to capture a scene. Later, you take the exposure brackets (with a collectively superior dynamic range than a single photo) and use HDR software to create a finished photo that you can print and view.

SHOOTING EXPOSURE BRACKETS

The point of shooting brackets is that each one has a different exposure, allowing you to expose for highlights, shadows, and all points in between (see 1-20, 1-21, and 1-22). Although two exposures are better than one, and more than three may be good in very high-contrast situations, three brackets is generally the ideal number.

Image 1-20 is a normal exposure with a good balance of highs and lows (which depends on the subject). This is what you should be shooting already. Image 1-21 is deliberately underexposed to bring down highlights and keep them from being blown out. Image 1-22 is overexposed to bring up the shadows so you can see what is in them. With exposure brackets, the exposure of each photo differs by a discrete amount, most often +/- 1 or 2 EV, depending on the ability of your camera.

USING SINGLE EXPOSURES

There is another approach to HDR covered in a bit more detail in Chapter 4. It is not technically HDR but, rather, a tone-mapping trick. To perform it, you load a single RAW photo file (or the false exposure brackets created by processing the single exposure multiple times) into an HDR program and tone map the result as if you are working with an actual set of exposure brackets.

This technique is especially useful for photographs of moving objects and other scenes where you do not have the time (or the ability) to shoot exposure brackets, as shown in 1-23.

While this method can be handy in some situations (it is a viable technique to process single camera raw exposures, regardless of whether it is HDR), this book focuses on taking bracketed exposures.

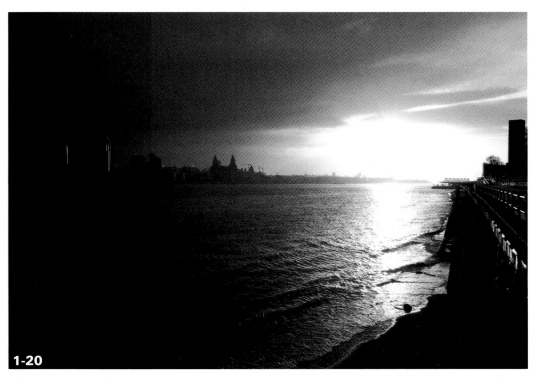

1-20

ABOUT THIS PHOTO *An average exposure. This is probably what you'd get on a normal day. (ISO 200, f/22.0, 1/80 second, Nikon 24-70 f/2.8 at 38mm) © Pete Carr*

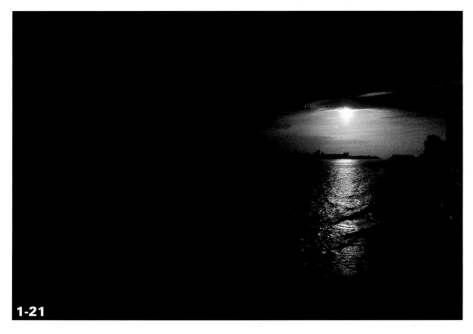

1-21

ABOUT THIS PHOTO *This image has been underexposed by three stops to bring out the detail in the sky. (ISO 200, f/22, 1/1250 second, Nikon 24-70 f/2.8 at 38mm) © Pete Carr*

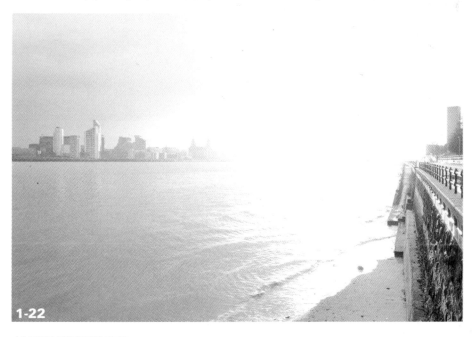

1-22

ABOUT THIS PHOTO *This image has been overexposed by 3 stops to bring out the detail in the skyline but at the expense of the sky, which is now just white. (ISO 200, f/22, 1/5 second, Nikon 24-70 f/2.8 at 38mm) © Pete Carr*

ABOUT THIS PHOTO *Having fun in the Greektown area of downtown Detroit. Pseudo-HDR brings out all of the intricate details. (ISO 100, f/8.0, 1/250 second, Sony 18-55mm f/3.5-5.6 at 22mm) © Robert Correll*

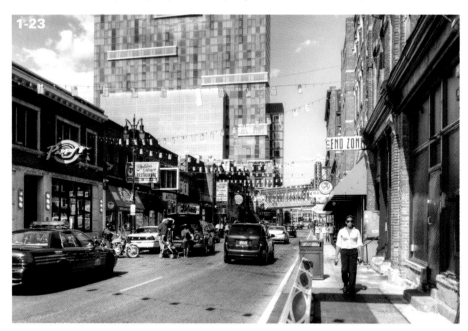

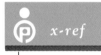

x-ref

See Chapter 4 for more information on single exposure HDR.

MERGING BRACKETS IN HDR SOFTWARE

The second aspect of HDR takes place in software. Basically, you load the bracketed exposures (RAWs, JPEGs, or RAW files converted to TIFFs) into HDR software, such as Photomatix Pro, tick a few boxes that define the HDR options you want, and it then creates a 32-bit HDR file. This produces an interim HDR file that you use to tone map. You can save the HDR file in a number of industry-standard file formats, like OpenEXR, Radiance RGBE, or Floating Point TIFF, before you start tone mapping (this can be useful if you want to use the HDR image in another program).

TONE MAPPING THE RESULT

What comes next is where the magic of HDR happens: tone mapping. Simply put, *tone mapping* is the process of compressing the tones in an HDR image from 32 bits per channel to 8- or 16-bits per channel, and selectively setting relative brightness and contrast levels.

As you can see in 1-24, an HDR image isn't usable unless you tone map it. This is because your screen (and this printing process) doesn't have the ability to show that much information.

HDR software is specifically optimized for this purpose and automates much of the process (see 1-25). You don't have to create complex masks, use blending modes, or vary the opacity of different image elements to achieve your purpose. After saving the tone-mapped file as a JPEG or TIFF, you can further process it with your favorite image editor prior to distribution.

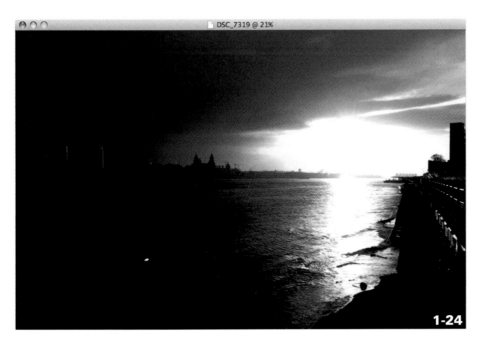

ABOUT THIS FIGURE
An HDR image in Photomatix.
Image © Pete Carr

ABOUT THIS FIGURE
The tone-mapping process in
Photomatix. Image © Pete Carr

1-25

A completed, tone-mapped HDR image is shown in 1-26. It was taken from nine bracketed photos that were merged into HDR and then tone mapped to create the look you see here. Notice that the sun is in view. This should cause the camera to underexpose everything else, resulting in dark shadows or silhouettes. However, details on the facing side of the arch and, in fact, the rest of the photo, are clearly visible. This is the power of HDR. You can retain more detail in your photos, shoot in a wider range of lighting conditions, and craft your final product to suit your artistic tastes.

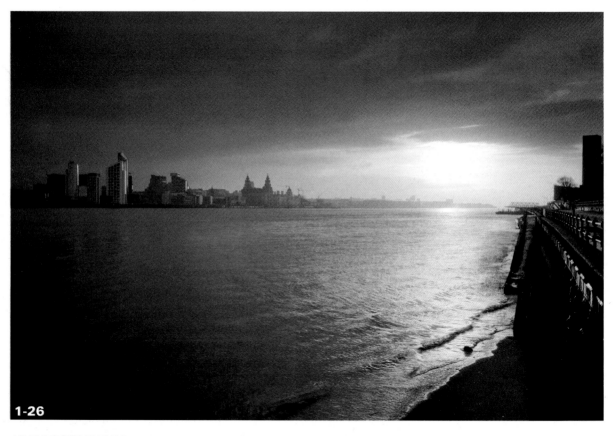

1-26

ABOUT THIS PHOTO *River Mersey in Wirral, United Kingdom. Shooting directly into the sunrise can be done without sacrificing the detail of the cityscape. HDR from seven exposures bracketed at -3/-2/-1/0/+1/+2/+3 EV. (ISO 200, f/22, 1/60 second, Nikon 24-70 f/2.8 at 38mm) © Pete Carr*

Assignment

Photograph a Sunset

This chapter has given you a lot of information about dynamic range and digital photography. Now it's time to become personally involved in the process. Grab your camera and capture a sunset. This scene will have a large dynamic range. Although you may want to experiment with filters or other exposure techniques, shoot at least one photo relying on the camera's inherent dynamic range. Try and take the best photograph you can, and note afterward where the exposure compromises are.

Next, use one of the editing techniques discussed in this chapter to recover, or bring out detail in, the shadows and highlights. Think about the advantages of HDR when planning your photo. After you finish reading the book, return to this scene and reshoot it for HDR, if possible.

Robert took the photo on the left near sunset from one side of a foot bridge under construction. The challenge in this situation was striking a balance between not blowing out the sunset and preserving some detail in the shadows. Afterward, he used contrast masking to darken the sun, and brighten the foreground and parts of the suspension bridge. Taken at ISO 100, f/8, 1/125 second, Sigma 10-20mm f/4-5.6 at 18mm.

Compare the non-HDR result (on the left) to the same scene shot and processed as HDR (on the right). In this case, three brackets were used, shot at a range of -3/0/+3 EV. The center bracket was taken at ISO 100, f/8.0, 1/500 second, Sigma 10-20mm f/4-5.6 at 18mm.

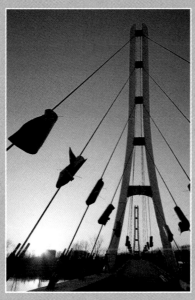 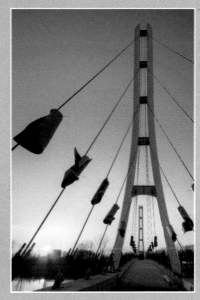

© Robert Correll © Robert Correll

 Remember to visit www.pwassignments.com after you complete this assignment and share your favorite photo! It's a community of enthusiastic photographers and a great place to view what other readers have created. You can also post comments, read encouraging suggestions, and get feedback.

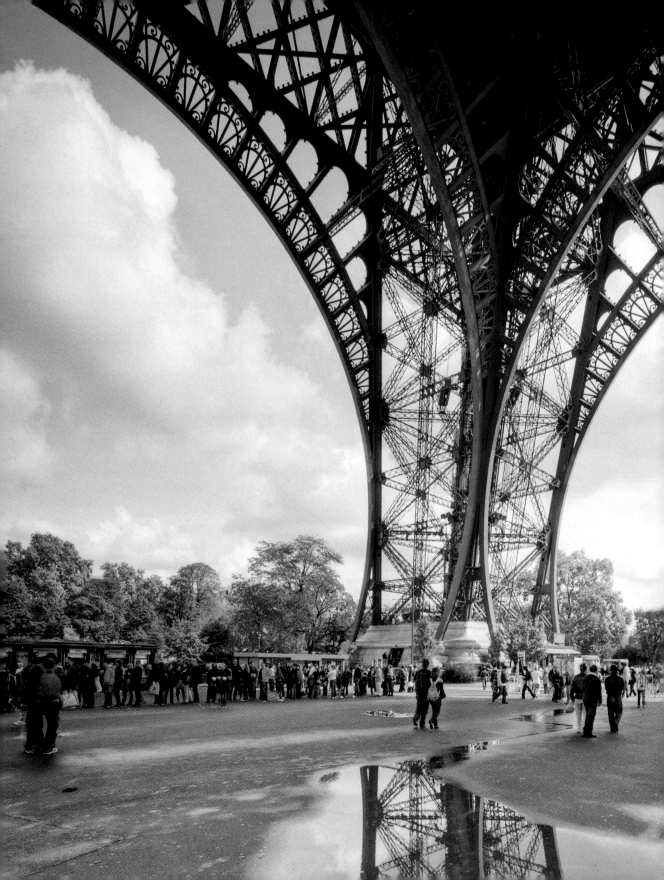

CHAPTER **2**

GEARING UP FOR HDR

Keeping Your Eyes on the Prize

Common Camera Types for HDR

Important Camera Features

Useful HDR Accessories

Lenses and HDR

HDR Photography Software

RAW File Processing and Photo Management

Photo Editing

© Pete Carr

Photography is about capturing light with your camera. The unique characteristics of the subject, scene, and photographic purpose, however, suggest (or may even dictate) specific tools for the job. You don't see photographers shooting long-distance shots of wildlife in Africa using macro lenses. Nor do you typically shoot nice wedding portraits with fisheye lenses.

HDR photography is no different. You capture light with your camera using the tools of the trade. The only HDR-specific tool is the software required to convert exposure-bracketed photos to high-bit HDR files, which are then tone mapped. Therefore, if you are a landscape photographer with all the gear, you're primed to start shooting HDR. If you are an amateur photographer with a fairly decent compact camera, you can get started, too.

This chapter covers a variety of gear that enables you to take photographs and transform them into HDR according to your creative vision — from camera types to lenses, tripods, and filters. You also get a brief introduction to the different software packages that make HDR possible.

KEEPING YOUR EYES ON THE PRIZE

Before getting to the gear, it is wise to start with the big picture. Photography in general — and HDR in particular — are activities that require a specialized set of equipment, the knowledge to use it, and the money to buy it. It is not an endeavor without cost and complexity. Time is also a factor. You need time to learn, to practice, and to grow.

HDR expands the working palette of you, the photographer. As you become more experienced with HDR you will notice your perceptions become tuned to different aspects of a scene. You become consciously aware that there are more creative possibilities than with traditional photography. You can look for high-contrast scenes and lighting conditions that you may have given up on before. Even if you shoot in the same conditions, your expectations of what the finished product can look like may be dramatically altered.

For example, the scene in 2-1 would have been tremendously hard to shoot and impossible to present this way without HDR. As it was, ISO was set to 200, which is the standard low ISO setting for the Nikon D700, and the aperture to f/8.0 so everything inside and out was sharp and in focus. HDR made it possible to see with clarity all of the minute details in the dimly lit cockpit, while retaining detail in the bright clouds and sky outside. This complex scene is greatly enhanced with HDR.

The photo in 2-1 was taken with a mix of the gear presented in this chapter: a digital SLR with a wide-angle lens, stabilized with a tripod. The camera's AEB function took care of the nine brackets after being triggered by a remote shutter release. The camera raw exposures were converted to TIFFs and sent to Photomatix Pro to be made into HDR and tone mapped. The final image was polished in Lightroom. Had more work needed to be done, Photoshop would have been called into action. HDR doesn't take an enormous amount of extra gear, but it does take the right combination of gear.

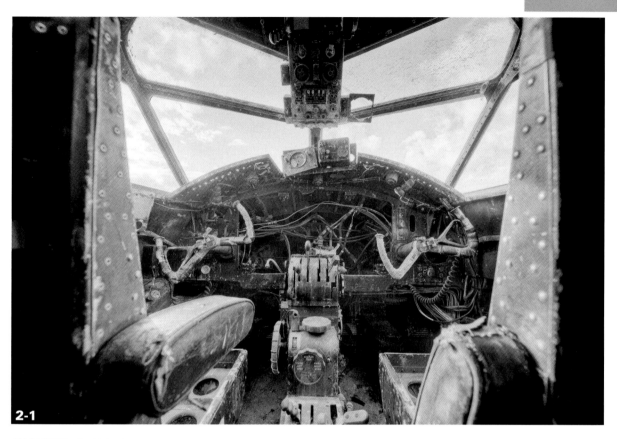

2-1

ABOUT THIS PHOTO *Interior of an old plane at Speke, Liverpool. HDR from nine exposures bracketed at -4/-3/-2/-1/0/+1/+2/+3/+4. (ISO 200, f/8.0, 1/5 second, Nikon 14-24 f/2.8 at 14mm) © Pete Carr*

COMMON CAMERA TYPES FOR HDR

As with regular photography, you have a number of camera choices when it comes to HDR. The camera that has the most HDR potential is the digital single-lens reflex (dSLR). You can also use a digital compact camera (including the fully automatic models) if you don't mind a few limitations. As long as the model you're using has *exposure compensation*, which is a camera feature that enables you to adjust the exposure brighter or darker, you're good to go.

Micro Four Thirds cameras are bridging the gap between dSLRs and compact digitals. The dSLR provides you with the best optics, the largest sensor, more internal processing power, and greater functional control. The digital compact is generally easier to use and costs less.

Ideally, you want a camera with Auto Exposure Bracketing (AEB), which enables you to photograph exposure brackets easily and swiftly. You can also shoot HDR with a camera that gives you manual control over aperture, ISO, and shutter speed. Lacking these features, you can use any camera that allows you to change the exposure through exposure compensation.

THE DSLR

The dSLR is based on the traditional SLR design that became very widespread and popular as a 35mm film camera. SLR describes how the camera works. Within the body of the camera there is a mirror that bounces the view coming into the lens up into the viewfinder (see 2-2). Therefore, you see exactly what the camera is seeing through the lens when composing and evaluating a shot. When you take the photo, the mirror moves out of the way and light exposes the camera's sensor (see 2-3). It's a brilliant design.

One of the other strengths of dSLRs is the ability to change lenses. Due to the modular design that separates the body of the camera from the detachable lens, you can purchase general-purpose lenses for every occasion or highly specialized lenses for specific purposes, such as the wide angle. Most dSLR lenses are also compatible with filters.

The dSLR is the camera of choice for HDR photography because the image quality is nothing short of stunning. The latest dSLRs are able to shoot at high ISO settings with little digital noise.

Most dSLRs have good built-in AEB features, so you don't have to bother with manual bracketing (although you may if you wish). In addition, dSLRs shoot faster than compact digitals, enabling you to capture faster-moving clouds without too much movement between brackets. The ability to take shots quickly is a requirement for handheld HDR.

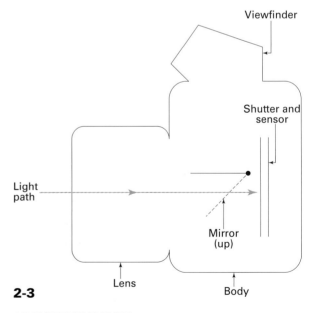

2-2

ABOUT THIS FIGURE *The internal structure of a dSLR with the mirror down. Light bounces up into the viewfinder.*

2-3

ABOUT THIS FIGURE *The internal structure of a dSLR with the mirror raised and out of the way as the camera takes the picture.*

COMPACT DIGITAL CAMERAS

Compact digital cameras are small and light-weight with built-in lenses. They usually have a fairly decent zoom lens and an LCD screen on the back. In some respects, the screen is similar to the viewfinder on the dSLR. You basically see what the camera sees and the screen is easier to use. It's much larger than the tiny viewfinders common to compact digital cameras.

Generally, there are five types of compact digital cameras. They are:

- **Fully automatic.** These cameras have auto and scene modes (like landscape or portrait) that reduce your ability to control specific characteristics of the shot. They also have a more basic zoom lens — zoom in or out, and take the photo when it looks good. They are not very suitable for HDR photography, although you can use exposure compensation in a pinch. Most compact cameras save photos as JPEGs, which is compatible with HDR, but will not produce the highest quality end product.

- **Auto with manual controls.** These cameras are a step up from the fully automatic, with a better zoom lens and some degree of manual control. You can enter the world of photography fairly inexpensively and have control over your exposures. There are fewer and fewer inexpensive compact cameras available that have semi-automatic or manual controls. These cameras are suitable for HDR in that you can manually bracket the scene. Some may even have AEB.

- **Bridge camera.** These cameras look like a dSLR but don't have the ability to inter-change lenses. They have decent optical zoom

ranges (some, up to 20x) and feel good to hold. The bridge camera should also have fully manual controls. Cameras in this class that feature powerful zoom lenses are sometimes called super zooms.

- **High-end traditional compact.** Also know as the "photographer's compact," they have fully manual controls and a high ISO range. They may also have interchangeable lenses, and Auto Exposure Bracketing (AEB, discussed in detail later in this chapter) capability. They should also have RAW file support. Their sensors tend to be larger than standard compact digitals, but they are still nowhere near the size of a Micro Four Thirds camera sensor.

- **Micro Four Thirds.** These cameras have larger sensors than traditional compact digital cameras, yet are the same size. They are as pricey (or more) than high-end traditional compacts, have interchangeable lenses, have hot shoes, manual and semi-auto exposure modes, and, as with high-end compacts, may have AEB.

IMPORTANT CAMERA FEATURES

A camera's features not only determine whether it meets your needs, but also if it is a good platform for pursuing HDR photography. Price, however, is not the best way to measure a camera's ability to shoot HDR. Investigate the specifications of any cameras in which you are interested fully before committing to make the purchase.

SHOOTING MODES

Fundamental to shooting multiple-exposure HDR is the ability to control exposure from the camera. There are several ways to control the camera, depending on what type you have. It is best, therefore to discuss HDR options mode by mode:

- **Full automatic.** In this mode, you simply point the camera and shoot. Not all dSLRs have this mode, although the entry-level and midrange models do. AEB is not normally available in auto modes, nor is manual bracketing possible because you cannot change the exposure. You may be able to use exposure compensation in Auto mode on some cameras.

- **Guided modes.** Also called creative auto, these modes give you some control over certain elements of a photo, such as whether or not you want the background blurred, but otherwise act similarly to automatic mode. As a result, this mode isn't suitable for HDR.

- **Scenes.** When shooting in a scene mode, you identify what type of shot you are taking, such as a landscape or portrait, and the camera sets the exposure for you. Many cameras allow you to use AEB in these modes. This means that you can shoot brackets even if you don't have precise control over the camera's aperture and shutter speed. You may also be able to use exposure compensation when shooting a scene.

- **Program AE (auto exposure).** This mode allows you to select a combination of shutter speed and aperture, but does not let you manually bracket the scene. However, you may often be able to use AEB or exposure compensation to manually bracket.

- **Aperture Priority.** This is an auto exposure mode, but it allows more freedom when choosing an aperture. Using Aperture Priority mode (see 2-4) is preferable in conjunction with AEB. This locks in the desired aperture and the camera handles changing the shutter speed to bracket the scene. You may use exposure compensation in this mode should you want to manually bracket. This isn't normally needed with dSLRs, as you can always enter Manual mode and set the exposure yourself.

- **Shutter Priority.** This auto exposure mode is less desirable for HDR because the shutter speed is held constant while the aperture changes. This can result in varying depths of field between brackets, which might ruin the photo. As with Aperture Priority mode, you may also use exposure compensation in this mode, should you want to manually bracket.

- **Manual.** Manual mode gives you full control over the camera. You use it to manually bracket. Set the ISO for the general conditions, then the aperture, and finally, adjust the shutter speed up and down to capture the exposure brackets. This is manual bracketing in a nutshell. If you want to deviate from the exposure the camera suggests (even if using AEB) enter Manual mode and set the exposure for the main bracket where you want it. You could also use exposure compensation to intervene.

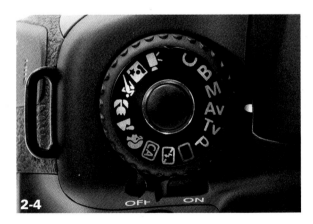

ABOUT THIS PHOTO *Setting a camera to Aperture Priority AE mode. Image © Robert Correll*

■ **Exposure compensation.** Although it's technically not a shooting mode, exposure compensation (see 2-5) gives you the ability to indirectly set the camera shutter speed by increasing or reducing the exposure. It's a last resort for shooting exposure brackets for HDR. Exposure compensation is often available in shooting modes and cameras where you have no direct control over exposure settings.

Anyone with virtually any camera can begin shooting HDR — you don't have to buy a fancy new model. Start with what you have, get the process down, learn the software, and have fun with HDR. Upgrade when you can and when you have a better idea of what you want. You may not be able to shoot the highest quality photos, nor will you be able to shoot in all circumstances, but at least you can get going.

AUTO EXPOSURE BRACKETING

Auto Exposure Bracketing (or AEB), is one of the handiest features to have. It's not required for HDR, but it makes capturing multiple, exposure-bracketed images extremely easy. If your camera has an Auto Exposure Bracketing setting, using it means you do not have to manually bracket your shots (which is a hassle). AEB automatically changes the camera's settings between multiple exposures. It varies the exposures by the amount you determine, from +/- 0.3 to +/- 3.0 EV between shots.

Exposure bracketing has historical roots that go back well before HDR. Quite often landscape photographers would take a photo at f/8.0 and 1/500 second as a normal exposure, then adjust the shutter speed to 1/250 second to take another photo and perhaps finally to 1/1000 second. They did this (and still do) to secure an alternate

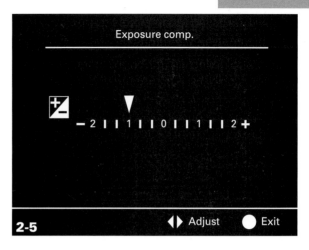

2-5

ABOUT THIS FIGURE *Exposure compensation allows you to indirectly control shutter speed. Here, the exposure is being decreased by 1 EV. The camera sets the shutter speed based on this setting.*

exposure in case it was better than their original settings. In the end, they had one normal photo, a darker one, and a brighter one, just in case they needed it.

If you use a remote shutter release and continuous shooting, you can simply hold down the button. The camera then takes the number of necessary photos, adjusting the settings as it goes — it's quite brilliant.

For example, if you set the camera to +/-2 EV, as shown in 2-6, and shoot the three bracketed photos: one will be underexposed by 2 EV, one will be a center exposure (0 EV), and one shot will be overexposed by 2 EV. Notice the three EVs that are highlighted in 2-6 — this is an HDR bracket of -2/0/+2 EV.

ⓟ *note*

Technically speaking, there are many ways to shoot brackets of varying exposures — you can alter ISO, shutter speed, aperture, flash intensity, and so forth. However, varying shutter speed is the most predictable and consistent. Raising ISO, for instance, elevates noise levels between exposures.

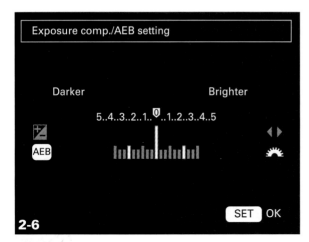

Exposure comp./AEB setting

Darker Brighter

5..4..3..2..1.. 0 ..1..2..3..4..5

AEB

2-6 SET OK

ABOUT THIS FIGURE *The AEB menu function.*

> **note** Shooting with a tripod is usually a big part of HDR, but it doesn't have to be. A good camera with high fps and AEB helps you bracket if you forget your tripod.

SPEED

Shooting speed, measured in frames per second (fps), is the rate at which your camera can take and store photos. Modern cameras are achieving ever-faster shooting speeds, with some of the latest dSLRs attaining speeds upward of 11 fps. Entry-level dSLRs average between 3 and 5 fps, while mid-level and semi-professional dSLRs shoot between 5 and 8 fps. New semi-pro and professional dSLRs shoot between 7 and 11 fps.

If you are working with a tripod, outright speed is not as important for HDR as it is for, say, sports photography. There are times, however, when you want higher shooting speeds — even if you are set up and stabilized on a tripod. Clouds, for example, move across the sky faster than you may realize (see 2-7). Being able to shoot auto exposure brackets at a reasonable speed (3 fps) is very helpful. If you want to try handheld HDR, speeds of 5 fps or more are desirable.

PHOTO FILE TYPES

There are three main file types used in photography: JPEG, TIFF, and RAW. All modern digital cameras support JPEG as the standard photo type. Your decision will be whether to buy a camera that also stores RAW photos for you to manipulate. TIFFs, rarely seen in cameras anymore, are high-quality images. They can, for example, be used when saving tone-mapped HDR files.

JPEGs, TIFFs, and even RAW files all store EXIF metadata within the file (but out of view), including information such as camera type, aperture, shutter speed, time, and so forth. When you publish your finished product, strip out the information you don't want publicly disseminated, but add copyright and other information you want to share. Each graphic application has its own routine for accessing and altering file and EXIF information.

■ **JPEG.** The JPEG (.jpg denotes a specific file) format has many benefits. It is very common and compatible. It can display millions of colors and can be compressed to minimize file size. JPEGs also store camera metadata, such as exposure information, in EXIF. As such, it is very commonly used for displaying photographs on the web.

> The downside to JPEGs is threefold: Lossy compression, an 8-bit data format, and limited editing choices after the photo is taken. Every time you save a JPEG image it is recompressed, causing a slight loss of data every time — even on the lowest possible compression setting — which is why it is referred to as lossy. The 8-bit data format limits your ability to manipulate exposure.

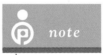

> **note** JPEG stands for Joint Photographic Experts Group.

2-7

ABOUT THIS PHOTO *West Kirby, Wirral, United Kingdom. A stunning sunset filled with detail and color. HDR from three exposures bracketed at -2/0/+2. (ISO 200, f/8.0, 1/100 second, Canon 24-70 f/2.8 at 25mm) © Pete Carr*

> With JPEGs, what you see is, essentially, what you get. If the photo is overexposed, you are limited to about one stop or so of exposure manipulation to bring it back. The same holds true for underexposed photos. Finally, if you get white balance wrong or oversharpen in-camera, you are basically stuck with the camera's decisions.

■ **TIFF.** Data integrity is the primary benefit of using TIFFs (Tagged Image File Format). TIFFs save data in a lossless format, which means you can save it over itself repeatedly and not lose any image quality.

> TIFFs can be saved as 8 or 16 bits, which means they can store more information than a JPEG with greater quality.

> In HDR, TIFFs are most often used as interim files (16-bit TIFFs saved from Photomatix) and for printing. Today, few (if any) cameras save photos in TIFF format. RAW files have replaced TIFFs as the high-quality photo option.

■ **RAW.** Camera raw files actually come in a collection of proprietary file formats developed by individual camera manufacturers.

Therefore, a camera raw file may have any one of a multitude of extensions in addition to RAW. To name a few, Canon uses CRW and CR2, while Nikon uses NEF and NRW. Adobe (the one non-camera manufacturer in the group — it provides software to develop camera raw exposures) is attempting to standardize one camera raw file format: the Digital Negative, or DNG.

> The thing to remember with camera raw files is that they are, indeed raw. In other words, they aren't a finished photo that you can load into a web browser and view or print directly. They are, in essence, something like a negative. A RAW file has to be converted to something more usable, like a TIFF or a JPG. That's why you get the Adobe Camera Raw interface every time you load a camera raw file into Photoshop. Unlike a JPEG, it's not usable until you process it.

> RAW files offer a number of advantages over JPEGs. First and foremost, they haven't already been converted. The data is as good as it gets from the camera's sensor. It hasn't been interpreted, converted, compressed (in some cases), or truncated. With RAW files, the original data is preserved.

> Another benefit of shooting and saving camera raw exposures is that you can create artificial brackets in a pinch. For instance, if you want to experiment with pseudo-HDR, you could process a single camera raw exposure into three brackets and use them in HDR software.

> Most photo editing software (including anything by Adobe) preserves your original exposures. If you process a RAW file by making changes (such as exposure, sharpness, color, or other parameters) and the changes are saved in another file, you can then export, open, or save the result as a JPEG, TIFF, or other format. You can also revert to the original RAW file whenever you want to because it hasn't been overwritten or changed. This is called nondestructive editing.

USEFUL HDR ACCESSORIES

The accessories listed in this section are optional. You need a camera, of course, but you don't always need a tripod, filters, or an automatic shutter release. This doesn't mean that they aren't helpful in many situations, but you don't need to run out and buy a set of ND grad filters to start shooting HDR. If you want to plan and budget your purchases, consider getting a tripod first, then a remote shutter release, followed by filters and a monopod, if the mood strikes you.

TRIPODS

There are two main types of tripods used in photography. The first comes with the legs and head (the part onto which your camera mounts that tilts and pans) assembled as one unit. You can't take these apart to switch legs, heads, or head types. These are generally cheap, but not very sturdy. However, they're great if you need a tripod and don't have the budget for a more expensive model.

The second type comes a la carte. You buy the legs that give you the height, weight, and sturdiness that you want, then you buy and attach a compatible head (it is often helpful to stick with the same manufacturer, but any compatible combination will do). The advantages here go well beyond quality. You get the tripod you want and can then

customize it by adding a ball, pan, or even a panorama head to the legs. This means that if you want one set of sturdy, heavy legs for general HDR and another lighter set for backpacking, you don't have to go out and buy new heads.

Each type comes in all sorts of sizes, weights, and materials. Making a decision comes down to these factors:

■ **Size.** Smaller tripods are lighter and easier to carry. As such, they may be referred to as backpack tripods. Larger tripods are heavier and, therefore, harder to carry around. They are also generally more expensive, but more stable.

■ **Weight.** Weight depends on the size and material used to construct a tripod. The more expensive tripods are made of strong, yet light carbon fiber, so they can hold heavy dSLRs with large lenses.

■ **Stability.** This depends on the material, and the quality of the design and manufacture. This is the very reason you're buying a tripod, so don't skimp on stability.

■ **Flexibility.** Some tripods do one thing — hold the camera. Others can be set up in different configurations with the legs and center pole out of the way so you can get to within a few inches of the ground.

■ **Head.** There are three types of tripod heads:

> Pan heads are like a television camera mount in that you can pan back and forth very easily. They are the most prevalent, especially in cheaper models.

> Ball heads offer a greater degree of freedom than pan heads. They are quicker to point and more agile, but are harder to track when shooting a panorama.

> Panorama heads, obviously, specialize in shooting panoramas. They reduce or eliminate parallax by ensuring the axis you pan around is centered on the focal plane of the sensor.

■ **Cost.** You can spend anywhere from $100 to $1,000 on a tripod. The important thing is to know what you need, and what will work best for you and your style of photography.

If you already have a compact digital camera you could have some fun with the Gorillapod (see 2-8). This fantastic tripod literally attaches to anything and can be adjusted to sit level on almost any terrain. The legs bend so you can attach it to a car door, a lamppost, a window sill — almost anything.

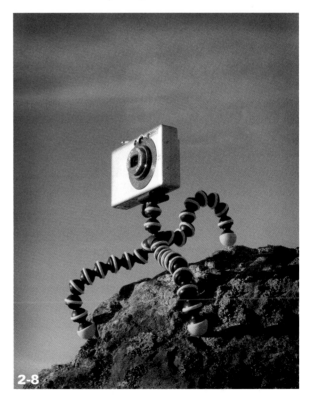

ABOUT THIS PHOTO *The Gorillapod can go anywhere and attach to anything. © Joby, Inc.*

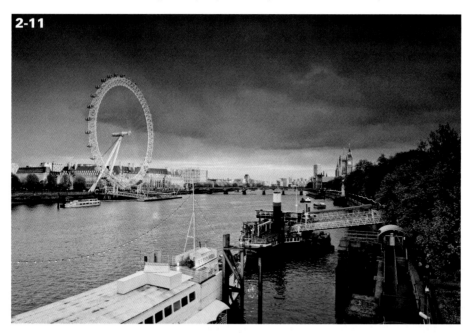

2-11

■ **Circular polarizer.** These filters reduce reflections in non-metallic surfaces, which can darken skies without darkening landscapes or buildings. You can see an example in 2-12 where the sky is a deep blue but the building is still bright.

> These filters can also reduce glare from water and make foliage appear less shiny. In the right conditions, they can also completely remove reflections from windows.

> The best time of day to use circular polarizer filters is during the Golden Hour, and the subject needs to be about 90 degrees from the sun. Rotate the filter and you should see a dramatic change in the sky from a normal to deep blue.

■ **IR (Infrared).** IR filters are different, fun, and creative. They block visible light while passing it in the near-infrared spectrum (normally invisible to the human eye) onto the camera sensor. Fewer people use them today because some camera sensors and lenses block infrared light.

> One issue you encounter when shooting with IR filters is a noticeable hotspot in the center of the image. However, this can be fixed in Photoshop.

> Infrared photography also takes longer than standard photography — often in the range of 30 seconds at f/4 — but the results, as shown in 2-13, can be amazing. The trees, bushes, and grass appear white because their chlorophyll reflects the IR in sunlight differently than the surrounding areas.

2-12

ABOUT THIS PHOTO *The circular polarizer filter darkens the sky without darkening the subject. (ISO 200, f/11, 1/320 second, Nikon 24-70 f/2.8 at 70mm) © Pete Carr*

LENSES AND HDR

You will surely be pleased to hear that there are no specialized lenses required for HDR. Good lenses are good lenses, and they will take good HDR photos. Cheap plastic lenses with significant chromatic aberrations and distortion will take bad HDR photos.

 note

This section applies most to those who have bought, or are considering buying, a dSLR.

The key to choosing lenses for HDR is to choose one that fits your subject and application. If you want to shoot portraits or street photography, an everyday zoom, prime, or even a wide-angle lens, would be appropriate. If you want to shoot a sweeping landscape or cityscape, go for the wide- or ultrawide-angle lens. Do you have a favorite lens? Use it for HDR.

2-13

ABOUT THIS PHOTO *This scene, taken with an IR filter, looks like winter in the summer. The colors were adjusted in Photoshop. (ISO 100, f/8.0, 6 seconds, Canon 50mm f/1.8) © Pete Carr*

caution

Before buying, make sure the lens you are looking at is compatible with the camera lens mount and sensor size (such as full-frame or cropped, APS-C, Four Thirds, and so on). You should also confirm that other features that you want, such as filter size, autofocus capability, anti-shake or other lens-mounted stabilization, and so on, are present.

EVERYDAY ZOOM

The everyday zoom lens, as shown in 2-14, is especially common among dSLR users because most dSLRs come with this as their stock lens. Everyday zoom lenses have focal-length ranges between 17mm to 70mm, depending on the model. Thus, they are capable of taking photos that are close to wide angle (the 17-20mm range), and yet they zoom in fairly well, too (within the 60-70mm range). This makes for a versatile lens you can carry in your bag and use in a variety of circumstances.

Everyday zoom lenses are sometimes called standard, all-in-one, or wide-angle zoom.

2-14

ABOUT THIS PHOTO *The Canon EF 24-70mm f/2.8L is a classic everyday zoom lens. It is perfect for portraits and three-quarter-length body shots. It lets in a lot of light and is just wide enough for landscapes and buildings. © Canon USA.*

WIDE- AND ULTRAWIDE-ANGLE

Wide and ultrawide-angle (shown in 2-15) lenses are where the fun really begins with HDR. They are, of course, perfect for land- and cityscapes, as well as panoramas. In addition, wide-angle lenses work very well for close shots because you can get physically close to a subject and still have a huge field of view.

2-15

ABOUT THIS PHOTO *The Sigma 10-20mm f/4-5.6 ultrawide-angle zoom lens is a tremendous lens for HDR. It has low distortion compared to other lenses in the category and is solidly made. © Sigma Corp.*

They are more of a challenge to master, however. They capture such a wide field that exposure can be problematic, even in HDR. Different areas of a scene can have dramatically different lows and highs, resulting in under- and overexposure.

PRIME

Prime lenses, as shown in 2-16, have fixed focal lengths, meaning they cannot be zoomed in or out. They generally have a wider maximum aperture than normal zoom lenses, which improves low-light capability. These lenses tend to be sharper and produce smoother *bokeh* — the out-of-focus area produced by a shallow depth of field. As you might imagine, primes work very well for HDR.

2-16

ABOUT THIS PHOTO *The Nikkor 50mm f/1.4D is a good, reasonably priced prime lens. © Nikon Corp.*

TELEPHOTO

Telephoto lenses, as shown in 2-17, are the opposite of wide-angle lenses. They offer an incredible ability to shoot from great distances and, as a result, are the favored lenses of wildlife and sports photographers. These are the lenses you most often see photographers using (note that they quite often use monopods to support the weight of the lens and help stabilize the shot) during sporting events. Due to their length and weight they are prone to wobbling more than a wide angle. This means that bracketed shots may not line up in processing.

MACRO

Macro photography, the purpose of which is to photograph subjects very closely, can be a tricky discipline. It requires specialized lenses, as shown in 2-18, with a 1:1 or 1:2 magnification ratio. Macro photographers also sometimes use specialized gear and lighting.

2-18

ABOUT THIS PHOTO *The Canon EF-S 60mm f/2.8 Macro is a true macro lens that can reach 1:1 magnification. © Canon USA.*

> **note** Macro lenses are not standard zoom lenses with a macro badge. The Sigma 24-70 f/2.8 falls short of the reproduction ratio of a true macro lens, having a 1:3.8 ratio.

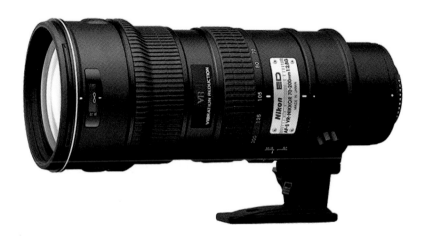

2-17

ABOUT THIS PHOTO *The Nikkor 70-200mm f/2.8G is a powerful and expensive telephoto lens. © Nikon Corp.*

True macro lenses can be less suitable for HDR than other types of lenses, not because of the lens itself, but because of the subjects (see 2-19) and lighting conditions. If you already have one, however, don't let that stop you from trying. Give it a go and share your results at photoworkshop.com.

HDR PHOTOGRAPHY SOFTWARE

As mentioned previously, HDR photography is about more than taking photographs. It certainly starts there, but it finishes within the realm of the computer.

There are three types of software of which you should be aware. The first (and most important) is HDR-specific software, such as Photomatix.

These types of applications generate HDR and provide robust tone-mapping and exposure-blending features. However, some HDR applications do more than just HDR. Artizen HDR, for example, has a built-in photo editor. Others feature more than one way to work with exposure-bracketed photos.

In the second category are image editors, such as Photoshop Elements. These applications are used to further post-process tone-mapped HDR files into a final product. Finally, there are RAW file editors, such as Adobe Camera Raw and Lightroom. These applications specialize in converting and editing camera raw photos, which are your source images for HDR.

2-19

ABOUT THIS PHOTO *This fly wouldn't sit still for brackets, so a single camera raw exposure was processed in Photomatix Pro as pseudo-HDR. This is an actual macro, not just a close-up. (ISO 1600, f/22, 1/160 second, Micro-Nikkor 105mm f/2.8G) © Robert Correll*

PHOTOMATIX PRO

HDR photography relies on an important software process that combines multiple-exposure bracketed photos into a single, high bit-depth HDR image, which you then save or continue to process by tone mapping.

Photomatix Pro (2-20) is a leading HDR software application. It offers several options for generating HDR and powerful tone-mapping features. You can create something nice and natural or go completely crazy, turning your photograph into a surreal piece of art. Photomatix Pro (often referred to simply as Photomatix) can import images in a variety of formats, and export HDR images in both Radiance RGBE and OpenEXR formats. When you finish tone mapping, you can save the result as a JPEG, or an 8- or 16-bit TIFF.

Photomatix Pro 4 offers two types of tone mapping (the Details Enhancer and Tone Compressor) and another feature called Exposure Fusion. Photomatix Pro also works with single, camera raw exposures to create what it calls *pseudo-HDR*, which allows you to use the tone-mapping tools on one image instead of using brackets.

HDRSoft has also released a simplified HDR application, called Photomatix Light. It has fewer features and is easier to use than Photomatix Pro, but it is also less expensive.

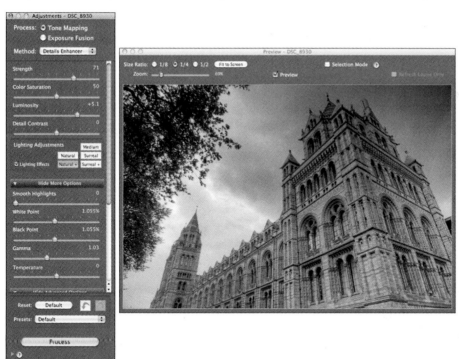

2-20

ABOUT THIS FIGURE *The Photomatix Pro 4.0.2 for Mac OS X interface with tone mapping in progress. Image © Pete Carr*

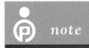 Photomatix is often misspelled or misspoken because our brains insist on putting an 'r' where it doesn't belong. People have gone months or years merrily creating HDR in "Photomatrix," not realizing they were actually working in Photomatix.

OTHER HDR SOFTWARE

In an effort to avoid making this harder (or more confusing) than it is, Photomatix Pro is the software chosen to present HDR in this book. It's not perfect, but then, applications rarely are. Still, it's popular and, in general, well liked.

However, that doesn't mean you have to follow suit. There are a number of HDR applications available, including (alphabetically): Artizen HDR, Dynamic Photo-HDR, easyHDR (and easyHDR PRO), Essential HDR Community Edition (and Essential HDR), FDRTools (Basic and Advanced), HDR Express (and HDR Expose), HDR Photo Pro (and HDR Darkroom), Luminance HDR, Picturenaut, and so on. You can also experiment with Photoshop, Photoshop Elements, or Corel PaintShop Pro.

If you're not happy with the program you're using, download another and try it out. Software exists to serve us, after all.

RAW FILE PROCESSING AND PHOTO MANAGEMENT

As covered further in Chapter 4, you should ideally *develop* or *process* (that is, convert the RAW image file to a usable, editable image format) your camera raw exposures, and save them as TIFFs before loading them into a dedicated HDR

application. This better preserves the image quality as compared to using the RAW files directly. It also allows you to have control over the specific processing options you choose, such as sharpening, white balance, and noise reduction.

Two of the leading RAW developers are Adobe Lightroom and Apple Aperture. However, there are quite a number of RAW file processing applications available — both free and commercial — from camera manufacturers and others. Use any of them that you like. When you shoot brackets, the number of photos you must track and manage increases dramatically compared to traditional photo shoots. Being able to scan the thumbnails and have fast access to EXIF data is invaluable.

LIGHTROOM

Officially released in January 2007, Photoshop Lightroom is the Adobe photography editing program (see 2-21). It differs from Photoshop in that it is a one-stop photo library and editor. It has all the major features needed by professional photographers to do their job without resorting to opening their work in Photoshop. It also has a full-featured image library that allows you to easily catalog and control your work. You have the ability to keyword, rate, group, and flag images for enhanced organization.

The development side has everything necessary to develop RAW, JPEG, TIFF, and PSD files. You can adjust the exposure (white balance, levels), as well as the saturation, hue, and brightness per color channel, and then save these edits as presets to apply to other images later. Lightroom has revolutionized the photographer's workflow.

2-21

ABOUT THIS FIGURE *Adobe Lightroom interface showing the Library. Image © Pete Carr*

APERTURE

Aperture is the Apple answer to Adobe Lightroom. As such, it shares many similarities with Lightroom. However, there are some significant differences between the programs. Rather than being only an image editor, Aperture is also a full-fledged digital asset manager. You have the option of assigning library management to Aperture or managing photos yourself. The interface, shown in 2-22, is also very different. You can access metadata whenever you want rather than having to jump back and forth between tabs. Aperture also excels at full-screen editing.

PHOTO EDITING

Photo-editing applications can normally develop camera raw photos. They may also have built-in HDR capabilities, and rudimentary photo and file management systems, but their main focus is

2-22

ABOUT THIS FIGURE *Apple Aperture in action. Image © Pete Carr*

photo editing. They can perform the basic photo-editing adjustments, such as brightness, contrast, and color, but are also ideal for creating and manipulating layers, using masks, layer transparency, blending modes, correcting lens distortion, reducing noise, and sharpening.

This section summarizes the three leading photo-editing packages. As with all software involved with HDR photography, downloading trial versions is highly recommended. Experiment and learn about them, and then decide which one you like best based on your skill level, budget, workflow, and other factors.

PHOTOSHOP

Photoshop is the industry-standard image-editing program (see 2-23) and has been around for nearly 20 years. Photoshop is widely used in

2-23

ABOUT THIS FIGURE *The Adobe Photoshop CS5 interface. Image © Pete Carr*

every image-based industry, including web and print design, photography, digital art, and video. HDR support was introduced in Photoshop CS2. In CS5, the HDR features extend to tone mapping single camera raw exposures and even include tone-mapping presets. In this book, Photoshop is not used to create or tone map HDR files — it is used exclusively to process, finalize, and publish the tone-mapped image.

PHOTOSHOP ELEMENTS

Photoshop Elements, shown in 2-24, is the consumer version of Photoshop. It is essentially a slightly stripped-down version of Photoshop, designed for newcomers to the world of digital photography. Photoshop Elements is a pretty solid product with a low cost of entry. The interface isn't as complex or scary looking as Photoshop, nor is the learning curve as great.

2-24

ABOUT THIS FIGURE *The Adobe Photoshop Elements interface. It's friendly and well organized. Image © Pete Carr*

It has all the necessary tools for basic and intermediate image editing, but does not overload you with professional features you may not need. For this reason, it is considerably less expensive than Photoshop. Photoshop Elements 9 introduced rudimentary HDR into Elements. The biggest challenge when using Photoshop Elements with another HDR application is its limited support for working with 16-bit-per-channel images. This is not insurmountable, but you will more limited using Photoshop Elements instead of Photoshop for HDR.

COREL PAINTSHOP PRO

Corel PaintShop Pro X4 (which started out as PaintShop Pro) is the main alternative to the Photoshop family for Windows users, as shown in 2-25. It is not perceived as being as advanced as Photoshop, but it is in fact a very powerful application with a plethora of graphics and photo-editing capabilities, including an updated HDR routine. PaintShop Pro has proven hugely popular since its release in 1992. However, unlike Adobe products, PaintShop Pro is available only for Windows.

2-25

ABOUT THIS FIGURE *The Corel PaintShop Pro X4 interface has room for help, tools, and other features. Image © Robert Correll*

Assignment

Photograph What You Love

This is a simple assignment: share your passion. Shoot something that moves you.

What drives you to get out there with your camera? Is it landscapes, cityscapes, portraits, events, or motorsports? Whatever it is, go out and photograph it. Take your favorite gear and shoot what you love. Feel free to play with filters and long exposures — they can be great fun. Process it in your normal photo-editing package and get something that really shines.

Make an accounting afterward and compare the gear you love using with that which you need to tackle HDR. Do you need anything new to get started? Is it hardware or software? If so, come up with a plan to start gathering your kit.

The Louvre in Paris is a fantastic contrast of old and modern architecture. For this photo, Pete used a Nikon 14-24mm lens. It was set to 14mm as the building is quite wide and he wanted to get in as much of the older architecture as he could. He also used a very long exposure to get the best reflection possible from the water. This shot was taken at ISO 200, f/22, 126 seconds, with a Nikon 14-24 f/2.8 lens at 14mm.

© Pete Carr

Remember to visit www.pwassignments.com after you complete this assignment and share your favorite photo! It's a community of enthusiastic photographers and a great place to view what other readers have created. You can also post comments, read encouraging suggestions, and get feedback.

© Robert Correll

SELECTING AND PHOTOGRAPHING SUBJECTS

© Pete Carr

As the title states, this chapter covers how to select and photograph subjects for HDR. Both aspects of the process are important. First, although you can use any subject for HDR, learning how to evaluate and choose the right scenes to photograph make the most difference with HDR. In other words, not everything needs HDR processing, but for those things that do, it really helps.

Once you select the scene, HDR involves taking two or more identically composed but separate exposure-bracketed photographs. You can accomplish this by using your camera's AEB (Auto Exposure Bracketing) feature or by bracketing the scene manually. These technical details are also covered in this chapter.

How to process your photos is discussed in Chapter 4. For now, concentrate on identifying good subjects for HDR and correctly shooting the brackets. Mastering those skills will provide you with great source material to work with for many years to come. If you skimp on the photography, you end up spinning your wheels and wondering why things aren't going well in software. In the end, HDR is not simply a software trick.

SELECTING A SCENE

HDR starts with selecting a good scene to photograph. Not surprisingly, this exercises your photographer's instinct to capture the viewer's attention, even in mundane surroundings. Knowing what to look for and seeking out the scenes that make the most of HDR saves you frustration in both the photography and software phases.

BECOMING A BETTER PHOTOGRAPHER

This short section is a reminder to follow the general rules of good photography as you pursue HDR. It's a myth that you can fix a poor set of photos by throwing HDR at them. After all, a blurry cat will be a blurry cat whether you trick it out with brackets and HDR or not.

Here are some photography tips to keep in mind:

- **Know your camera.** When you pick up your camera, you should know how to use it. Metering, shooting modes, drive modes, autofocus modes, choosing an AF point (if necessary), and AEB all things you should understand. If you're working with a compact digital camera, know how to use exposure compensation. The worst time to try and figure something out is on scene when the light is fading. Practice at home or somewhere close by and work out the kinks of your bracketing strategy.

- **Have a subject.** Have a subject in mind when you take your photos (by the way, your idea of what the subject is can change after you see the photo). It may be a barn or some other building, the sunset, a person, a tree, or a bridge — it doesn't matter what it is as long as you have something. Consciously thinking about your subject helps you frame the scene and process it later.

- **Be imaginative.** Don't always set your tripod up at eye level and take the same shot everyone expects you to take. Get down low or climb up high. Look for different angles and times. Do something different.

■ **Commit to photography.** It's okay to start out at home or walk down the street in front of your house, but you won't find very many interesting subjects to photograph (whether for HDR or not) from your couch or computer chair. Go out and see the world! Find a scene that really wows you and capture it with your camera. If you nail the shots in-camera, they make the final HDR image worth it.

For example, the photo in 3-1 is of the tread and bogey wheels of an old tank on display at a memorial. Apart from HDR, it is interesting. HDR, contrary to rescuing a poor photo, has enhanced the details throughout and made it better. The tread and wheels have a rich and satisfying texture to them.

To excel at HDR, your challenge is twofold: Take good photographs and learn how to use HDR to make them better. The former is critically important.

LIGHT

A common misconception is that HDR allows you to take any photo, at any time of day, and Photomatix (or the HDR software of your choice) then magically turns it into a great photo. Nothing could be further from the truth. Although HDR gives you greater flexibility in capturing the dynamic range of the scene, good photography principles still apply. In other words, capturing all the bad light does not make it good.

3-1

ABOUT THIS PHOTO *The unusual angle and interesting details make this photo memorable. HDR brings out the tone and texture of the clouds, metal, and rust. HDR created from seven camera raw exposures bracketed at -4/-3/-2/-1/0/1/2 EV. (ISO 100, f/11, 1/25 second, Sigma 10-20mm f/4-5.6 at 10mm) © Robert Correll*

It might surprise you to know that HDR potential is everywhere. It helps to know when and where to maximize its beauty. Light is the most important factor in photography. That's what you're trying to capture. The question to ask, then, is whether there are certain times of day when the light is at its best.

The answer is yes. Generally, the world looks best — and sometimes stunning — at dawn, dusk, sunrise, and sunset. In photography circles, you hear the time around dawn and dusk referred to as *the Blue Hour* (think twilight), and the time around sunrise and sunset referred to as *the Golden Hour*.

Strictly speaking, these are not exact hours, as sometimes you can get amazing sights before they begin or right before they end. The point is that the light during these times is different than it is during midday — it's better.

During the Golden Hour, the light is softer and warmer (that is, reds and yellows are the dominant natural colors). As a result, you see the following effects, depending on the type of scene you're shooting:

- **Portraits.** People have warmer skin tones. There is often a wonderful golden backlight illuminating the scene.

- **Buildings.** Harsh shadows cast by buildings are softened. Light shines on buildings from a shallower angle, which illuminates the sides of the building better as you can see in 3-2. Shadows create interesting patterns on the ground or on other buildings.

- **Landscapes.** These scenes benefit from softer shadows and better illumination, which can bring out a more pleasing color palette than

3-2

ABOUT THIS PHOTO *Tower Building, Liverpool. The amazing late afternoon light and HDR really helped Pete capture what he saw. HDR from three camera raw exposures bracketed at -2/0/+2 EV. (ISO 100, f/8.0, 1/125 second, Sigma 10-20mm f/4-5.6 at 20mm) © Pete Carr*

the one you find at noon under a harsh, vertical sun. In particular, clouds take on a magical appearance during the Golden Hour, as they are illuminated from the side or below.

■ **Black and White.** Warmer tones translate well into black and white, and shadows or streaming light rays can be very dramatic (see 3-3).

If you want vibrant, full-color images, shoot during the Golden Hour, when you can photograph landscapes and buildings with beautiful sunset backdrops. You can also see a stunning array of color from blues to reds at this time.

Another time to consider is the Blue Hour. Technically this is the hour right after sunset and before sunrise, so you might have to wait 20-30 minutes after sunset for the right light.

As the name suggests, this is the time of day when you get lovely deep-blue light, as in 3-4. It's a complete contrast to the rich yellows of the Golden Hour. The best thing about this time of day is that there are very few harsh shadows, especially if you are photographing landscapes.

Annoyingly, if you are photographing a cityscape or a building, you may run into issues with city lighting. Instead of a single light source, you may

3-3

ABOUT THIS PHOTO *The Museum of Liverpool and Mersey Ferry Terminal. Amazing golden sunset light made for a dramatic contrast against the dark clouds. (ISO 200, f/11, 1/100 second, Nikon 85mm f/1.8) © Pete Carr*

3-4

ABOUT THIS PHOTO *The HMS Liverpool, docked in Liverpool. A really beautiful evening with many tricky light sources. HDR from seven camera raw exposures bracketed at -3/-2/-1/0/+1/+2/+3 EV. (ISO 400, f/8.0, 1.3 second, Nikon 24-70 f/2.8 at 29mm) © Pete Carr*

have to deal with the lights shining from an entire town. Thankfully, HDR can help in these instances as long as you bracket enough exposures. Of course, if you want to get the best from this time of day you need a tripod for shooting long exposures to capture enough light from the scene.

In the end, HDR gives you the flexibility to shoot outside during these hours and dramatically expands the dynamic range of your camera. This allows you to capture more than simple silhouettes and bring out the colors, contrasts, and tones very well with HDR software.

While these are the best times of day to take photographs, there is no strict rule saying you should only take photographs during these times. If you see something interesting, take the photo. After all, you may never see it again.

TIME

There are also better times of year to shoot outdoor photography. Winter, despite the freezing temperatures, is a very good time because the sun is lower in the sky (the difference, however, isn't as pronounced near the equator). The light is

richer, and not as harsh as it can be during summer when the sun is more directly overhead. This means you can shoot virtually all day in the winter because the light is fantastic.

In addition, sunrise and sunset are at more convenient times in winter, so you don't have to get up at 4 a.m. or stay up until midnight to photograph them. The exact time of sunrise and sunset varies depending on your location (and whether it uses a form of daylight saving time), but the

point is that during winter, the best times to be out photographing HDR aren't too early or too late.

Autumn and spring are also great times to shoot. The sun is higher than in winter, but the light is still quite usable during the day (see 3-5). Another factor that makes autumn and spring so exciting is that they both have a very distinctive color palette. Fall features oranges, yellows, browns, and reds, while spring births bright greens, blues, and yellows.

3-5

ABOUT THIS PHOTO *An airplane at the old Speke airport in Liverpool. While not the perfect golden sunset light, this was still a nice day for photography. HDR from seven camera raw exposures bracketed at -3/-2/-1/0/+1/+2/+3 EV. (ISO 200, f/8.0, 1/250 second, Nikon 24-70 f/2.8 at 24mm) © Pete Carr*

LOOKING FOR HIGH CONTRAST

High contrast is a term used to describe the dynamic range of a scene. High-contrast scenes have a dramatic lighting difference between dark and light areas. Sunsets are a classic example of this, as shown in 3-6, 3-7, and 3-8, which are the three exposure brackets of the scene shot at -2/0/+2 EV. As you can see, the setting sun and horizon are very bright, while the rest of the scene is dark or in shadow.

This sunset looks much better in 3-9, with some artistic license and HDR. You are, of course, seeing the sunset after the brackets have been converted to HDR and tone mapped. The tone mapping settings, which are the subject of Chapter 4, accentuate or hide detail, enhance or minimize contrast, and balance or imbalance the light across a scene.

The fact that HDR excels at capturing high-contrast scenes should tip you off about the types of scenes you should be seeking. The best HDR is found in scenes with high contrast. Look for deep shadows and bright highlights. You can literally find these everywhere — urban scenes, country landscapes, seascapes, your backyard, a park — they all have high-contrast possibilities. Be on the lookout for these sources of light and dark:

■ **Shadows.** Clouds cast great shadows, as do buildings and other large objects. Objects between you and the sun create shadows toward you. Late and early light casts longer shadows. Dark colors and materials — whether they are in shadow or not — often anchor the dark end of the contrast spectrum.

3-6

ABOUT THIS PHOTO *The underexposed photo captures the sunset in this high-contrast scene. (ISO 100, f/8.0, 1/640 second, Sigma 10-20mm f/4-5.6 at 10mm) © Robert Correll*

3-7

ABOUT THIS PHOTO *The center bracket still produces a silhouette because the pattern metering algorithm is protecting the highlights. (ISO 100, f/8.0, 1/160 second, Sigma 10-20mm f/4-5.6 at 10mm) © Robert Correll*

■ **Highlights.** The sun is the most significant highlight of all, as are reflections from buildings and water, street- or other lights, rays of light breaking through trees, and well-lit, brightly colored objects. In addition, light colors and materials can be the source of highlights in the photo.

DETAILS

Bringing out the detail in a subject can make a photo much more interesting. Unique textures, such as tree bark, concrete, wood, and bricks, are

ABOUT THIS PHOTO *The overexposed image captures details that 3-6 and 3-7 left in shadow. (ISO 100, f/8.0, 1/40 second, Sigma 10-20mm f/4-5.6 at 10mm) © Robert Correll*

ABOUT THIS PHOTO *The same scene processed as HDR. Three bracketed photos shot at -2/0/+2 EV. (ISO 100, f/8.0, 1/160 second, Sigma 10-20mm f/4-5.6 at 10mm) © Robert Correll*

loaded with highlights and shadows. Smooth objects like chrome, glass, and water often reflect shadows and highlights from other sources.

Urban scenes are great for HDR, in part because of all the details (see 3-10). Look for places like abandoned warehouses, dockyards, trains, and construction sites. Downtown cityscapes work well because of the level of detail contained in the architecture. Take this same mind-set into the country. Trees, barns, clouds, fences, and other objects provide much-needed detail in a photo.

TRIAL, ERROR, AND PERSISTENCE

It might be awhile before you can spot these scenes and get the best from them. Don't worry — the light will return tomorrow and you can learn from every photo you take. Go out at sunrise or sunset and try different locations. Wait for dusk and see how dramatically the light changes. If you like, try shooting at noon and then shoot the same scene during the Golden Hour and compare your results. Shoot directly into the sun and see what happens. Most likely, it will take more than three exposures to bring out the detail in the

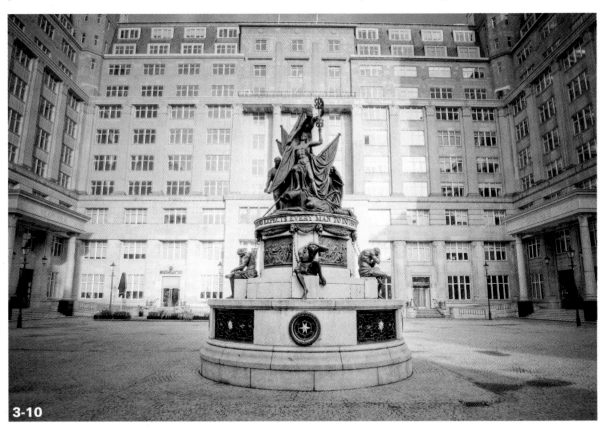

3-10

ABOUT THIS PHOTO *Exchange Flags, Liverpool. HDR helps bring out the detail in the monument. HDR created from five camera raw photos bracketed at -2/-1/0/+1/+2 (ISO 800, f/8.0, 1/800 second, Nikon 24-70 f/2.8 at 24mm) © Pete Carr*

scene without the sun looking like a giant white blob. So, change the angle a bit. Hide the sun. Stand behind a tree, a sign, or a building, as shown in 3-11.

SETTING UP ON LOCATION

Good preparation is invaluable if you want to make the most of your time out. You can get everything together, inspected, cleaned, and ready before you leave your staging location, whether that is your house, your vehicle, or somewhere else. Pack extra gear (lenses, filters, camera bodies, lens cleaner, memory cards, extra batteries) in your camera bag.

Remember to reset your camera before leaving. Check your shooting and autofocus modes, and make sure the ISO isn't set on high. Forgetting to turn down ISO is a very common problem.

Once on location, pick out a spot to set up your tripod and camera for your first shoot. Your primary concern (aside from safety and provided you aren't

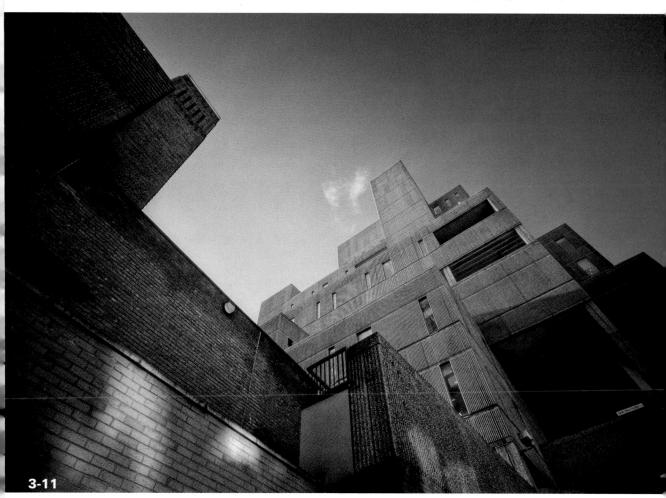

3-11

ABOUT THIS PHOTO *The sun is setting behind the building. HDR created from three bracketed exposures at -2/0/+2 EV. (ISO 200, f/5.6, 1/50 second, Sigma 10-20mm f/4-5.6 at 10mm) © Pete Carr*

CONFIGURING THE CAMERA

With the camera set up nice and steady, and everything attached, it's time to enter the right settings. The most important settings to lock in are shooting mode, aperture, auto or manual focus, ISO, and AEB.

Always take a close look at the settings before you start, as they hold over from your last shoot. It's a real pain to start shooting only to realize you forgot to turn autofocus back on. Get into a routine so you are never surprised at the mode you are in or the options you have enabled at the start of every shoot.

> *tip* Check the camera manual to see if you should turn off the anti-shake/stability feature on the camera or lens when using a tripod, or other support.

CHOOSING A SHOOTING MODE

The shooting mode you choose depends on whether your camera has an AEB feature.

■ **AEB.** When shooting brackets with your AEB feature, it's best to use Aperture Priority mode. This locks the aperture and therefore keeps the depth of field constant across all the exposures.

> Depending on the camera, Program AE might change shutter speed and aperture to bracket the scene. Shutter priority locks in the shutter speed and alters aperture and, possibly, ISO. These settings are interesting to experiment with, but not ideal in practice.

■ **Manual bracketing.** When shooting brackets manually, the mode you use is Manual, because you must have the ability to change your shutter speed and keep the aperture constant. If you are in any kind of auto exposure mode, the camera will attempt to change something against your wishes to bring the exposure back to 0.0 EV.

> You can use Manual mode as if it were a form of Aperture Priority with manual exposure. In other words, set your aperture and then leave it alone. Use shutter speed to modify your exposure and shoot the brackets.

■ **Exposure compensation.** If you have a camera that doesn't have AEB and doesn't have Manual mode, exposure compensation is the only way to bracket a scene. It's a form of manual bracketing that doesn't require you to be in Manual mode. That's excellent news if you're starting to experiment with HDR using a compact digital camera that doesn't have the same capabilities as a dSLR.

> If you have exposure compensation, you can shoot manual brackets. Simply enter a shooting mode that allows you to use exposure compensation. Most often, this includes about every mode you have, with the possible exception of full auto.

SELECTING AN APERTURE

An aperture is the opening in the lens that lets in light. By adjusting the aperture, you change how much light goes through the lens and is registered by the sensor. You do this by changing what's called the *f-stop* on your camera. The lower the f-stop number is, the greater the amount of light that is allowed into the lens.

 note

This point bears repeating: If you use the AEB feature of your camera, Aperture Priority mode is often best because it guarantees the aperture remains fixed. If you manually shoot the brackets, your camera is in Manual mode. Consult the manual for the specific design details of your camera and how AEB works with shooting modes.

When choosing an aperture, keep one in mind that is best for your photo and work from there. If you want an extended depth of field, as shown in 3-14, select a larger f-number, such as f/8 or

3-14

ABOUT THIS PHOTO *View from across Canning Half Tide Dock, Liverpool. HDR created from three camera raw exposures bracketed at -2/0/+2 EV. (ISO 100, f/8.0, 1/500 second, Canon 24-70 f/2.8 at 24mm) © Pete Carr*

higher. Notice that the seats, fence, and buildings in the far background — elements of this photo that have detail and generate interest — remain relatively sharp and distinct. This would have been impossible to achieve with a smaller f-number, such as f/2.8 or lower (see 3-15).

When shooting brackets, you generally have to worry less about the effect of aperture on shutter speed, unless you are shooting on a day with moving clouds or other objects (like tree branches blowing in the wind). When shooting a static subject, simply choose the aperture that gives you the depth of field you want, and shutter speed adjusts to get the right bracketed exposures. If you do find the shutter speed is too slow for the aperture you want, increase the ISO.

MANUAL VERSUS AUTOFOCUS

Today's dSLRs and digital compacts have very good autofocus (AF) systems. You should be able to focus on the object you want quickly and automatically most of the time. This is especially true if you are located far from the action, such as with land- and cityscape shots.

If the AF system locks onto something you don't intend, try selecting an AF point manually and continue on from there. That should clear up any AF confusion, especially if the scene has a number of close objects that are competing for focus attention.

However, your camera may try to refocus after each bracketed photo. If you hear the AF motor running and see the lens hunting for focus in the middle of your brackets, your bracketed shots won't be usable.

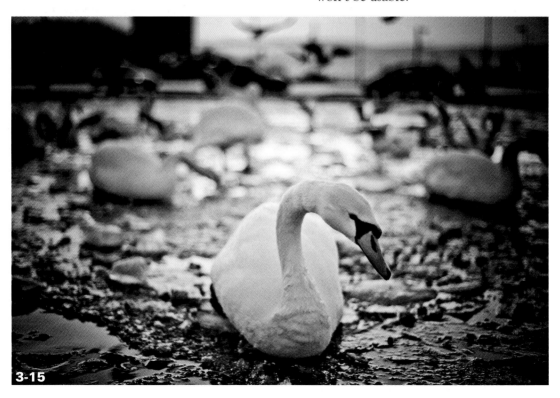

3-15

ABOUT THIS PHOTO *Swans on a frozen boating lake, New Brighton, United Kingdom.* *(ISO 400, f/1.8, 1/800 second, Nikon 50mm f/1.8) © Pete Carr*

There are ways around this. The quickest and easiest is to focus on your subject and set the camera and lens to manual focus. Otherwise, take your AF system off of continuous focus (Canon calls this AF Servo while Nikon uses the term Continuous-Servo AF). On some dSLRs you can lock the focus. On others, you can take focusing away from the shutter button and assign it to another. That way you focus with one button and take the photo with another. This can be quite handy when bracketing as the camera never refocuses unless you tell it to.

On many digital compact cameras you may have no other option except autofocus. Some models do allow you to switch to manual and use the zoom buttons on the camera to adjust the focus.

In the end, it's up to you. If you prefer the control of manual focus and get good results, then use manual focus for HDR, just as you would in any other situation. HDR doesn't demand AF but, as with other types of photography, AF takes some of the workload off your shoulders.

ISO

Unlike traditional photography, HDR often uses multiple bracketed shots to capture the dynamic range of a scene. As such, whatever noise you save to the file is multiplied by the number of exposures you take. The effects of HDR processing can often add to the noise level, especially at high ISOs.

In digital photography, noise comes in two forms: Luminance and color. *Luminance noise* is what makes your photos look grainy. In moody, atmospheric black-and-white photographs, this type of noise can look great. However, it can ruin a nice color photograph of a sunset. *Color noise* is also grainy, but the noise is composed of red, green, and blue dots. You can see the effect of noise in 3-16. It should be a clean sky, not too dissimilar from 3-17, but due to a high ISO and processing that has been pushed too far, it looks quite bad.

ABOUT THIS PHOTO *Close-up of excessive digital noise in a photograph. (ISO 6400, f/2.8, 1/2 second, Nikon 14-24 f/2.8) © Pete Carr*

ABOUT THIS PHOTO *Clean digital noise in a photograph. (ISO 200, f/22, 1/50 second, Nikon 14-24 f/2.8) © Pete Carr*

To counteract noise issues, use the lowest ISO you can and still get the shot you want (typically 200 or less, but check your camera). Only raise it if you absolutely have to. Every time you raise the ISO, the sensor doubles its gain to simulate twice as much light hitting it. This doubles the noise, causing your images to look grainy and dirty.

As always, you are in creative control. If you need to shoot at a higher ISO, do so with the knowledge that the image will be noisier. That being said, full-frame cameras are very good at controlling noise at higher ISOs. The photosensitive sites on their sensors are larger than cropped-frame dSLRs, which results in less noise. The brackets in 3-5 were shot as ISO 800 and show very little, if any, noise.

If you don't have a full-frame camera and are worried about noise issues, make sure to shoot with the ISO as low as you can. Otherwise, you have to resort to the noise reduction techniques described in Chapter 10. It is much nicer to shoot with a low ISO and not have to remove noise at all.

AUTO EXPOSURE BRACKETING

If your camera supports AEB you should use it every time you shoot HDR exposure brackets. Remember, in AEB mode the camera automatically changes the exposure (by changing shutter speed or another combination of factors you may be able to select in the AEB setup menu) within a given range measured in EV across at least three photos. This results in one photo taken at the exposure you have manually set (called the center bracket), plus at least two photos — one underexposed and one overexposed.

The benefit of using AEB is that it allows you to work at the speed at which your camera can take photos — normally three to six exposures a second — as opposed to the longer amount of time it takes to change settings manually (not to mention the fact that you have to touch the camera repeatedly, which can cause it to move or shake). AEB is especially handy on windy days when the clouds are moving quickly.

If your camera has an AEB option and you want to use it, set it now. AEB can be found in the camera settings menu for most dSLRs and many compact digital cameras. Some cameras place their AEB settings under Drive. Others may employ an AEB button in conjunction with the menu system.

Set the number of exposures to at least three and, if possible, choose an EV range of 2. The camera shown in 3-18 automatically sets the number of exposures to three, but limits the bracketing distance to either +/- 0.3 or +/- 0.7 EV. In the case of 3-19 (a compact digital camera), you can choose +/- 0.3, +/- 0.7, or +/- 1 EV. The camera shown in 3-20, is set to five exposures separated by +/- 1 EV. Some cameras, like the example in 3-20, do not let you change the exposure difference at all — this model limits you to +/- 1 EV.

If your camera can shoot up to nine photos separated by 1 EV each, you can capture a wider dynamic range (+/- 7 EV total range) than you could with a camera that shoots only three photos separated by 2 EV (+/- 4 EV total range). If your camera is less capable, you may choose to manually bracket in order to get a wide enough EV range.

> **note** As a reminder, if you are in an auto exposure mode, such as Aperture Priority, you won't set the exposure yourself, even in AEB mode.

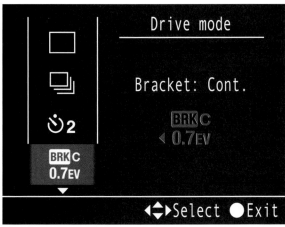

3-18

ABOUT THIS FIGURE *An AEB screen showing the maximum bracketing spread (0.7 EV).*

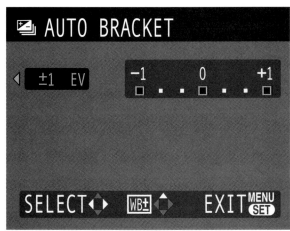

3-19

ABOUT THIS FIGURE *The AEB screen from an older compact digital camera.*

3-20

ABOUT THIS FIGURE *An AEB screen with five brackets selected to be separated by 1.0 EV.*

Try shooting three exposures separated by +/- 2 EV or five exposures separated by +/- 1 EV. These are the best overall settings. If you can shoot three exposures but are limited to +/- 1 EV or less, consider bracketing manually. If the dynamic range of the scene is very large, increase the number of exposures past five if possible, leaving the bracketing distance at +/- 1 EV.

The HDR police aren't going to come and arrest you, no matter what you do. If your AEB EV range is limited and you want to use it anyway, go ahead. You pay a price, though, because you capture a smaller overall dynamic range in one bracketed set than someone with a larger EV spread.

DRIVE MODE

Set the camera drive mode (also called release mode) to Continuous shooting if you want to take your three brackets very quickly. Just hold the Shutter Release button down and the shots quickly fire off. If you want to take the photos more casually, leave it on Single shooting.

TAKING PHOTOS

Once you select a scene, set up gear, and have the camera ready, it's time to take the photos. Recompose the scene if necessary and, if you like, take a few test shots (with or without brackets) to make sure everything is okay. You may decide to use a filter depending on what you see. Make any necessary adjustments based on the test shots. At this point, you're ready to take the exposures for HDR through a process called bracketing.

note Some cameras allow you to enter timer mode while using AEB and the camera automatically takes three shots in sequence. Be sure to read your manual to understand how to enter and use all the modes necessary (or advantageous) for HDR photography.

AUTO BRACKETING

When you're in AEB mode and ready to shoot, press the Shutter Release button on the camera or the remote shutter release. If you're in single-shot mode, press the button the number of times that matches the number of brackets you've chosen in your AEB setup. If you are in Continuous drive mode, you should press and hold the Shutter Release button until the camera stops taking exposures. In the case of 3-21, 3-22, and 3-23, that turned out to be three photos.

You can take more than one set of bracketed photos of the same scene (thereby capturing a massive cumulative dynamic range) either by adjusting the center exposure for another round of AEB, or by continuing to manually bracket outside of the current bracket range. AEB is surprisingly easy, which is precisely the point of using it!

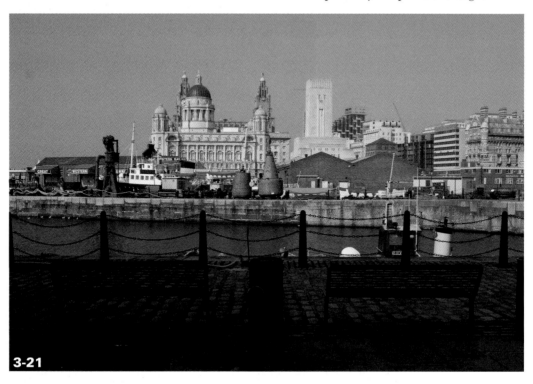

3-21

ABOUT THIS PHOTO *View from across Canning Half Tide Dock, Liverpool. Bracketed exposure at 0 EV. (ISO 100, f/8.0, 1/160 second, Sigma 10-20mm f/4-5.6 at 15mm) © Pete Carr*

ABOUT THIS PHOTO
View from across Canning Half Tide Dock, Liverpool. This image is overexposed by +2 EV. (ISO 100, f/8.0, 1/160 second, Sigma 10-20mm f/4-5.6 at 15mm) © Pete Carr

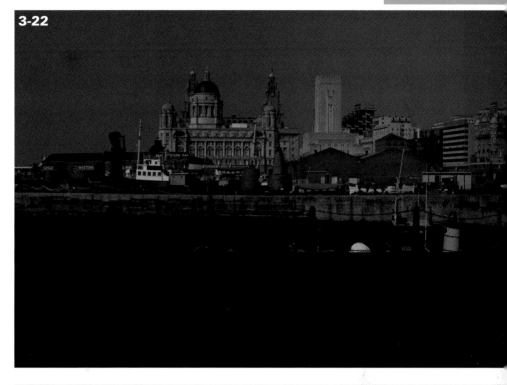

ABOUT THIS PHOTO
View from across Canning Half Tide Dock, Liverpool. This image is overexposed by +2 EV. The final HDR image created from these brackets is shown in 3-14. (ISO 100, f/8.0, 1/160 second, Sigma 10-20mm f/4-5.6 at 15mm) © Pete Carr

MANUAL BRACKETING

Alternatively, you may choose to bracket the scene manually. If so, set the camera to Manual mode, single-shot drive. Set the aperture and ISO you want to use, and evaluate the exposure with the built-in (or an external) light meter. Adjust the shutter speed so that the exposure reads 0 EV (see 3-24).

Take the first photo, which is the center bracket, at 0 EV. Manually adjust the shutter speed to -2 EV and take another shot (see 3-25). This is the underexposed photo. Next, adjust the shutter speed so the exposure reads +2 EV (see 3-26). Take the final shot, which is the overexposed photo.

You may want to shoot the brackets in a different order. Many people prefer shooting the underexposed photo first, followed by the 0 EV photo, and then the overexposed photo. You may also want to shoot more brackets separated by the same exposure distance. For example, you could shoot five brackets at +/- 2 EV, resulting in a series of -4/-2/0/+2/+4 EV. You could also change

the exposure difference to +/- 1 EV and shoot them that way (five brackets at +/- 1 EV, resulting in a series of -2/-1/0/+1/+2 EV).

Pay attention to what is happening in 3-24, 3-25, and 3-26. The ISO is set to 100 and does not change. The aperture is at f/8 and also remains constant. The camera is in Manual mode, which allows you to make exposure changes yourself. The exposure index shows the current exposure as a downward-pointing white triangle. In the case of 3-24, the suggested "correct" exposure has been evaluated by the camera (after pressing the Shutter Release button halfway), and the 0 EV index matches the combination of the three exposure settings: 1/400 second, ISO 100, and f/8. This is the center bracket.

After taking this bracket, increase the shutter speed by 2 EV. In this case, that turns out to be 1/1600 second. Notice that everything else stays the same. The exposure is reading -2 EV, which means the photo is underexposed by 2 EV — that's exactly what you want. Take this photo as the underexposed bracket.

3-24

ABOUT THIS FIGURE *Manual bracketing. These settings produce a 0 EV photo.*

3-25

ABOUT THIS FIGURE *Manual bracketing. The shutter speed quickens to produce an underexposed (-2 EV) photo.*

Finally, slow the shutter speed down so the exposure index reads +2. In this case, the shutter speed had to decrease to 1/100 second. Slower shutter speeds let in more light. This is the overexposed photo.

USING EXPOSURE COMPENSATION

The other way of getting the necessary bracketed photographs is to use exposure compensation. Exposure compensation is a really handy feature on most cameras, and opens up the world of HDR to even the most automatic cameras. If you are taking photos and you want to quickly make the shot darker or brighter, you can use exposure compensation. Generally you can alter the exposure of a photo by +/- 2 stops, but some cameras may do more or less.

For example, suppose you are photographing a sunset but you think the camera isn't metering it as you want. The photograph is a little too bright. Instead of switching to full Manual mode and

working out the settings you need, you can quickly set the exposure compensation to -1 or -2 stops. The camera automatically adjusts the settings accordingly and you get your darkened photo.

You might already see how you could use this for HDR if your camera doesn't have an AEB feature. Set up your camera, compose the shot, and get a standard exposure that is to your liking. Using exposure compensation, drop the exposure down by -2 stops and take a photo. It will be dark. Now increase the exposure by +2 stops and take the shot. It will be bright and look overexposed, but hopefully that means you have detail in the shadows. Images 3-27, 3-28, and 3-29 show how exposure compensation looks on a camera screen.

It is very similar to working with the shutter speed and manual bracketing. This time, however, you're using exposure compensation. The secret is that exposure compensation adjusts the camera shutter speed, provided it can be adjusted fast and slow enough to match the

3-26

ABOUT THIS FIGURE *Manual bracketing. These settings take the overexposed (+2 EV) photo.*

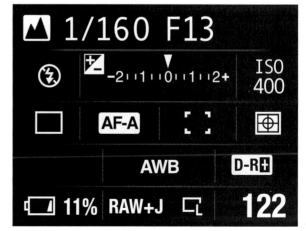

3-27

ABOUT THIS FIGURE *Preparing to shoot exposure brackets using exposure compensation in Landscape mode. Exposure reads 0 EV.*

desired exposures. Double-check the aperture as you make exposure compensation changes to make sure it isn't opening or closing. This indicates you may need to adjust the ISO.

In 3-27, no compensation is dialed in. The camera is in Landscape mode and the aperture has been set automatically. The ISO was raised so the aperture wouldn't open up. This is the center bracket.

For 3-28, the exposure compensation has been set to -2 EV. Notice there are two indications of this. You can see the amount of the correction shown on the top line as well as on the exposure index. Also, notice that the shutter speed has changed while the aperture has remained the same — that's the key. This is the underexposed bracket.

Image 3-29 shows the exposure compensation has been set to +2 EV. The shutter speed has changed to make this possible, while the aperture and ISO remain the same. This is the overexposed bracket.

In all three figures, notice that the ISO is 400. Raising the ISO in this instance enabled the shutter speed to vary while the aperture remained the same for the +2 EV bracket. Given the lighting conditions the camera was in, a lower ISO resulted in the camera changing the aperture to f/8 or wider to capture the overexposed bracket.

The only downside to this is that it's not as quick as AEB. If you've got fast-moving clouds, they might move too much between photographs because you have to take a photo, alter the settings, take another photo, and so on. It's a bit sluggish compared to the fire and forget AEB method.

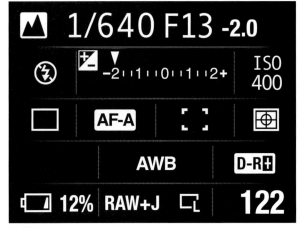

3-28

ABOUT THIS FIGURE *Dialing down two stops of exposure compensation (note the -2.0 beside the aperture display) results in a faster shutter speed for the underexposed bracket.*

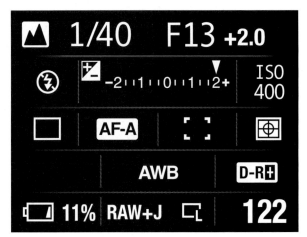

3-29

ABOUT THIS FIGURE *This time, exposure compensation is raised by two stops (+2.0 EV), resulting in a faster shutter speed and an overexposed bracket.*

Assignment

Compare Bracketing Methods and Apply HDR

Use what you learn in this chapter to go out and find a great scene for HDR. Look for good lighting and high contrast. Consciously try to take great photos.

Set up your gear and shoot using at least two of the bracketing methods described here. For example, if your camera has AEB, use it and then manually bracket. You could also compare manual bracketing to exposure compensation. If you're feeling adventurous, shoot and compare all three types of bracketing using different cameras.

Think about how long it takes you to get your settings dialed in and take the shots. Analyze the strengths and weaknesses of each bracketing method with which you shoot. Were the clouds moving? Was the scene totally static? Did you shoot more than three exposures? Why? If your camera has AEB, evaluate it in terms of whether you had enough brackets available and whether the distance between them, and the total EV range with which you shot, was enough for the scene.

Later, come back and process each set as HDR and share your results on the website below.

Here are four brackets Robert manually shot of a colorful local bookstore. They were taken late one afternoon (just before the Golden Hour) in the fall, facing away from the sun. It may surprise you to know that this scene has a very large contrast ratio. The sky is a bright blue and highlights on the building add brightness. On the other hand, there are a number of dark textures and shadows in the scene.

Although the photo is interesting on its own, the colors and textures stand out in HDR. In addition, the door and windows hide less in the shadows. There were no moving clouds or other factors that made shooting AEB a necessity. He chose an unusual number of brackets that straddle, but do not include, 0 EV. The HDR image was created from four bracketed photos at -3/-1/+1/+3 EV, taken at ISO 100, f/11, 0 EV indicated at 1/125, Sigma 10-20mm f/4-5.6 at 20mm.

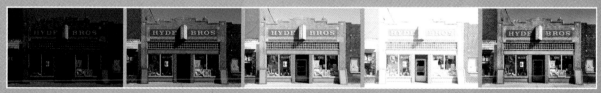

© Robert Correll

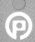 Remember to visit www.pwassignments.com after you complete this assignment and share your favorite photo! It's a community of enthusiastic photographers and a great place to view what other readers have created. You can also post comments, read encouraging suggestions, and get feedback.

CHAPTER

4

GENERATING AND TONE MAPPING HDR IMAGES

>

>

5. G
w
P
d
al
to

6. T
th
m
m
m
of

>

>

7. Fi
Fi
in
P
ch
re
n
fi
th

© Pete Carr

MECHANICS

This is, perhaps, the most challenging part of HDR. However, you have all the power of Photomatix at your fingertips in the Adjustments window just waiting to be unleashed.

At the top of the tone-mapping Adjustments window are several global settings for the Details Enhancer:

- **Strength.** Controls the strength of the contrast enhancements, both locally and globally. It should be noted that increasing the strength can also increase the noise.

- **Color Saturation.** Sets the color strength (from grayscale to pure color) in the image. Although you can lower Color Saturation to create a grayscale image, the best time and place to do this is after tone mapping in your image editor.

- **Luminosity.** This controls the tonal range compression, which has the effect of adjusting the global luminosity level. Positive values increase shadow detail and brighten the image. Negative values give a more natural feel to the image. Luminosity is very helpful in balancing the light and dark areas of the image so neither one predominates.

- **Detail Contrast.** Controls how local details are accentuated. Higher settings can make the image appear more contrasted and bring out details.

- **Lighting Adjustments.** This setting has two modes: Default and Lighting Effects. The default mode is a slider (if the slider is not visible, deselect the Lighting Effects mode check box). The Lighting Effects mode takes the form of labeled buttons. The effect on the image differs depending on the mode as a different algorithm is used for each.

Below these are two further sets of options: More and Advanced Options. The options included under More are:

- **Smooth Highlights.** Higher settings smooth highlights, thereby reducing contrast enhancements within them. Use it to prevent highlights from turning gray or to reduce halos around objects.

- **White & Black Points.** Tone mapping compresses the image from a high-contrast ratio to a more manageable tonal range. These options control the clipping points at either end of this range. Moving them to the right clips the image, increasing contrast. Be careful not to clip the highlights too much and create overexposed areas, or the shadows so much that you lose details in darkness.

- **Gamma.** This adjusts the midtone of the image. Moving it right makes the image brighter, and moving it left makes the image darker.

- **Temperature.** This is similar to white balance. Moving it to the right gives the image more red tones. Moving it left gives the image blue tones. This can be useful for sunsets, or when Photomatix creates an image that is too red or blue.

The Advanced options are:

- **Micro-smoothing.** Higher settings smooth local details enhancements, which can create a more natural look in a photo. It can also reduce noise by smoothing it out. If you feel the image doesn't look real, increase Micro-smoothing to produce an image similar to what you may get with exposure blending.

- **Saturation Highlights & Shadows.** This adjusts the color saturation of highlights and shadows relative to the Color Saturation

slider. Move it right to increase and left to decrease. Be careful of oversaturation, which can increase noise levels in an image.

- **Shadows smoothing.** Higher settings smooth shadows, reducing contrast enhancements in darker areas of the image.

- **Shadow clipping.** This controls the shadow clipping, which is handy for reducing noise in dark areas of an image taken in low light. Higher settings clip more shadows, resulting in those areas being darkened. Don't push it too far or the shadows may look unnatural.

There are so many settings in the Details Enhancer — and they interact with each other in so many different ways — you can spend a lot of time experimenting with different looks.

tip

Once you find a combination of settings that work, save them as a baseline using the Presets drop-down list at the bottom of the Details Enhancer section of the tone-mapping Adjustments window. You can also save settings every time you save a tone-mapped image. Load and apply these settings to other images and make adjustments to customize each one. For photos that don't look right, start with the default settings.

When you are happy with the look of your photo, click Process. This applies all the tone-mapping settings to the high-bit HDR photo and produces a product suitable for further post-processing.

Save the resulting HDR-processed file as a 16-bit TIFF. This preserves the highest quality file, which can be manipulated and, ultimately, converted to a more suitable viewing format.

STYLES

The large number of settings within the Photomatix Pro Details Enhancer can seem overwhelming at first. You may want to start with a series of good settings you have saved as a baseline, which is exactly what is shown in Figure 4-9. These general settings illustrate what HDR and Photomatix do best: blend exposures together to enhance details in shadow, without a loss of detail in highlights. The settings (including those below the area shown in the image) are explained in detail in the list that follows.

- **Strength set to 75 percent.** This makes the image seem more detailed and contrast is added to the photo.

- **Color Saturation set to 50 percent.** Raising Saturation above the default setting adds more color to the image. However, be careful not to overdo this. It is one of the key things for which HDR images are criticized.

- **Luminosity set to +5.** Luminosity is increased to get an even exposure. In other words, the highs are nicely balanced across the image with no blown areas. If there are blown areas, drop the White Point down to compensate.

- **Detail Contrast set to 0 (default).** You can adjust this on an individual basis to accentuate details.

- **Lighting Adjustments set to Lighting Effects mode and Natural+.** This keeps the image looking natural. Lower settings increase the chance of it looking very unnatural.

- **White Point set to 1.2 percent.** Increasing the White Point increases highlight contrast.

- **Black Point set to 1.2 percent.** Increasing the Black Point increases shadow contrast.

- **Gamma left at 0.9 (1 is the default).** This image needed a little brightening.

- **Temperature left at 0 (default).** There are no color temperature problems in this photo.

- **Saturation Highlights left at 0 (default).** The saturation level of the highlights looks fine.

- **Saturation Shadows left at 0 (default).** The saturation level of the shadows looks fine.

- **Micro-smoothing set to 10.** Adjusting this lessens the overprocessed HDR look. Here, it's set to 10 to achieve a nice natural look.

- **Highlights Smoothing left at 0 (default).** The highlights in this image do not need smoothing.

- **Shadows Smoothing left at 0 (default).** The shadows in this image do not need smoothing.

- **Shadows Clipping left at 0 (default).** The shadows do not need to look darker in this image.

The result of these settings is shown in 4-10.

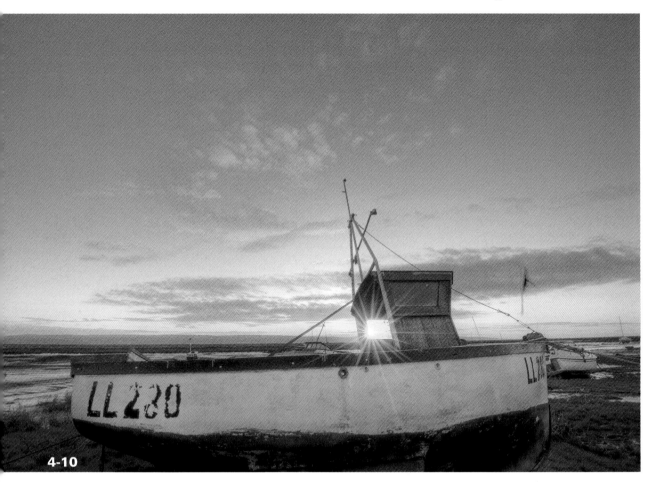

4-10

ABOUT THIS PHOTO *The result of the tone-mapping style settings covered in this chapter. They make a great starting point and consistently result in a nice image. You can continue to process in Photoshop Elements or another graphics program. (ISO 200, f/22, 1/80second, Nikon 14-24mm f/2.8 at 14mm) © Pete Carr*

Figure 4-11 shows the effect that setting the Luminosity to -10 has on an image. The light here is not as balanced as in 4-10 and the result defeats the purpose of HDR. There are no details in the shadows.

The difference is more dramatic when you compare 4-11 with 4-12. They have almost exactly the same settings, except that in 4-12, Luminosity has been raised to +10. The level of detail in

shadow has been greatly increased and the image is more balanced than 4-11. This is why it is normally best to keep Luminosity above zero. If the image looks washed out (as it does in 4-12), lower the Luminosity until it starts looking better, which should be around +5. In the case of 4-12, raising Luminosity to its maximum creates an image that has too much detail and not enough contrast.

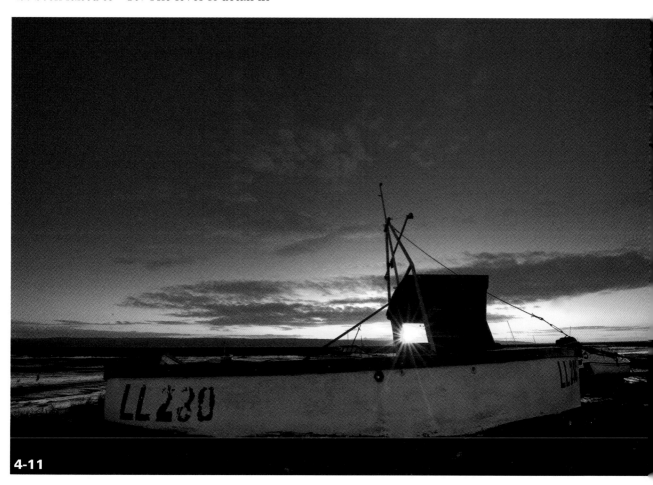

4-11

ABOUT THIS PHOTO *The effect of minimizing the Luminosity setting in Photomatix. (ISO 200, f/22, 1/80second, Nikon 14-24mm f/2.8 at 14mm) © Pete Carr*

4-12

ABOUT THIS PHOTO *The effect of maximizing the Luminosity setting in Photomatix. (ISO 200, f/22, 1/80 second, Nikon 14-24mm f/2.8 at 14mm) © Pete Carr*

In the next example, 4-13, Lighting Adjustments has been set to Surreal+. Other than that, all settings are the same as those used for 4-12. The effect is huge — and bad. There is a lot more noise on the boat and a halo can be seen around the mast. The sky is also unrealistically dark. In general, setting Lighting Adjustments to anything other than Natural+ causes these sorts of problems.

SINGLE-EXPOSURE PSEUDO HDR

It is important to remember that, to get the most out of HDR, you should shoot multiple exposure brackets of a scene. You get the best results this way. However, there is an alternative processing path that relies on using a single RAW exposure. It's called single-exposure, or *pseudo HDR*. It's not effective for capturing more dynamic range at

4-13

ABOUT THIS PHOTO *The effect of reducing Lighting Adjustments to Surreal+. It is dramatically different and seems quite plastic — more noise, harsh light, and extreme local contrast. (ISO 200, f/22, 1/80second, Nikon 14-24mm f/2.8 at 14mm) © Pete Carr*

the scene, nor can it always compete with today's excellent group of RAW file processing software. However, it's an option with which you should be familiar if you want to experiment.

Pseudo HDR uses one RAW file and relies on the fact that camera raw photos have a bit depth equal to the camera's sensor and processing design (normally 12 to 14 bits). As a result, there are several stops of information in the

RAW file that are irretrievably lost when it is converted to an 8-bit JPEG or TIFF. This is enough room to create pseudo brackets out of a single exposure or to simply tone map that exposure. This is not as effective as shooting bracketed exposures, which actually extend the dynamic range of the camera. However, tone mapping a single camera raw exposure or brackets created from a single camera raw shot is a valid way to

access the hidden RAW file data. You can then process it to maximize the use of the existing range of the photo.

In addition, there are times when you cannot shoot brackets or when you may need to tone map a single camera raw image to highlight details that can't be done successfully in another editing program. You might prefer this method to dodging and burning in Photoshop, for example, or complex blending with layers.

The times you generally need to use pseudo HDR are when shooting complicated motion shots — when you, your subject, or both of you, are moving. Perhaps you are on a boat or photographing a race track. In these scenarios, it is impossible to bracket fast enough to capture the subject without significant movement between frames.

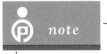

note Although you can use pseudo HDR as an alternative, bracketing is the true way to pursue HDR photography.

There are two ways to tone map a single RAW file: You can convert it to three shots at different exposures or drop it right into Photomatix Pro.

CONVERTING A SINGLE EXPOSURE TO BRACKETS

Converting the single camera raw image to three photos bracketed at -2/0/+2 EV tends to reduce noise and lessen the overprocessed feel of a photo. If you want to experiment, try using one camera raw photo as a test image to evaluate the HDR potential in a shot. After tone mapping start over, but this time, create brackets using the steps below. Compare the results and decide on your own.

tip HDR and the software on which it relies can be notoriously finicky. At times, you'll discover that the theoretical best approach does not produce the best-looking image. When that happens, don't become handcuffed to the process — do what looks best.

To create bracketed files from a single camera raw photo, start by creating three separate exposures from the camera raw image: One exposed for shadows, one for midtones, and one for highlights. Afterward, load these into Photomatix and create the HDR image. Then tone map it as you would normal brackets.

Here are the general steps to follow:

1. **Launch your raw editor or image application and load the RAW file.** This can be Adobe Photoshop Elements, Photoshop, Lightroom, Apple Aperture, your camera manufacturer's RAW file software, or whatever else you use to convert RAW files to TIFFs.

tip Dropping the RAW file into Elements or Photoshop automatically launches Adobe Camera Raw.

2. **Load your RAW file editor defaults.** How you do this depends on the RAW file editor you use. In the case of Adobe Camera Raw, it depends on whether you are using Photoshop Elements (which has basic setting management) or Photoshop (which has many more settings and setting-saving features). The point is to make sure you are working with the default settings so that you start with a clean slate. Your primary goal is to process the camera raw image and convert it to a 16-bit TIFF without overprocessing it. Loading the default settings applies them to the photo.

3. **Save the file as a 16-bit TIFF file.** This is the center bracket containing the midtones. Do not close this file — keep it open for the next two steps.

4. **Set the exposure setting to -2 EV, and save the file as a new 16-bit TIFF file.** This is the underexposed bracket containing high-light detail.

5. **Set the exposure setting to +2 EV (from the original) and save the file as a new 16-bit TIFF file.** This is the overexposed bracket containing shadow detail.

> You now have three new files to work with, each created from the original camera raw exposure. You can play around with the numbers, but the idea is to take the single raw photo and save it three times, each with a different exposure. You should therefore end up with three, 16-bits-per-channel TIFFs at -2/0/+2 EV.

6. **Exit your RAW file editor and open your HDR application.** Load the three TIFF files you just created into Photomatix Pro and proceed to create the HDR image as if they were separate photographs.

Photomatix may have a hard time interpreting the exposure values of your three images because it reads the EXIF information from the files. If this happens, the Exposure Correction dialog box appears, as shown in 4-14. Select the correct value (2) from the Specify the E.V. spacing drop-down list and click OK.

At this point, continue to generate the HDR and then tone map it the way you would any other HDR image. Because the three exposures were created from a single image, however, you won't need to select the Align source images or Remove ghosts check boxes in the Preprocessing Options dialog box (see 4-3).

4-14

ABOUT THIS FIGURE *Use the Photomatix Exposure settings for generation HDR image dialog box to set the correct exposure spacing. Images © Pete Carr*

DROPPING A SINGLE CAMERA RAW EXPOSURE INTO PHOTOMATIX

The simpler (and quicker) way to process a single camera raw exposure is to load it directly into Photomatix. To do this, go to the File menu, and then find and open the file. Alternatively, you can simply drag and drop the exposure onto the Photomatix interface (Windows) or the icon (Mac).

When you open it, a set of options appears, as shown in 4-15. There's nothing too complicated here, as these options are present when you load actual brackets. Change if necessary, and click OK.

4-15

ABOUT THIS FIGURE *Photomatix settings for a single camera raw file.*

ADDITIONAL PROCESSING SOLUTIONS

Using Photomatix to create an HDR image and then tone mapping it isn't the final step. You need to put the finishing touches on your images in further processing. This involves fixing problems such as noise, color balance, and contrast. You may also need to optimize local contrast and tone by dodging and burning, or improving sharpness.

You can use your image-editing application of choice for additional processing. The procedures and results should be similar to those shown here. The point is to use all the tools at your disposal to create the best product you can. Photomatix and other HDR applications excel at creating HDR files and tone mapping them. In and of itself, however, tone mapping is not the same as image editing.

REDUCING NOISE

Tone-mapped HDR images can be noisy, even if you shoot at ISO 100. Shooting at higher ISOs multiplies this problem (see 4-16). There are ways to reduce the noise as you take your photos. First, use the lowest ISO you can. Second, shoot brackets if possible — at least three photos — rather than a single exposure.

In software, the first line of defense against noise is your RAW file editor. This is another reason why it is good practice to convert your camera raw photos into 16-bit TIFFs to process in Photomatix — you have the ability to fix things before you even get to HDR. Adobe Camera Raw, for example, has two noise-reduction options: Luminance (which is grayscale noise) and Color. The next method of fighting noise is to select the Reduce noise option when generating HDR in Photomatix. Finally, you can use your image editor to reduce noise.

A few things you should be aware of when using any noise-reduction routine are:

- **Settings.** Noise-reduction filters normally have settings that allow you to set Strength plus other options. For example, the Photoshop Elements Reduce Noise filter has three settings: Strength, Preserve Details, Reduce Color Noise, and an option to Remove JPEG Artifacts. Some routines may ask you to set a Threshold, which is often based on a pixel radius.

- **Selectivity.** RAW file editors, Photomatix, and the standard noise-reduction filters in image editors reduce noise across the entire image by default. You can selectively apply noise reduction to limited areas by using the application's selection tools and then applying the noise reduction to those areas. For

example, if the sky is noisy, select it. When selecting an area, make sure you smooth its edges so that it blends nicely. In Photoshop Elements, after you make the selection, choose Select⇨Refine Edge to enter Smooth and Feather amounts to ease the transition from the noise removal in the selected area and the rest of the image.

■ **Native versus third party.** All of the top image editors (Photoshop Elements, Photoshop, Corel Paint Shop Pro, and so on) have native noise-reduction tools. In fact, you may have several options from which to choose. Paint Shop Pro has no less than five major tools (One Step Noise Removal, Digital

Camera Noise Removal, Edge Preserving Smooth, Median Filter, and Texture Preserving Smooth) to remove noise, in addition to other texture and softening aspects. If you aren't happy with any of these, consider purchasing a third-party plug-in such as Noiseware.

■ **Perfection.** No image is perfect, and no photo is absolutely noise free. Don't fret over not being able to remove every trace of noise in your photos. At times, especially in black and white, some noise can add texture and ambience. Work first at removing the most obvious or distracting noise.

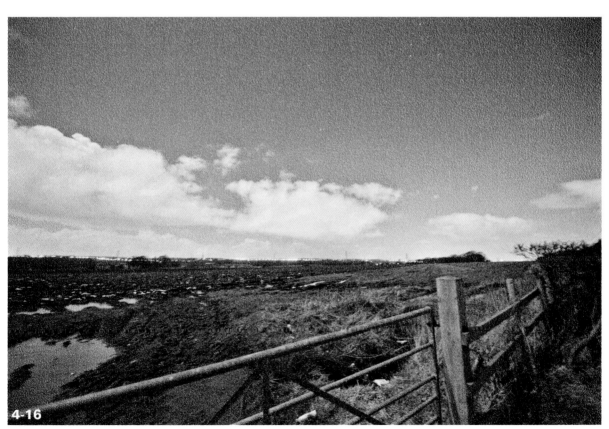

4-16

ABOUT THIS PHOTO *Before noise reduction is applied. (ISO 6400, f/2.8, 0.5 seconds, Nikon 14-24mm f/2.8 at 14mm) © Pete Carr*

Sharpness. The cost of noise reduction is often sharpness. Applying full noise reduction to an image can make it look soft, as shown in 4-17. This is because you're smoothing areas of the image to hide the noise causing edges to lose their sharpness. With patience, you can find a balance between sharpness and softness that suits your photo. You may also find it necessary to sharpen areas of your photo after you reduce the noise.

CORRECTING COLOR

At times, Photomatix produces images in which the color looks odd or oversaturated. Sometimes the effect is limited to individual color channels like Red or Blue. At other times the effect is across all color channels. Approach color problems from the beginning and work your way through the process as follows:

In camera. Make sure you have the right white balance and no other creative settings enabled that could alter the colors of the scene, or oversaturate a color channel.

RAW file conversion. If you need to correct white balance problems, this is the best place because you can move on to HDR and tone mapping with good images. Your camera raw editor may also offer robust hue and saturation options. One word of caution, however: the goal of processing RAW files for HDR is not the same as processing them to present the best possible photo. Be careful that your changes do not alter the exposure (which is the point of bracketing), or make one photo of a bracket fundamentally different than the others in terms of hue and saturation.

Tone mapping. Photomatix has saturation and color temperature controls that affect how color appears in your image. Don't wait to fix issues in your image editor — if you can, avoid creating the problem altogether or fix it in Photomatix.

Post-processing. If you cannot resolve the problem using other techniques, you have to address it in additional post-processing.

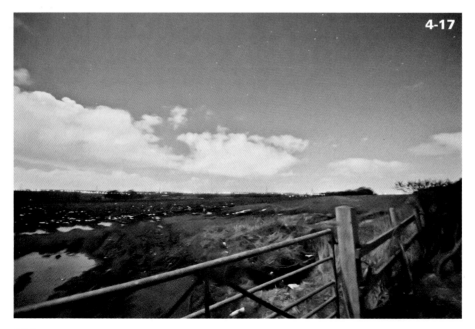

4-17

ABOUT THIS PHOTO
After maximum noise reduction is applied. (ISO 6400, f/2.8, 0.5 seconds, Nikon 14-24mm f/2.8 at 14mm) © Pete Carr

To correct color hue and saturation problems using Photoshop Elements, follow these steps:

1. **Choose Enhance⇨Adjust Color⇨Adjust Hue/Saturation.** You can control saturation from the Hue/Saturation dialog box, shown in 4-18.

2. **Choose a color from the Edit drop-down menu (it's set to Master in 4-18) and make changes.** If the reds are a little too red, select Red from the list and make changes. Move on to each color within the list to correct problems or accentuate certain colors. All the changes accumulate, so you can make a hue change to red and a saturation change to yellow at the same time.

3. **Alternatively, leave Master as the default choice in the Edit menu and make Hue and Saturation changes.** These Hue, Saturation, and Lightness changes affect the entire range of colors in the image as opposed to selective hues.

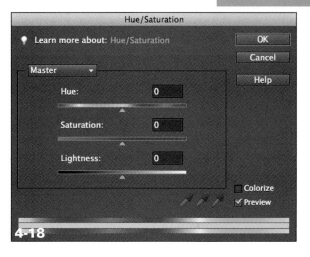

ABOUT THIS FIGURE *The Hue/Saturation dialog box in Photoshop Elements.*

The before and after color correction examples are shown in 4-19 and 4-20, respectively.

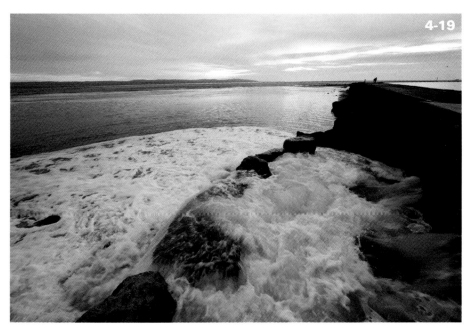

ABOUT THIS PHOTO
Before color adjustment. (ISO 1250, f/11, 1/40 second, Nikon 14-24mm f/2.8 at 14mm) © Pete Carr

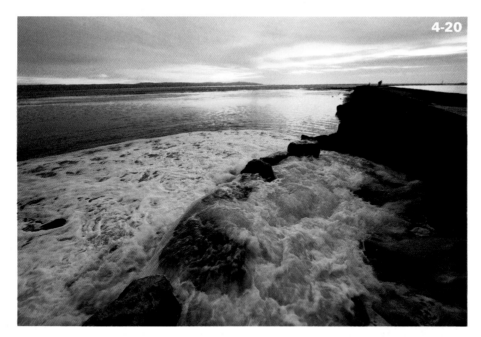

4-20

ABOUT THIS PHOTO
After color adjustment. (ISO 1250, f/11, 1/40 second, Nikon 14-24mm f/2.8 at 14mm) © Pete Carr

MAKING HISTOGRAM ADJUSTMENTS

There are times when images from Photomatix look a little underexposed and flat. You can fix this in a few different ways. First, try a Levels adjustment on the entire image. You can also select areas to make individual adjustments to them in isolation. The Levels tool is easy to use — just follow these steps:

1. **Choose Enhance⇨Adjust Lighting⇨Levels.** The Levels dialog box appears, as shown in 4-21.

2. **Analyze the histogram.** You see a histogram of your image, which shows the distribution of lows, mids, and highs, from left to right. Ideally, you don't want the graph to hit either side of the window, as that means you've lost shadows and highlights. In general, the distribution of levels is weighted to the left if the photo is underexposed and to the right if it's overexposed.

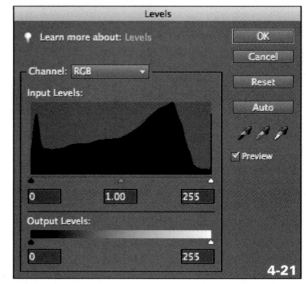

4-21

ABOUT THIS FIGURE *The Levels dialog box in Photoshop Elements.*

3. **Make lighting adjustments using the sliders.** To fix a dark area, drag the white triangular slider (at the far right) to the left, which brightens the image. To fix a light area, drag

the dark triangular slider (at the far left) to the right to darken it. Extreme settings can produce noise or blow out shadows and highlights.

4. **Make contrast adjustments.** Using the center slider, which controls gamma (or contrast), drag it left to reduce contrast or right to increase contrast. Bunching up the left and right sliders also increases contrast, as shown in 4-22.

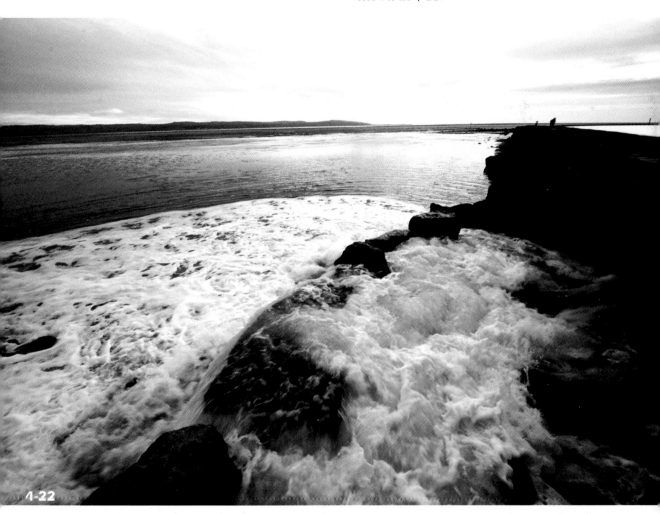

4-22

ABOUT THIS PHOTO *Image 4-19 after Levels adjustments were applied. (ISO 1250, f/11, 1/40 second, Nikon 14-24mm f/2.8 at 14mm)* © Pete Carr

Assignment

Photograph a Scene and Apply HDR

The last few chapters covered what you need to know in order to enjoy HDR photography. You now know what gear you need, how to select scenes, shoot brackets, and process everything in HDR software.

For this assignment, shoot at least three exposure brackets of a scene that interests you. It doesn't have to be grandiose or dramatic, but make it something you think would benefit from HDR. Concentrate on your bracketing technique on location and then merge them in Photomatix when you get home.

Start with the default Photomatix Pro tone-mapping settings laid out in this chapter. Investigate how the light changes as you adjust different settings. Don't be afraid to drag the sliders from their minimum to maximum values to see clearly what they do.

In the end, pick a few settings on which to focus. See how Luminosity adjustments change the tone of the image and how increasing the Strength can often give you a grittier looking photograph.

Robert photographed the brackets for this image on his birthday in 2009. The first image is the central bracket, before generating and tone mapping the HDR image. The second photo is the final image. It was tone mapped in Photomatix Pro and finished in Photoshop. Many of the default settings were used, although the Strength and Luminosity were both increased to make the scene look more dramatic. HDR from five bracketed photos at -2/-1/0/+1/+2 EV. ISO 100, f/8.0, 1/160 second, Tokina 11-16 f/2.8 at 11mm.

© Robert Correll

Remember to visit www.pwassignments.com after you complete this assignment and share your favorite photo! It's a community of enthusiastic photographers and a great place to view what other readers have created. You can also post comments, read encouraging suggestions, and get feedback.

© Pete Carr

Chapters 1 through 4 cover the theory behind High Dynamic Range photography, the gear required to shoot it, and the steps you follow to generate and tone map HDR images. From here, this book is about learning how to apply the principles of HDR in specific situations. As a result, this might read more like a photography book at times, rather than a tutorial on how to use HDR software. That's no mistake. To master HDR, you must learn how to visualize and take good photographs. The most important, fundamental truth of HDR is that it's photography.

So, first up for discussion are landscapes. Landscape photography takes place outside in natural light. You have little to no control over the conditions. You decide in what light to shoot based on timing (time of day, time of year) and the orientation of your camera (whether you're pointing up, down, at the sun or away from it). Landscape photography is challenging in and of itself.

What HDR brings to the table is the ability to cope with scenes that have very wide dynamic ranges, without blowing out skies or losing important aspects of the scene in shadow. HDR expands your shooting envelope.

As you work your way through this chapter, don't worry too much about camera settings. The challenge of landscapes has more to do with scene selection and framing than it does with shooting modes and exposure settings. Aperture priority mode is your friend. Keep the ISO low and set the aperture to f/8.0. Use AEB and a tripod, and get out there and find something beautiful.

BRINGING LANDSCAPES TO LIFE WITH HDR

This section serves two purposes: To introduce you to the challenges of shooting landscapes for HDR and to illustrate a general HDR workflow

from start to finish. As you gain more and more experience, these steps will become second nature.

EVALUATING THE SCENE

Anyone can take uninteresting landscape photos. In fact, everyone has. To increase your odds of capturing great landscapes, pay careful attention to how you seek out, evaluate, and frame the scene. These skills are important whether or not you're shooting for HDR.

However, not all good landscapes are ideal for HDR. It is best suited for high-contrast scenes, of course. Be on the lookout for bright sunsets with deep reds, blues, and oranges. Look for clouds, because they can often add drama to the scene. Mountains, deserts, rivers, oceans, fields, and many other types of landscapes are equally viable subjects.

Regardless of the individual scene, look for a fantastic view that has something interesting to say *and* needs HDR to bring it out. Most of the time, you feel the landscape speaking to you first. Listen! If it moves you, it will move others, too.

> **note** Rules are often meant to be broken. If you have a clear blue sky with nary a cloud, but a very interesting foreground subject, you may still be able to achieve the look you want. Try it and see.

Speaking of which, 5-1 is a photo of one of Pete's favorite places to capture sunsets. It is the West Kirby marine lake near Liverpool. When calm, this westward-facing location offers stunning reflections of sunsets. Almost every sunset here is guaranteed to be a winner.

Pete composed the photo with the jetty in the shot to add foreground interest. Landscape photographs can often feel two-dimensional with just the horizon and a sunset. Remember to add focal points, hopefully, without cluttering the image. These objects lead people's eyes around the photo.

On this particular day, Pete was only passing through West Kirby. He had his camera with him (he normally takes it everywhere), but only the camera— no tripod and no filters.

This illustrates a situation where HDR can be very handy. A veteran landscape photographer would probably take Pete to task for not having filters and a tripod in his car. Filters often help solve exposure problems with simple landscapes such as this. ND graduated filters are great for darkening the top half of the scene (namely, the sky), which helps balance the exposure and brings out detail in the darker water. Without filters, Pete had to rely on another tool in his arsenal: HDR.

tip

Although HDR is fun and looks cool, it's great at problem solving, too. Try it, even when you're not after that HDR look. Exposure bracketing and HDR processing help balance exposure between very bright and very dark elements of the scene. Go for a realistic look and no one even needs to know you're using HDR!

5-1

ABOUT THIS PHOTO *Sunset in West Kirby, United Kingdom, 0 EV exposure. (ISO 200, f/6.3, 1/80 second, Sigma 10-20mm f/4.0-5.6 at 10mm) © Pete Carr*

SHOOTING THE BRACKETS

Images 5-2, 5-3, and 5-4 show the brackets for 5-1. Because Pete didn't have a tripod, he rested his camera on the railings around the marine lake. It wasn't an ideal situation, but the shutter speeds were not outlandishly slow (that helps when shooting handheld or when you're manually supporting the camera).

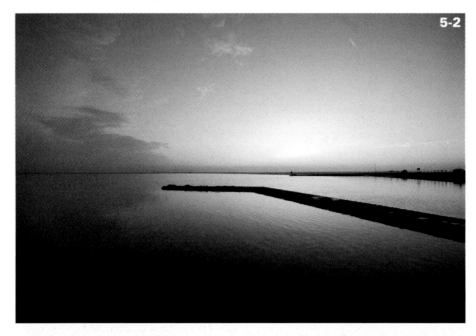

5-2

ABOUT THIS PHOTO
West Kirby, Wirral, United Kingdom. The 0 EV exposure for 5-1. (ISO 200, f/6.3, 1/80 second, Sigma 10-20mm f/4.0-5.6 at 10mm) © Pete Carr

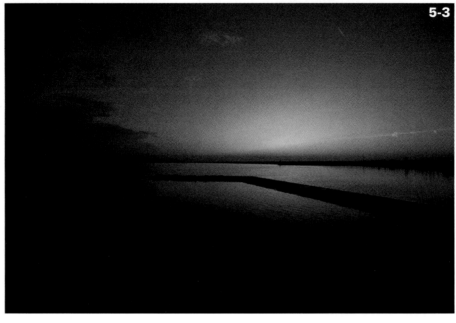

5-3

ABOUT THIS PHOTO
West Kirby, Wirral, United Kingdom. The -2 EV exposure for 5-1. (ISO 200, f/6.3, 1/320 second, Sigma 10-20mm f/4.0-5.6 at 10mm) © Pete Carr

ABOUT THIS PHOTO
West Kirby, Wirral, United Kingdom. The +2 EV exposure for 5-1. (ISO 200, f/6.3, 1/20 second, Sigma 10-20mm f/4.0-5.6 at 10mm) © Pete Carr

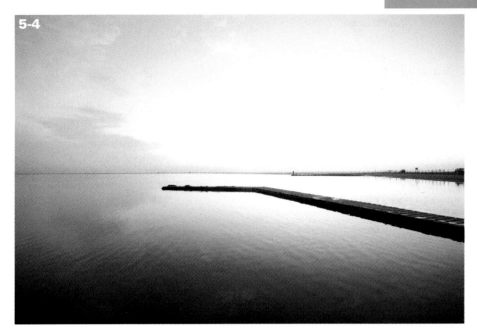

5-4

When shooting handheld HDR, it is very important that you use your camera's AEB feature, as Pete did. Even when using a tripod, though, it is the most convenient way to photograph the brackets. If you want to use your camera's Aperture Priority auto exposure mode, set the shooting mode to A (or Av) and select the aperture. Next, if possible, set up and enable your AEB feature by specifying the number of brackets you want to take, and the exposure difference. Now, you're ready to fire away. In this case, it only took a moment to capture three brackets at -2, 0, and +2 EV.

HDR PROCESSING

When you get home, load your bracketed photos into Photomatix Pro to merge them into an HDR image to tone map. Remember, in this example,

the camera wasn't firmly supported by a tripod, so, there will undoubtedly be slight alignment issues between the brackets. Thankfully, the alignment routine works very well in Photomatix Pro. Select the Align source images check box and select By matching features in the Photomatix Pro Preprocessing Options dialog box (shown in Chapter 4) as you generate the HDR image.

It's not an issue in this example, but when there is movement in a scene, select the Remove ghosts option. As covered in Chapter 4, this can minimize or eliminate ghosting caused by objects appearing in different spots of the scene between brackets. If desired, select the Reduce noise and Reduce chromatic aberrations options.

The HDR image for this sequence of shots is shown in 5-5. Notice that the highlights are blown out and the shadows are very dark. The data is there, it's just that standard computer displays aren't able to display all the detail present in the High Dynamic Range image. That's why tone mapping is so important. It transforms an image with tremendous, albeit impractical, details into something usable.

TONE MAPPING

It's important to compose lansdscape scenes with a nice selection of elements to produce a balanced image. The same can be said for processing — look for balance. Image 5-1 shows a lovely, calm pastel-like sunset. Overprocessing it in an attempt to bring out too much detail wouldn't do this scene justice. Just as having too many elements in the frame would create a busy picture, developing too much detail when tone mapping might create the same.

Image 5-6 illustrates the danger of overprocessing. The settings in Photomatix were: Strength 100 percent, Luminosity +10, Color Saturation 75 percent, Detail Contrast +10, Lighting Adjustments set to Natural+ in Lighting Effects mode, and Micro-smoothing set to 0. In many ways, this results in an image that is worse than the original photos straight out of the camera. There's a very heavy vignette around the sunset, which shows up as darkened top and bottom corners. The jetty has odd, oversaturated red areas and the area around the sun is too distinctly globular. HDR should help bring out detail in your photos. When these settings are used, details are lost, which defeats the purpose of HDR.

Tone mapping is often a back-and-forth process. You load your images, generate the HDR, and begin to tone map. As shown in 5-6, some settings may present problems to overcome. The challenge of tone mapping is to be flexible and imaginative enough so that you aren't afraid to change the sliders.

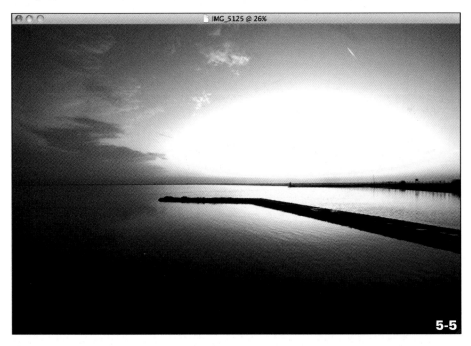

IMG_5125 @ 26%

5-5

ABOUT THIS PHOTO
Merged HDR photo in Photomatix using the bracketed exposures 5-2, 5-3, and 5-4. (ISO 200, f/6.3, 1/80 second, Sigma 10-20mm f/4.0-5.6 at 10mm) © Pete Carr

The next step here is to try and bring out more detail by changing the Lighting Adjustments settings in Lighting Effects mode. Dropping it down to Surreal+, as shown in 5-7, fixes some issues from 5-6 but also presents new ones. The vignette is gone as is the bright egg of a sunset. The photo looks much brighter and details are more visible.

However, the image looks like it has had a grungy texture applied to it. It is incredibly noisy, and the colors, despite the Saturation being set to 75 percent, are muted. The sunset itself is hardly noticeable and the jetty appears to have a halo surrounding it. This case illustrates the difficulty of correcting some issues but creates a whole new

ABOUT THIS PHOTO
Merged HDR photo using the bracketed exposures from 5-2, 5-3, and 5-4. Maxed out Photomatix settings produce undesired results. (ISO 200, f/6.3, 1/80 second, Sigma 10-20mm f/4.0-5.6 at 10mm) © Pete Carr

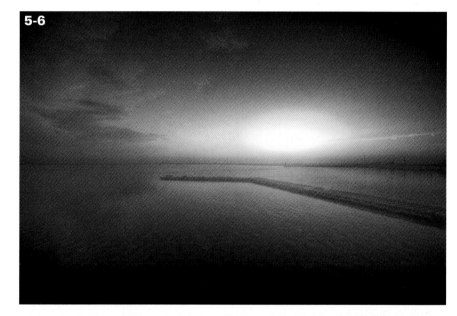

ABOUT THIS PHOTO
Merged HDR photo using the bracketed exposures from 5-2, 5-3 and 5-4. Photomatix settings maxed out with smoothing set to minimum still produces undesired results. (ISO 200, f/6.3, 1/80 second, Sigma 10-20mm f/4.0-5.6 at 10mm) © Pete Carr

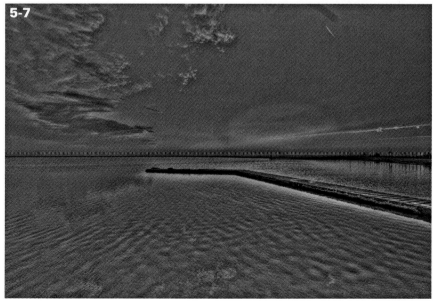

batch. This doesn't show the nice, calm, relaxing sunset Pete saw and it isn't what he wanted to use HDR to produce.

You need to be ready to rethink your settings to solve problems. In 5-7, Lighting Adjustments isn't the issue — it's the other settings. When you attempt to rein in an overly dramatic image, try adjusting the settings that may be boosting detail (whether local or global contrast) and color. In this case, reducing the Strength to 60 percent helps reduce the vignetting around the edges. Reducing the Color saturation to 45 percent removes the oversaturated red areas on the jetty and prevents the image from looking too rich. It was not a vibrant sunset; it was a calm, pastel-like sunset, so it doesn't need overly vibrant colors.

Photomatix Pro has other settings that can help you even out contrast — try changing Detail Contrast to zero. Remember, even though you may be photographing a high-contrast scene, the final image doesn't have to be high contrast.

Additionally, raising the Luminosity to +4 helps reduce some of the detail in this scene. That may sound a bit strange, as you normally use HDR to bring out detail, but when Luminosity was set at +10 it brought out noise and the reddish areas on the jetty. Despite reducing the saturation, the red areas on the jetty continued to look overcooked. Reducing Luminosity keeps the same level of color saturation but resolves the issue. Finally, increasing Micro-smoothing can also reduce contrast. In this case, +10 helps a lot. The resulting image, shown in 5-8, is a calm, serene sunset with plenty of pastels.

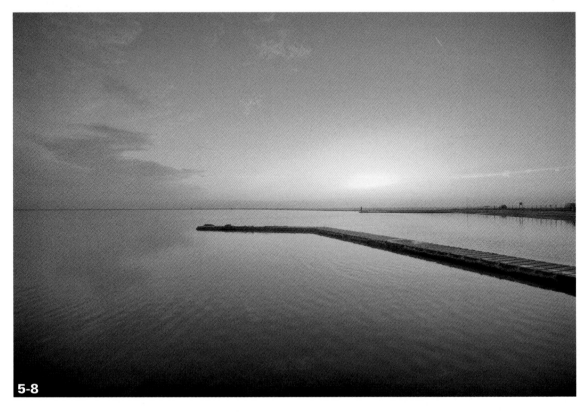

5-8

ABOUT THIS PHOTO *Merged HDR photo using the bracketed exposures from 5-2, 5-3, and 5-4. Photomatix settings adjusted to produce the desired result. (ISO 200, f/6.3, 1/80 second, Sigma 10-20mm f/4.0-5.6 at 10mm) © Pete Carr*

FINALIZING

Quite often, the last step in the HDR process is finalizing it in an image editor like Adobe Lightroom or Photoshop. Photomatix isn't designed for polishing, finishing, and publishing images. Use it to generate your HDR and tone map the HDR image. Save your result as a 16-bits-per-channel TIFF and finish up in your favorite image editor. This gives you a lot more flexibility and control.

Image 5-8 best illustrates Pete's vision of the scene. However, there are always artistic and practical alternatives. For example, you may be in the mood for more drama and choose to process a scene to emphasize contrast rather than

reduce it. In addition, if the medium or venue in which you're publishing isn't suited to a muted, pastel sunset, you may want to increase the contrast to make the photo stand out a bit more.

You don't always need to go back to Photomatix Pro and start over. Image 5-8 was used to create the alternate image shown in 5-9. A contrasted tone curve was applied. The clouds and water in the foreground were dodged and burned a bit. The entire photo was also treated to a small amount of noise reduction to produce a photo with more contrast. The colors appear more vibrant and the image has a little vignetting as a consequence.

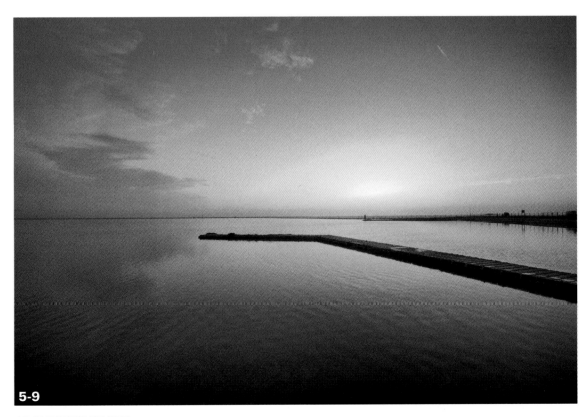

5-9

ABOUT THIS PHOTO *An alternate interpretation of the scene shown in 5-8, processed in Adobe Photoshop. (ISO 200, f/6.3, 1/80 second, Sigma 10-20mm f/4.0-5.6 at 10mm) © Pete Carr*

COMPOSING EFFECTIVE LANDSCAPES

Although there are various methods of composing good landscape photos, you should become familiar with the basic approaches presented in this section. They offer a few different ways to enhance the appearance of depth in landscapes. While no rule is universally applicable, these simple framing strategies can help you take landscape photos that appeal to others.

The truth is composing effective landscape images has nothing to do with HDR. It's critical for you to understand that HDR isn't meant to replace every photographic philosophy and technique. It does not magically turn a poorly composed, uninteresting shot into a prize-winning photo. Exposure brackets and tone mapping expand your operating envelope, but do not turn your photography into something else.

RULE OF THIRDS

The most effective and easiest way to analyze a landscape scene (and many other types as well) is called the Rule of Thirds. To apply this rule, in your mind's eye, turn the scene into a grid that looks like a tic-tac-toe board — three squares high by three squares wide.

tip To more easily apply the Rule of Thirds, check and see if your camera has a framing grid in the viewfinder or LCD display. It may be a default feature or you may just need to turn it on.

With this grid in mind, place the focal points of the image along the lines and where they intersect. As shown in 5-10, the sun sits perfectly where the vertical left and bottom lines intersect. The right side of the photo is a nice, open space. Using the Rule of Thirds, you can place elements in the frame so they are nicely spaced and create aesthetically pleasing images.

You don't always have to place the horizon on the line across the bottom third of a scene. The next two photos show two interpretations of the same basic scene. Robert shot them from slightly different vantage points along a picturesque river.

Visualize the grid and notice in 5-11 that the horizon is aligned on the line separating the upper third from the rest of the photo. The trees don't form a solid, straight line, but the horizon is clearly defined. The sky in this photo takes up the top third of the photo. This has the effect of de-emphasizing it in comparison with the river, which is in the lower two-thirds of the scene. That brings out the sky's reflection in the river. It's a very well-balanced photo, even with the horizon near the top.

In the case of 5-12, the horizon is placed near the bottom of the scene. Both 5-11 and 5-12 use the Rule of Thirds, but they use it differently. Notice that the effect in 5-12 is to emphasize the sky rather than the river.

In both cases, HDR made it possible to capture the scene without blowing out the sky. These shots were taken on an October evening after six o'clock and processed in Photomatix Pro with identical settings. Robert sometimes prefers high

Strength and Color saturation settings. In this case, they were 90 and 80, respectively. All in all, that doesn't result in an outlandish HDR effect.

Detail Contrast was set to 5.9 and Micro-smoothing to 6.0. These settings keep the highlights in the clouds from getting too bright while increasing definition in the clouds. Saturation Highlights and Shadows were both increased, which emphasizes the blues in the sky and water, and the autumn colors in the trees. Micro-smoothing was increased to 6.0 to lower contrast.

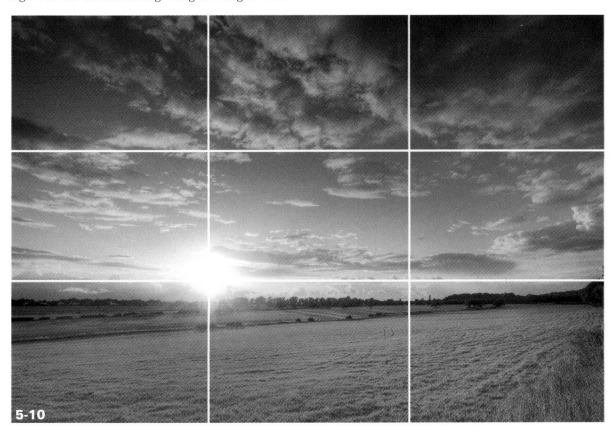

5-10

ABOUT THIS PHOTO *Storeton, United Kingdom. A balanced photo using the Rule of Thirds. HDR from three bracketed photos at -2/0/+2 EV. (ISO 200, f/8.0, 1/160 second, Sigma 10-20mm f/4.0-5.6 at 10mm) © Pete Carr*

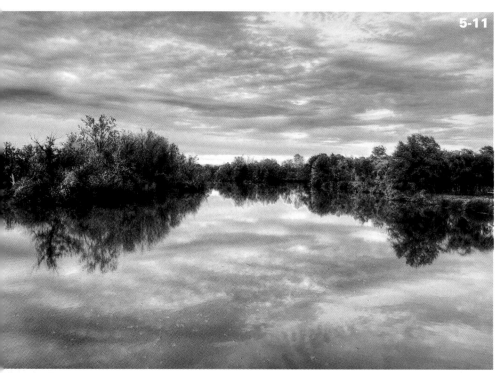

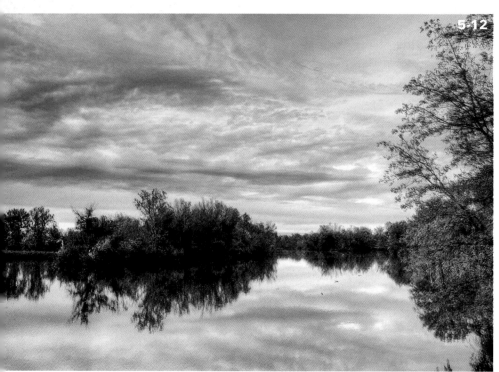

LEADING LINES

As helpful as the Rule of Thirds can be, an image sometimes needs more than that. Some photos, even when processed as HDR, can appear two-dimensional. You might have a lovely sky at the top and a decent foreground, but the photo may feel flat. Using *leading lines* in an image can help give a more three-dimensional feel to the photo.

As the name suggests, leading lines guide you through the scene. A classic example is shown in 5-13. This scene shows a train track leading off into the distance with a mountain at the end. Although you may not be able to see the track clearly (it is in the center of the valley), it leads your eye from the front left to the center-right rear of the photo. There, it converges with the mountains and the other side of the valley.

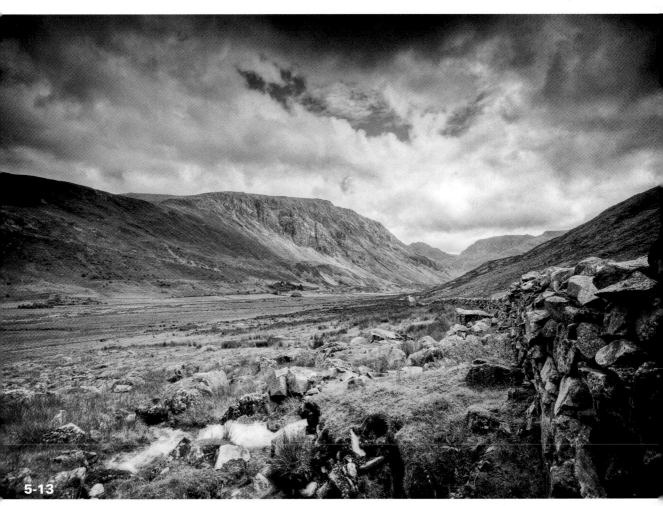

5-13

ABOUT THIS PHOTO *Mountain valley in North Wales, United Kingdom. HDR from three exposures, -2/0/+2 EV. (ISO 200, f/10.0, 1/125 second, Sigma 10-20 f/4.0-5.6 at 10mm)* © Pete Carr

Some leading lines are a bit more obvious. The scene in 5-14 is a shot from a bridge over a frozen river. The riverbanks, trees, and even the clouds, appear to point to the lower center of the photo where the river splits. Everything leads your eyes to that location and, in the process, gives depth and dimension to the photo.

Settings in Photomatix Pro de-emphasized contrast. Strength was set to only 65 and Lighting Adjustments were raised to 4.6. The White Point was kept low to keep the sky from getting too bright. Once more, Saturation Highlights and Shadows were both increased to 5.1 to brighten the colors.

USING OTHER FORE- AND MIDGROUND ELEMENTS

If you aren't at a location with leading lines, look for other elements that reside at different depths within the scene. Image 5-15 shows a nice park landscape, complete with a tree line in the background. Your eye naturally (albeit, not immediately) gravitates to the pond at the rear left, but there are many other interesting objects that hold your attention and impart depth to the shot. It feels very real.

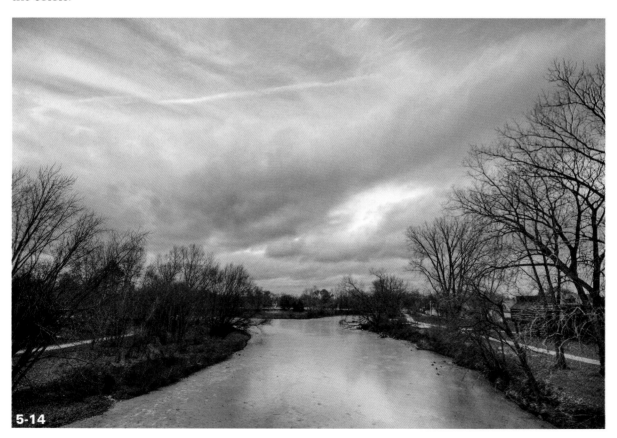

5-14

ABOUT THIS PHOTO *This scene is anything but a two-dimensional landscape. HDR from three bracketed photos at -2/0/+2 EV. (ISO 100, f/8.0, 1/20 second, Sigma 10-20mm f/4.5-5.6 at 10mm) © Robert Correll*

ABOUT THIS PHOTO *Using a foreground object to contrast with the tree line in the background. HDR from three bracketed photos at -2/0/+2 EV. (ISO 100, f/8.0, 1/500 second, Sigma 10-20mm f/4.5-5.6 at 11mm) © Robert Correll*

On the other hand, 5-16 is more about the midground. The bottom third of the scene is grassy and contains little to hold your attention. The top third has luscious foliage that balances the green grass but, again, this area isn't the central feature of the scene. The middle third is where the action is. The far tree line serves as a nice boundary as your eyes investigate the trees, water, and other elements of the park. The feeling of depth is immense, even though it only takes up the center of the frame.

Both 5-15 and 5-16 were taken at the same park on the same day. They were processed the same, except that the Temperature in 5-15 was lowered to -2.0 and in 5-16 to -2.5. This makes the sky look bluer in 5-16. A lower Temperature also helps prevent the mulch in 5-15 from overpowering the photo with reddish-brown hues. In other respects, the settings were fairly straightforward: Strength at 100 percent and Color Saturation at 80 percent. Except for the White and Black Points (set to 4.159 and 0.393, respectively), everything else was left at the default setting.

5-16

ABOUT THIS PHOTO *This scene is more about what is at intermediate depth than the background. This creates a feeling of depth. HDR from three bracketed photos at -2/0/+2 EV. (ISO 100, f/8.0, 1/60 second, Sony 18-70mm f/3.5-5.6 at 24mm) © Robert Correll*

WORKING WITH NATURAL LIGHT

Understanding light is a critical aspect of landscape photography. This understanding doesn't come in the box with your new dSLR either. You have to work to develop it. Reading and studying are an important part of that — soak up everything you can — but you have to go out into the field and practice, as well.

The fact is every landscape is subjected to light from the sun. Because the earth rotates, the sun moves across the sky creating different light at different locations throughout the day. Your photographs are birthed into this situation — not the other way around. Therefore, you need to know when to go out and when to stay home.

> **tip** To help develop your skill for working with light, read anything by Ansel Adams, the famous American landscape photographer. He was rigorous and methodical. He thought and studied — it was not just a feeling to him. His photographs do evoke powerful feelings, but he was the consummate professional in his approach.

SHOOTING AT SUNRISE AND SUNSET

As covered earlier, the Golden Hour (the hour after sunrise and before sunset) is one of the best times to shoot landscapes. The light is different during these times compared to the rest of the day. The sun is much lower on the horizon and casts much longer, more interesting shadows. The fact that light from the sun has to pass through more of the atmosphere at sunrise and sunset changes the wavelength of the light that reaches you. This is why sunset and sunrise are so colorful.

Sunrise and sunset are magical hours that can contribute to some of the most stunning images you can take — highlights are tamed, the light is diffused, and the photo appears warmer. Cloud formations, coupled with the warm sunset light, can produce amazing skies, as shown in 5-17. You can see how dramatic sunset light can be. The lovely warm orange tones on the horizon blend nicely into the blues.

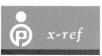

note Winter is the best time of year to photograph because the sun is lower and produces nicer light. The shadows cast on objects aren't as harsh either because the angle is lower.

x-ref See Chapter 3 for more information on the Golden Hour.

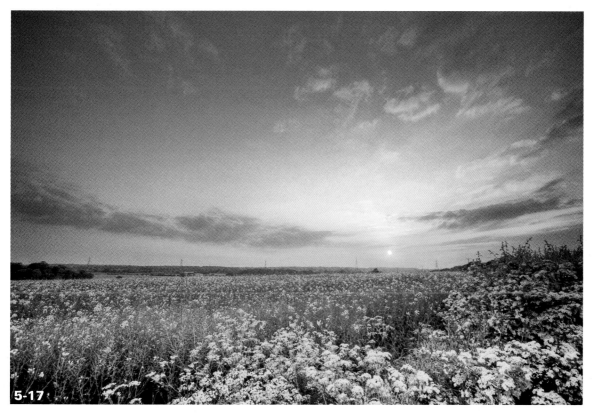

ABOUT THIS PHOTO *Sunset over oilseed rape fields in Storeton, United Kingdom. HDR from five bracketed exposures at -2/-1/0/+1/+2 EV. (ISO 100, f/8.0, 1/100 second, Sigma 10-20mm f/4.0-5.6 at 10mm) © Pete Carr*

The problem is that our cameras cannot often compete with our eyes. The finished HDR image in 5-17 is close to what Pete saw (albeit, exaggerated a little for a more aesthetically pleasing effect). What was present that evening was a stunning sunset over a field of lovely yellow flowers. When he took the photograph, however, it just didn't live up to what he saw. This is what drives landscape photographers mad.

To make matters worse, Pete was passing the area on his way home from another shoot. He didn't have his filters with him so there was no way to bring out details in the dark field and compensate for the bright sunset. Thankfully, HDR doesn't screw into the front of your lens —it's always with you. In this case, Pete took five exposure brackets of the field and sunset and relied on Photomatix to bring out the details.

Images 5-18, 5-19, and 5-20 illustrate the difficult issues that are often faced when shooting sunsets and landscapes. Image 5-18 has clearly been metered for the sky. The field is too dark and the whole photo lacks impact. Image 5-19 is 2 stops underexposed enabling the detail around the sun to be captured, while 5-20 is 2 stops overexposed, which reveals details in the field. You can see why three shots are needed. There's simply too much contrasting light for the camera to deal with in a single exposure — it doesn't have enough dynamic range to capture the scene.

Inside Photomatix Pro, the tone-mapping process offers a multitude of options to process your images. It's so exciting and fun that it's hard not to overdo it. To help counteract that urge, begin at a reasonable starting point and then make changes. Therefore, the settings from Chapter 4 are applied, but the image looks a little dark. The name of the game now is problem-solving and adjusting. Don't be afraid to move the sliders around.

x-ref

See Chapter 4 for the suggested settings to start with in Photomatix.

5-18

ABOUT THIS PHOTO
Sunset over oilseed rape fields in Storeton, United Kingdom. A bracketed photo for 5-17, 0 EV exposure. (ISO 100, f/8.0, 1/100 second, Sigma 10-20mm f/4.0-5.6 at 10mm) © Pete Carr

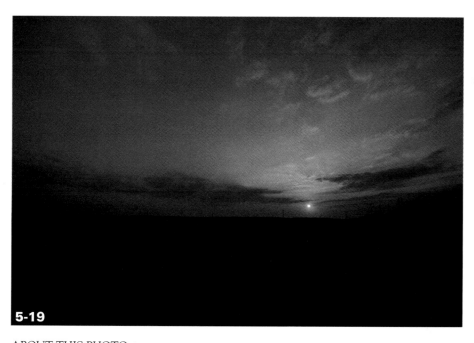

5-19

ABOUT THIS PHOTO *Sunset over oilseed rape fields in Storeton, United Kingdom. The underexposed bracketed photo for 5-17, -2 EV exposure. (ISO 100, f/8.0, 1/400 second, Sigma 10-20mm f/4.0-5.6 at 10mm)*
© Pete Carr

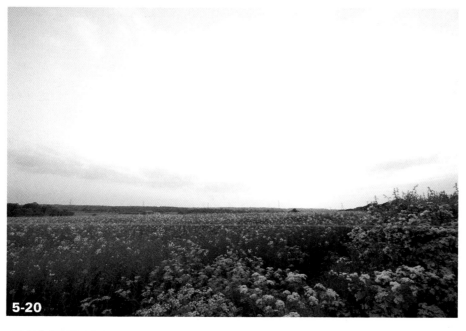

5-20

ABOUT THIS PHOTO *Sunset over oilseed rape fields in Storeton, United Kingdom. The overexposed, bracketed photo for 5-17, +2 EV exposure. (ISO 100, f/8.0, 1/25 second, Sigma 10-20mm f/4.0-5.6 at 10mm)*
© Pete Carr

For 5-21, the Strength setting was reduced to 50 percent. This kept the image light, especially around the edges. Quite often, a Strength setting that is too high causes vignetting. The higher the setting, the more aggressive the vignetting may appear. Luminosity was fine at +5. A higher setting causes the yellow colors in the sunset to turn an orange-red. That's an artistic decision, though, and in this case the yellow is nice. After performing these adjustments, the image was still too dark, so Gamma was increased to 0.6. All other settings were the standard starting-point settings from Chapter 4.

As shown in 5-21, these settings bring out plenty of detail in the field and the sunset is full of color. It's a great example of how HDR can help bring the detail out of a sunset from just three photographs. No extra gear was required.

Remember, tone mapping isn't always the last step. You may choose to make it the end, but this image was also tweaked in Adobe Lightroom (the results are shown in 5-17). The overall contrast was increased to add punch and the image was, again, brightened a little to add more pop.

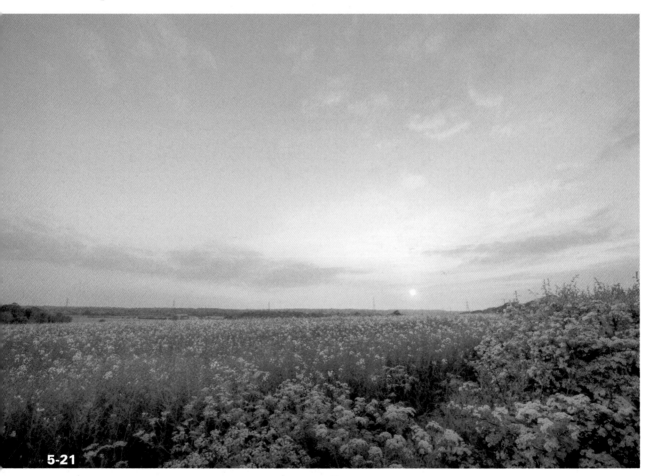

5-21

ABOUT THIS PHOTO *Sunset over oilseed rape fields in Storeton, United Kingdom. (ISO 100, f/8.0, 1/100 second, Sigma 10-20mm f/4.0-5.6 at 10mm) © Pete Carr*

HAZE

Hazy mornings work much like diffused sunsets. The sun is tucked strategically behind a tree in 5-22 on a hazy early morning, making it possible to shoot into the sun. On days like this you get fantastic dramatic rays of light streaming through the trees. If you find the right landscape, a hazy autumn morning can make interesting photography.

This image has a blown-out sky, however. If you convert it to black and white, the final image might look fine, but in actuality, the scene was a lovely sunny day. While 5-22 presents an interesting silhouette in the trees, 5-23 shows why HDR is so powerful — and illustrates a powerful

way to approach it. Image 5-23 was bracketed and processed to bring out additional details hidden by the bright light.

The great thing is that, while HDR helped bring out more details, it wasn't at the expense of the beautiful streams of light coming through the trees. Pete kept the settings in Photomatix fairly restrained. He didn't want to present a large dramatic scene but, rather, a nice atmospheric park photo.

As you will find, not every scene needs the same treatment. This one doesn't need to be deluged by processing — it just needs a bit to bring back the sky and some additional details in the background. To keep things under control, first try

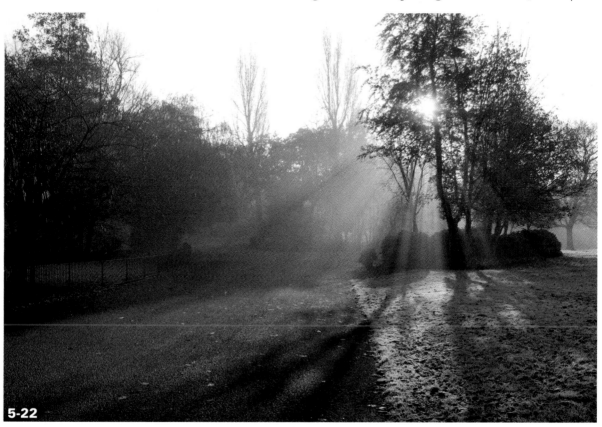

5-22

ABOUT THIS PHOTO *Sunrise over Sefton Park, Liverpool. (ISO 100, f/8.0, 1/125 second, Canon 24-70mm f/2.8 at 24mm) © Pete Carr*

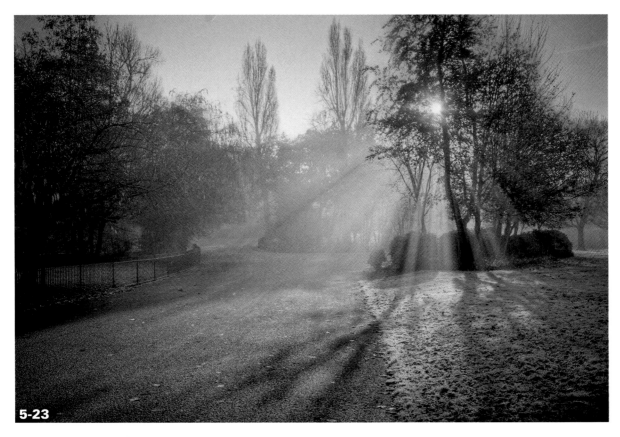

5-23

ABOUT THIS PHOTO *The tone-mapped image of the sunrise over Sefton Park, Liverpool. HDR created from three bracketed camera raw images at -2/0/+2 EV. (ISO 100, f/8.0, 1/125 second, Canon 24-70mm f/2.8 at 24mm) © Pete Carr*

lowering Strength. Here, Strength was set to 50 percent. Increasing it made the image darker. Luminosity was set at +5 to reduce the contrast in the sky. Lighting Adjustments were set to Natural+ in Lighting Effects mode. Everything else was set to normal except for the Color Temperature. At the default setting (0), the sky was gray, but adjusting this to -5 brought back the blue.

tip Sometimes HDR can cause overexposed areas to turn gray, so you may need to adjust the color temperature to compensate for that.

Alternatively, the image could be made more dramatic (see 5-24) by dropping the Microsmoothing down to 0 and increasing Strength to 75. These changes bring out contrast which, in this image, translates to more defined beams of light. You may have to fight overexposure when you do this. Here, an area of the sky is blown out a bit. If this happens, try reducing the White Point. In this case, it was changed from 1.2 to 0.36, which helped fix the problem.

Finally, there was also a bit of a halo surrounding the trees and the image was a bit noisy. Thankfully, these aren't huge issues and they were fixed. Remember, tone mapping can be a

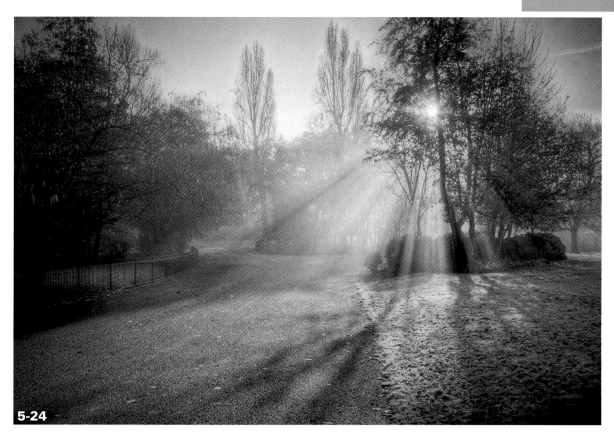

5-24

ABOUT THIS PHOTO *Tone-mapped image of the sunrise over Sefton Park, Liverpool. HDR created from three bracketed camera raw images at -2/0/+2 EV. (ISO 100, f/8.0, 1/125 second, Canon 24-70mm f/2.8 at 24mm) © Pete Carr*

delicate process. By adjusting one thing you may cause an issue elsewhere. Keep an eye on all parts of the image as you adjust your tone-mapping settings.

WHITE BALANCE

One of the great features of RAW file editing is that you can adjust the white balance (which adjusts color temperature and tint) after you take the photo. Suppose you are photographing a wedding and you misread a scene, producing a more yellow-tinted image. This can happen in churches due to the candles. Thanks to RAW file editing, you can adjust that tint. In Adobe

Camera Raw, for example, you can select the White Balance Correction tool, click on what you know is white and the image is adjusted. It's a brilliant feature of the software.

note Not all applications have White Balance controls. You cannot directly edit color temperature or white balance in Photoshop Elements, for example, but must use Remove Color Cast. Although there are many ways to adjust color in Photoshop, none involve adjusting color temperatures. One application that does allow this is Paint Shop Pro Photo, in which you can choose specific color temperatures and tints from the Color Balance dialog box.

You can use white balance (and, therefore, color temperature) adjustments artistically as well as functionally. For example, if you take a photograph of an amazing sunset, but it doesn't look as golden as you remember onscreen, you can adjust it using the White Balance setting. In 5-25, the white balance was adjusted to produce a photograph with a warmer feeling in keeping with the sunset. Compare that to 5-26, which was adjusted by dropping the color temperature down to make the light look bluer. The result is that the image

feels more like dusk than sunset. However, both images work nicely. How you adjust the white balance is simply a matter of taste.

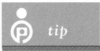

tip

If you struggle to capture blue skies and water, make white balance corrections as you convert your camera raw exposures to TIFFs (prior to generating the HDR image), as you generate the HDR image in Photomatix Pro, or during tone mapping (the Temperature control). The earlier you make the change, the better.

COLOR TEMPERATURE Color temperature can be confusing because it is related to white balance and the overall mood imparted by a photo. Technically, color temperature is the temperature of the light source. It is measured in units called Kelvin (K). Color temperature should not be confused with the wavelength of the light emitted, although wavelength and temperature are related. When measuring color temperature, hotter light sources appear blue and cooler light sources appear red. For example, candlelight, which humans perceive as having a yellow color, has a color temperature between 1,000K and 2,000K. Midday sun, which humans perceive as being a colorless white light, has a color temperature between 5,000K and 6,500K. Shade, which humans see with a blue tint, measures between 7,000K and 8,000K.

These light sources should be familiar, as they are White Balance presets in many cameras. Setting a specific white balance in a digital camera helps eliminate colorcasts in the photos you shoot. For example, when shooting in fluorescent lighting, white objects do not appear white, but often look reddish-orange. Therefore, objects (white objects especially, hence the need to set the correct white balance) are colored according to the temperature of the predominant light source.

The main confusion surrounding color temperature is how it contradicts our association of color with a feeling of coolness or warmth. We label blue as a cool color and associate red with warmth. This is the opposite of their true color temperatures, where blue color temperatures are hotter than red. When editing, you can make your photo appear cooler, which humans perceive as being bluer, when in fact you are raising the color temperature of the light source by altering the white balance.

ABOUT THIS PHOTO
A warmer sunset over West Kirby, Wirral, United Kingdom. (ISO 160, f/8.0, 1/40 second, Sigma 10-20 f/4.0-5.6 at 10mm) © Pete Carr

ABOUT THIS PHOTO
A cooler sunset over West Kirby, Wirral, United Kingdom. (ISO 160, f/8.0, 1/40 second, Sigma 10-20 f/4.0-5.6 at 10mm) © Pete Carr

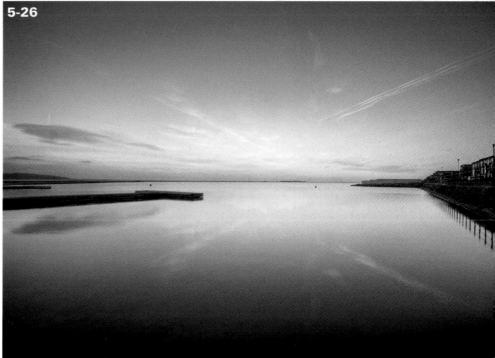

CAPTURING GREAT SKIES

One of the great things about HDR is how it brings out the detail and color of clouds, adding drama to a photograph. The incredible details are already there — but traditional photography is often incapable of showcasing them.

The trick to shooting clouds is to be patient enough to wait for them. Notice them. Find them. Shoot them. Sunsets and sunrises often produce stunning scenes with deep reds and oranges reflected off the clouds. These are breathtaking scenes that HDR can enhance by pulling the details.

WORKING WITH CLOUDS AND HDR

The main problem with clouds and great skies is that they are often brighter than the landscape you are photographing. Many landscape photographers, therefore, put a small collection of filters on the front of their lenses to compensate for this. As with all decent photography gear, decent filters can be expensive.

A typical example of a visually interesting landscape is shown in 5-27. You see a great mountain range with an interesting foreground and a good sky. What you can also see is that the clouds are blown out in places and there's not much detail

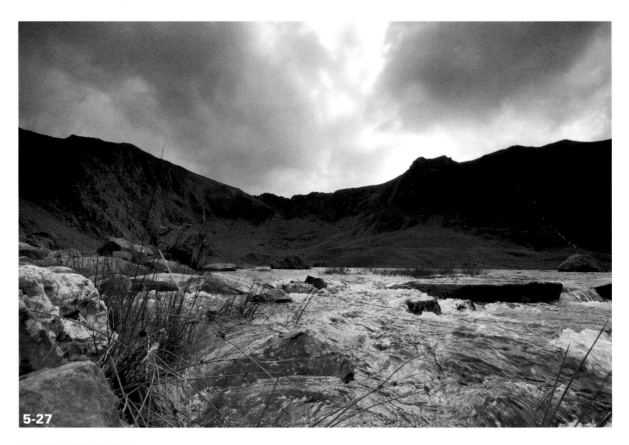

5-27

ABOUT THIS PHOTO *Devils Kitchen, North Wales, 0 EV exposure. (ISO 200, f/8.0, 1/125 second, Sigma 10-20mm f/4-5.6 at 10mm) © Pete Carr*

in the mountains. Image 5-28 is 2 stops brighter than 5-27 and shows what happens when you try to expose for the landscape. The details in the clouds are practically wiped out. You continually combat this problem as a landscape photographer. One way around it is to take the third underexposed photograph and use the brackets to create and tone map an HDR image.

The final, tone-mapped result is shown in 5-29. There are great details in the clouds, landscape, and lake. To achieve this, the Photomatix settings presented in Chapter 4 were used as a starting point. Luminosity was kept at +5, which helped retain detail in the clouds. Gamma was pushed to 0.6 to lighten the overall image. There was a small area of blown-out detail in the clouds, however. Pushing the Luminosity up to +10 helps control it, but also reduces the contrast in the image. Using Photoshop to add contrast back in later is possible, but doing that here would cause the sky to blow out again. Keeping Luminosity at +5 is the best solution.

> **tip** Don't just photograph clouds. Look for a stunning landscape or a story to tell — and then look up. If it is the middle of the day and the lighting is too harsh, try shooting anyway and see what you can capture. Come back closer to sunset and shoot during the Golden Hour for better light.

5-28

ABOUT THIS PHOTO *Devils Kitchen, North Wales, +2 EV exposure. (ISO 200, f/8.0, 1/125 second, Sigma 10-20mm f/4-5.6 at 10mm) © Pete Carr*

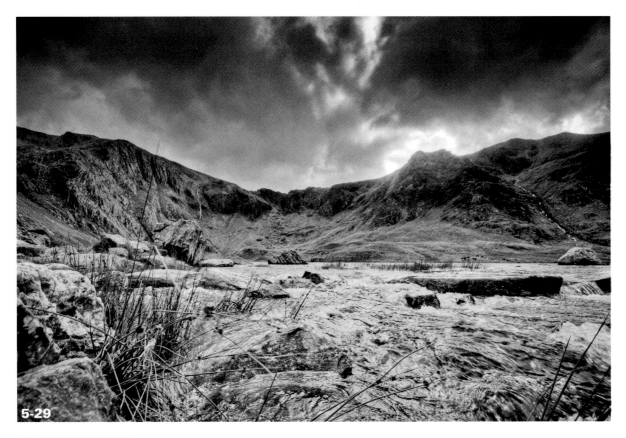

ABOUT THIS PHOTO *Devils Kitchen, North Wales. HDR from five bracketed exposures, -2/-1/0/+1/+2. (ISO 200, f/8.0, 1/125 second, Sigma 10-20mm f/4.0-5.6 at 10mm)* © Pete Carr

tip Details. Tension. Story. Ambiguity. These are some of the things you should be thinking about when you take your photographs. Their presence can make one photo of a sunset stand out from another — even if the viewer doesn't at first perceive it on a conscious level. Captivate your audience. Show them something they weren't expecting. Tell them a story they don't know. Don't reveal everything. These factors come into play from composition through final post-processing. Use them throughout your workflow.

CAPTURING WIDE-ANGLE SKIES

Wide-angle lenses offer tremendous advantages when capturing skies. You can create epic visual landscapes with these lenses. Remember, you can achieve great results if you shoot during the Golden Hour. It's annoying that you only get a few of these precious hours each day, but they are generally considered to be the best lighting conditions for many scenes. As always, however, it's up to you to experiment on your own and decide what works best for you.

tip Be careful when looking through the viewfinder with a wide-angle lens. Your depth perception is skewed and it can get a little disorienting. Be careful not to walk off a cliff or into a passing bus.

The ideal equipment for capturing clouds and the sky is a wide- or ultrawide-angle lens. For cropped-sensor cameras, 10-20mm or 12-24mm are great focal lengths that are nice and wide. Remember to take your crop factor into account — for example, a 15mm focal length on a camera with a crop factor or 1.5 is really 22.5mm in 35mm equivalent terms. For full-frame cameras, your crop factor is always 1, which means you want something in the 14-24mm or 17-40mm range.

The example in 5-30 was taken with a Sigma 10-20mm f/4.0-5.6 at 10mm. On a full-frame camera, that's about 15-16mm, which is very wide. You do have to be careful with ultrawide-angle lenses because it's possible to fill the frame with nothing but sky. While that can be pretty, you need to have something for people to focus on. In this example, there is an iron figure of the artist Anthony Gormley standing on the beach. It's the focal point of the image, with the backdrop of the stunning wide sky nicely reflected in the beach.

> **tip**
> You need something in the frame — a castle, a tree, or something else — with which people can connect. Good photographers use the sky to their advantage as part of the image to tell a wider story.

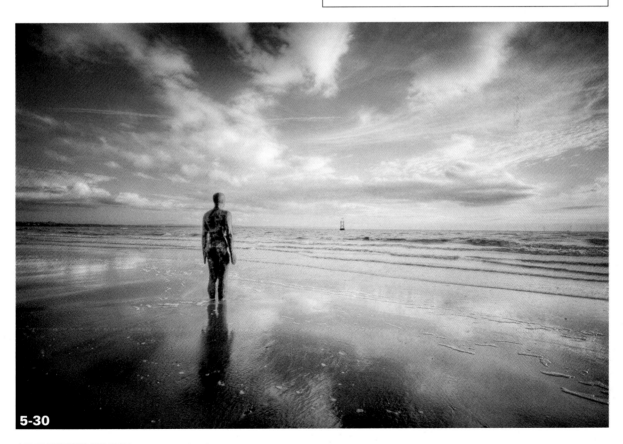

5-30

ABOUT THIS PHOTO *Anthony Gormley's Another Place, Crosby Beach, Liverpool. (ISO 100, f/5.0, 1/60 second, Sigma 10-20mm f/4.0-5.6 at 10mm) © Pete Carr*

The original can be seen in 5-31. Notice that the right side is fairly blown out and there is little detail in the iron man. This isn't a huge issue — there's enough detail to see that it's an iron figure. However, the loss of detail in the sky is a problem. It doesn't complete the shot and feels poorly executed.

To achieve the finished result in 5-30, the three bracketed exposures were merged to HDR in Photomatix and tone mapped as usual. The standard Photomatix settings from Chapter 4 were enough to bring out the lost detail in the clouds from the original exposure. Strength was reduced from 75 to 50 percent to keep the blue sky at the top from turning black. It would have been a shame to lose too much sky on such a lovely day. Changing the Luminosity only had a minor effect, and as the image looked fine at +5, it was kept at that level.

tip Don't just grab a wide-angle lens and expect to go out and create stunning landscapes in HDR. Wide-angle lenses are good but they can often be too wide. Composition means showing what you want rather than everything there is. Be selective.

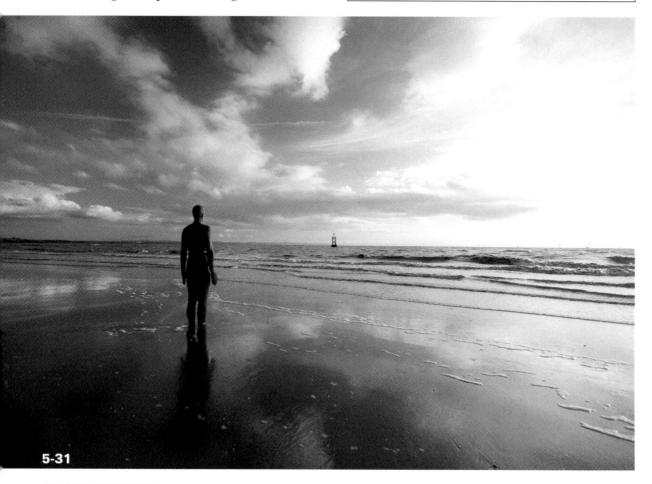

5-31

ABOUT THIS PHOTO *The original 0 EV exposure from 5-30. (ISO 100, f/5.0, 1/60 second, Sigma 10-20mm f/4.0-5.6 at 10mm) © Pete Carr*

WORKING WITH FAST-MOVING CLOUDS

Another issue that you may have to deal with is fast-moving clouds. When you shoot three bracketed photos, the clouds move between shots. How far they travel between frames depends on many things: The speed of the clouds, whether you are using AEB or manual bracketing, and the speed of your camera.

Yes, moving clouds can be a problem, but it's one that can be overcome. The recently updated version of Photomatix has a brilliant tool for removing ghosting from images. When you get to the first set of Preprocessing Options after loading your shots into Photomatix, look for the Remove ghosts check box and select it, as shown in 5-32. Select the with Selective Deghosting tool option.

idea Another way of dealing with fast-moving clouds is to use their movement to your advantage. Shoot with slower shutter speeds. The effect will be reminiscent of shooting water with longer exposures, which smoothes it.

When you click Preprocess (or OK in the Windows version), the Selective Deghosting window appears, as shown in 5-33, in which you can select areas to reduce ghosting. To use this tool, draw around the area that doesn't line up, then right-click and select Mark selection as ghosted area. To see this tool in action, click Preview deghosting and you should see the areas you circled change. If they look worse, go back to the selection mode and tweak it by right-clicking in the circled area and changing the exposure Photomatix uses.

The final result is shown in 5-34. Standard Photomatix settings were used here except the Gamma, which was set to 0.7 instead of 1.0 because the image turned out a little too dark.

5-32

ABOUT THIS FIGURE *The Photomatix Preprocessing Options.*

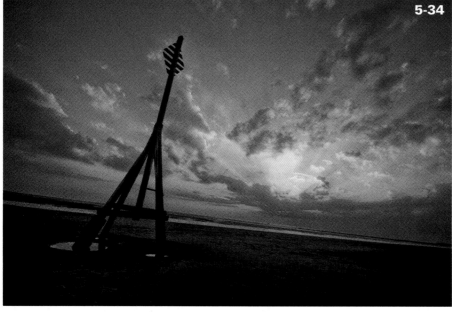

Assignment

Use HDR to Capture a Landscape

Your goal now is to apply the knowledge from this chapter. Pick a good time of day and find a location to capture a landscape. As you've seen in this chapter, you can get great photographs at times of day other than sunset. Try the Golden Hour or the middle of the day if you like. Experiment and push yourself. Travel the world if you need to, but find something that inspires you and capture it.

Remember to take three or more exposure-bracketed photos. Keep the ISO low. Use f/8.0 for your aperture. If your camera has it, use the AEB feature to automatically capture brackets. Otherwise, use the manual bracketing technique.

Take at least three exposure-bracketed photos. Convert your camera raw exposures to TIFFs and load them into Photomatix to create the HDR image. Use the settings in Chapter 4 as a starting point as you begin to tone map. Play around with the settings to see how details in the landscape and sky can be emphasized. Watch for haloes and noise, and try to reduce them.

The example shown here was taken in North Wales, United Kingdom. Wales is a stunning area, filled with mountains, lakes, waterfalls, and magnificent views. The HDR image was created from three bracketed photos at -2/0/+2 EV. ISO 200, f/8.0, 1/320 second, Sigma 10-20mm f/4.0-5.6 at 10mm.

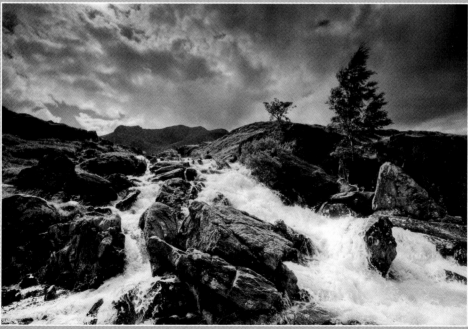

© Pete Carr

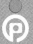

Remember to visit www.pwassignments.com after you complete this assignment and share your favorite photo! It's a community of enthusiastic photographers and a great place to view what other readers have created. You can also post comments, read encouraging suggestions, and get feedback.

© Pete Carr

Buildings and structures make great subjects for HDR. They are totally different from landscapes. The color palette is different, as are the tones and textures. They are also easier to work around. While it may not be possible to get to the other side of that mountain range to catch the changing light, it is relatively easy to change your vantage point when photographing a bridge, building, or sculpture.

The urban landscape, in particular, is a fantastic gallery of textures, details, buildings, streets, and contrasting lighting and tones. You can find them on every corner, and they are always changing. New buildings go up and old buildings come down. Structurally, a landscape may change once in 10 to 20 years. A city can change dramatically in a much shorter period of time, providing new angles and shapes with which to play. Look for high-contrast scenes where you can extract huge amounts of detail.

This chapter explores a few different types of subjects to inspire you. Remember, you need to get out there and practice in order to find what works best for you. Visit locations in and out of town — travel to new cities. Each one will have new locations to discover.

APPROACHING STRUCTURES

There are so many styles of buildings it can be overwhelming. What makes a good subject for HDR? A barn, a skyscraper, or maybe a cathedral? Probably all of them, given the right light. The key is to experiment with them and see what

works and what doesn't. Skyscrapers can be fun because they often reflect a stunning sunset or a city. Cathedrals are great for bringing out the exquisite detail in their construction. A lot of work goes into them, and it's great to really show that off with HDR. Public art is often brilliant, strange, and surreal. In Chicago, there is a giant reflective mirror shaped like a bean. It's huge and would be fantastic to photograph in HDR. All over the world there are things like this — architectural wonders, crazy-shaped artwork, and stunning religious symbols stretching back hundreds of years. This section looks at a few.

BRIDGES

Bridges can be a great subject to photograph and process with HDR. The older ones are filled with detail due to the stonework and iron. This results in interesting textures and surface details for HDR to bring out. More modern ones tend to be clean and minimal with lovely lines to lead you around the image.

Image 6-1 shows Tower Bridge in London at dusk. It's a stunning bridge known the world over as a symbol of London. As you can see, it's not a brilliant photo. Ten minutes earlier, the sky would have been a perfect deep blue and bright enough to complement the bridge. There's little you can do in a situation like this unless you happen to have a filter cut perfectly to darken the bridge while bringing out detail in the sky. That's a bit unrealistic.

6-1

ABOUT THIS PHOTO *Tower Bridge in London presents an interesting architectural photo. This is the 0 EV exposure. (ISO 200, f/11, 2 seconds, Nikon 24-70mm f/2.8 at 28mm) © Pete Carr*

The other option is to bracket, HDR, and tone map. This way you can take photos to capture the detail in the bridge (see 6-2) and to bring the color back to the sky (see 6-3). You can see how much detail is lost in the bridge in 6-3 by trying to bring it back to the sky. Some would argue that the best course of action is to get there on time, but some days it's just not possible, which is why it's good to have HDR in your toolbox.

6-2

ABOUT THIS PHOTO *Tower Bridge, London. The -2 EV exposure to capture detail in the bridge. (ISO 200, f/11, 0.5 seconds, Nikon 24-70mm f/2.8 at 28mm) © Pete Carr*

Chapter 4 presented a set of standard settings for getting started in Photomatix Pro. Those settings were initially loaded for 6-4 and then Strength was dropped to 50 percent, as the center of the image was oddly darker than the rest. Luminosity was fine at +5 as it helped reduce the overall contrast in the image and restore lost detail in the bridge. The lovely blue sky is also brought back into the photo.

You can see the result from Photomatix in 6-4 — plenty of detail to work with there. Remember that Photomatix isn't an image editor. Its main feature is in HDR merging and tone mapping.

After producing your tone-mapped image in Photomatix Pro, use an image editor like Adobe Lightroom or Photoshop Elements to really polish it up. Treat your tone-mapped HDR images like photos straight out of your camera. To that end,

ABOUT THIS PHOTO
Tower Bridge, London. The +2 EV exposure to bring detail back to the sky. (ISO 200, f/11, 8 seconds, Nikon 24-70mm f/2.8 at 28mm) © Pete Carr

ABOUT THIS PHOTO
Tower Bridge in London after tone mapping. HDR from five exposures, -2/-1/0/+1/+2 EV. (ISO 200, f/11, 2 seconds, Nikon 24-70mm f/2.8 at 28mm) © Pete Carr

you can see the polished final version in 6-5. Compare it to 6-1 and you see why HDR is so great. It's not about using the technology to polish bad photos taken in bad light. It's about understanding what you can do with light and technology.

While 6-5 represents the final version of this scene, you might have a different artistic interpretation you want to bring out. If you drop the Micro-smoothing to 0, the clouds become more prominent and potentially make for a more

dramatic photo, as shown in 6-6. If this is what you want, pay attention to noise levels. It's very easy to increase the noise in skies by pushing them around.

PIERS

Piers can be a great subject matter for HDR. They have a lot of interesting details both on top and below and there are many ways to photograph them. Topside, you might find interesting shops,

6-5

ABOUT THIS PHOTO *Tower Bridge in London. Final image after processing. HDR from five exposures, -2/-1/0/+1/+2 EV. (ISO 200, f/11, 2 seconds, Nikon 24-70mm f/2.8 at 28mm) © Pete Carr*

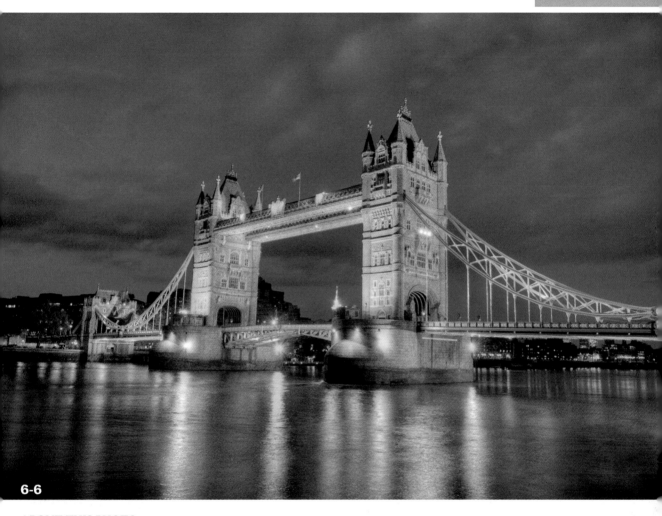

6-6

ABOUT THIS PHOTO *Tower Bridge in London with Micro-smoothing set to 0. HDR from five exposures, -2/-1/0/+1/+2 EV. (ISO 200, f/11, 2 seconds, Nikon 24-70mm f/2.8 at 28mm) © Pete Carr*

rides, or buildings. Wait for the right time of day to get the best light to photograph. Two of the best times would, of course, be sunset or sunrise. Depending on the location of the pier, you should be able to get a photo of it shining in glorious sunlight and one with a stunning sunset/rise as the backdrop. You could get underneath and create a nicely composed photo leading the viewer's eyes down the pier toward the sea. If you do

photograph from underneath, your best bet is to do so at dusk when the light is even enough to bring out the detail in the pier and the sky. Alternatively, you could take a long exposure when the tide is in.

Obviously, when photographing under a pier, the sun never shines up (it's like working inside in that respect) so it's never going to be as bright

as the top of the pier on a lovely sunny day. The problem here, as shown in 6-7, is that it's quite a high-contrast scene.

There is very little detail under the pier. The sun is shining on the sand and the town behind, but not under the pier. A very large reflector might help you bounce up the light, but that's not an easy job and it would cover the sand. As you can imagine, if you expose to get details under the pier you lose detail in the sky. Once again, HDR is the solution to a challenging exposure problem. It allows you to pull off a great photo under the pier without resorting to silhouettes at sunset.

Set up your tripod and take at least three bracketed exposures. A good range would be -2 EV to +2 EV. If your camera can do more, then go for it to get a smoother image. Unless you use a very wide range in bracketing (seven or nine brackets, for example), it's best to avoid composing a photo with the sun in it. That makes the scene too bright and you won't be able to claw many details back. Keep the bright daylight sun out of the frame.

For this image, the standard Photomatix Pro settings from Chapter 4 are initially applied. However, Micro-smoothing is lowered to +2 to

6-7

ABOUT THIS PHOTO *Underneath Blackpool Pier, United Kingdom. Single exposure at 0 EV. (ISO 200, f/8.0, 1/200 second, Sigma 10-20mm f/4.0-5.6 at 12mm) © Pete Carr*

create a more dramatic look in the sky, as shown in 6-8. In this instance, there wasn't a huge increase in the amount of noise in the sky caused by reducing the Micro-smoothing. Watch out for increased noise when you make setting changes to any sort of smoothing. If you have no choice, make sure to apply noise reduction afterward.

Once again, you run into the push-pull of tone mapping. When you reduce noise, you may find the image becomes a bit soft. It depends on how noisy the image is and how much noise reduction

you decide to apply. Balance is the key here. Balance between a dramatic and noisy sky versus a less dramatic but cleaner sky, and balance between noise and sharpness.

The final image is presented in 6-9. It is dramatic, but not overly contrasted in the sky. There's an ethereal quality to the seaside structures in the background. Details underneath the pier abound, which is due to shooting exposure brackets and processing them as HDR.

6-8

ABOUT THIS PHOTO Unprocessed HDR from underneath Blackpool Pier, United Kingdom. Three exposures, -2/0/+2 EV. (ISO 200, f/8.0, 1/200 second, Sigma 10-20mm f/4.0-5.6 at 12mm) © Pete Carr

6-9

ABOUT THIS PHOTO *Processed HDR from underneath Blackpool Pier, United Kingdom. Three exposures, -2/0/+2 EV. (ISO 200, f/8.0, 1/200 second, Sigma 10-20mm f/4.0-5.6 at 12mm) © Pete Carr*

GRAND ARCHITECTURE

The shot in 6-10 was taken from a very low angle (practically on the ground) thanks to the abilities of a decent tripod. It creates a dramatic feeling and gives the photo a sense of power. The building is tall and spectacular with the two towers piercing the sky, and shooting from a lower position emphasizes this.

As usual, bracketed exposures were taken to produce this image. In this case, five brackets at 1 stop apart (that is, five exposures at +/- 1 EV) are used. This particular camera doesn't allow a wider distance — +/- 1 EV is as large as you can go. It makes up for this by enabling you to shoot as many as nine total exposures.

Image 6-11 shows the original 0 EV exposure. On a perfect day, this building shines in sunlight. Annoyingly, on this day, the sun had just gone behind a cloud. Due to the schedule, there wasn't a lot of time to hang around for the perfect shot — that's photography sometimes. At times like this, bracket a larger number of exposures than you might otherwise shoot so you know you've got all the detail you need. As you can see in 6-10, the result is a stunner despite the sun being uncooperative.

ABOUT THIS PHOTO
Processed HDR of the Natural History Museum, London. Five exposures, -2/-1/0/+1/+2 EV. (ISO 200, f/13, 1/320 second, Nikon 14-24mm f/2.8 at 14mm) © Pete Carr

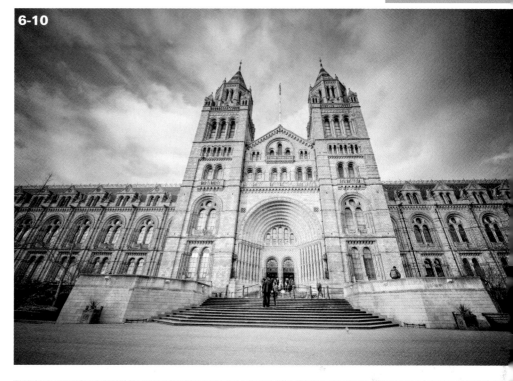

6-10

ABOUT THIS PHOTO
The Natural History Museum, London. Exposure at 0 EV. (ISO 200, f/13, 1/320 second, Nikon 14-24mm f/2.8 at 14mm) © Pete Carr

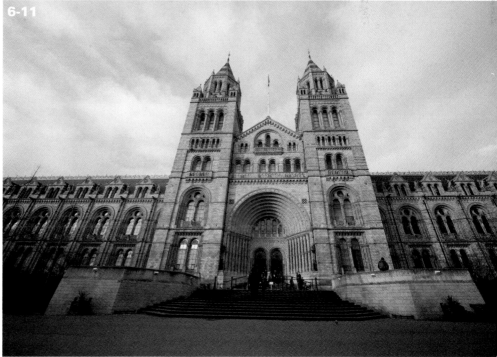

6-11

6-14

ABOUT THIS PHOTO *Church in Nantes, France. Exposure at -2 EV. (ISO 200, f/8.0, 1/500 second, Nikon 14-24 f/2.8 at 14mm) © Pete Carr*

Image 6-15 shows the brilliant church, but with a blown-out sky. Interestingly, this is the 0 EV exposure, and it's still underexposed by at least 1 stop. The 2 EV exposure brings out all the detail in the building but, as you would expect, there are no details in the sky.

Thankfully, the light that day was rather dull. Although HDR can bring out detail in shadows you may still find darker patches in your image. Sometimes it's nice to have an overcast day to soften the light.

This is also a handheld HDR example. No tripod was used because the camera had very good AEB capabilities and shot at a very fast frame rate.

Thankfully, the automatic alignment feature in Photomatix Pro is incredibly good and sorted out the alignment issues.

So, here you see the exposure dilemma: sky versus building, without filters or a tripod. Thankfully, HDR works well in these circumstances. As you probably know, the sky is brighter than the average street, so the challenge is to reduce the contrast between them to be able to show them at the same time. Bracketed photos give you the data, and tone mapping enables you to bring out detail in the sky and the building.

The standard tone-mapping settings from Chapter 4 were applied. No other tweaking was needed. As shown in 6-16, these settings brought out all the

ABOUT THIS PHOTO
Church in Nantes, France. Exposure at 0 EV. (ISO 200, f/8.0, 1/160 second, Nikon 14-24 f/2.8 at 14mm) © Pete Carr

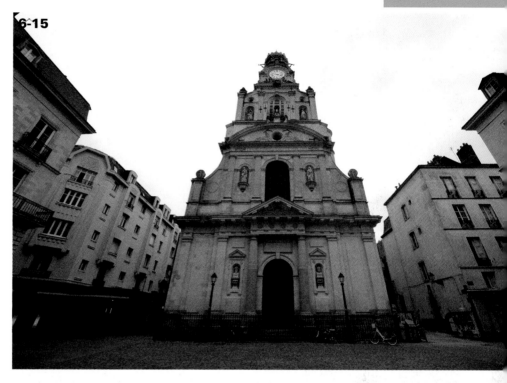

6-15

ABOUT THIS PHOTO
Church in Nantes, France. Exposure at 0 EV. (ISO 200, f/8.0, 1/160 second, Nikon 14-24 f/2.8 at 14mm) © Pete Carr

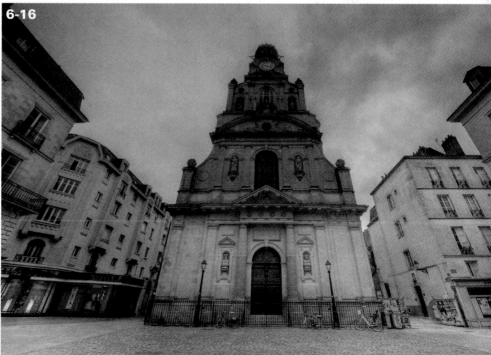

6-16

detail needed. The finished photograph can be seen in 6-17. It has been tone mapped in Photomatix Pro and cross-processed in Lightroom.

tip — With too much sky, even buildings can get lost in a photo. Pay attention to tone and contrast. If the sky and building have similar tones and lower contrast between them, the building needs to be larger.

Alternatively, if you want to bring more detail out of the sky and produce a more dramatic photo, you can change some of the settings in Photomatix. The key here is to drop the Micro-smoothing from +10 to +2 or 0. As you can see in 6-18, there is more detail in the sky and

brickwork and it's a far more dramatic photo. Of course, it's up to you to decide which style you prefer. Just remember not to push things too far.

SURFACES

Buildings can be constructed from a variety of materials — glass, concrete, plastic, metal, adobe, brick, stone, and wood have their own distinct mood and feeling. Modern materials often appear smooth, cold, and precise, while natural building materials are warm and tend to be more inviting.

Tone mapping reacts differently according to the surface of the building or structure. The reason is something called *local contrast*. Local contrast is not the same as the overall contrast of the image.

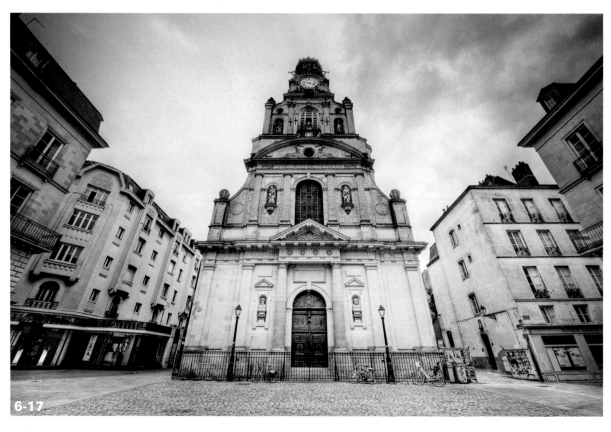

6-17

ABOUT THIS PHOTO *Church in Nantes, France. HDR from five exposures, -2/-1/0/1/2 EV. (ISO 200, f/8.0, 1/160 second, Nikon 14-24 f/2.8 at 14mm) © Pete Carr*

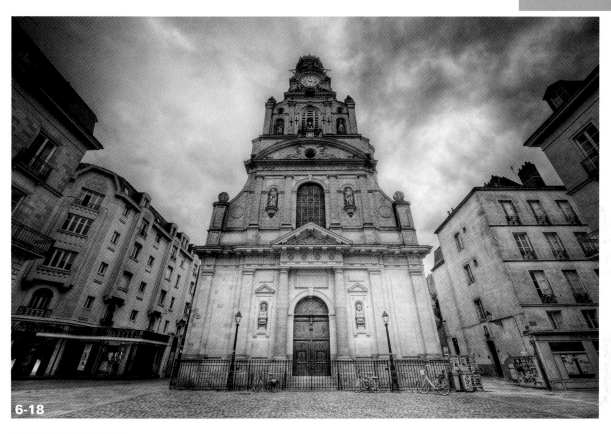

6-18

ABOUT THIS PHOTO *Church in Nantes, France. HDR from five exposures, -2/-1/0/1/2 EV. (ISO 200, f/8.0, 1/160 second, Nikon 14-24 f/2.8 at 14mm) © Pete Carr*

Rather, edges that make up the surface texture of the object you are photographing — a building, a face, the street, trees, water — can be accentuated and enhanced through the tone mapping process. This is something you can turn up or down based on the settings you use.

While it may be fun to bring up local contrast and make details more visible, it can also be powerful to smooth them over. Therefore, buildings with rough surfaces have the potential of greater local contrast and, hence, more details than buildings with smooth surfaces, regardless of other aspects of contrast in the photo.

The structure in 6-19 is the Millennium Bridge in Southport, United Kingdom. You can see the potential in this shot from the 0 EV exposure.

There is a decent sunset behind a reflective sculpture, but not enough detail in either the sculpture or the sunset to make the photograph compelling.

note

Reflective material can be great for HDR shots as you can bring out the detail in front of the camera and — to some extent — behind as well.

Three bracketed exposures were taken for this subject — one for the sunset, one for the sculpture, and one middle exposure. The three bracketed exposures were loaded into Photomatix and the normal settings from Chapter 4 were applied as a starting point.

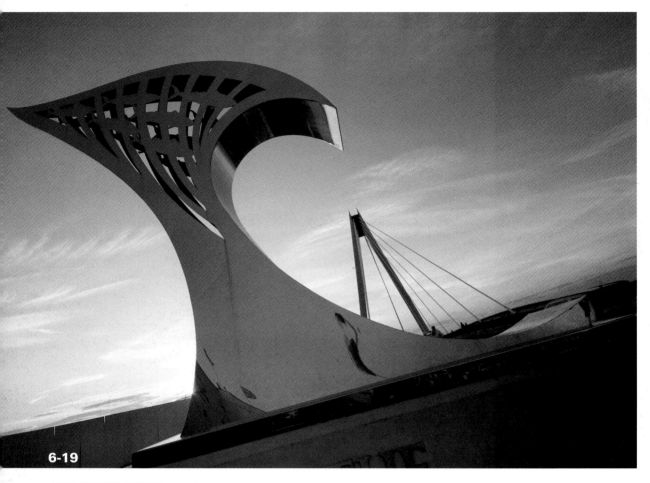

ABOUT THIS PHOTO *The Millennium Bridge in Southport, United Kingdom, presents a good opportunity for HDR. (ISO 100, f/8.0, 1/80 second, Sigma 10-20mm f/4.0-5.6 at 10mm)* © Pete Carr

Increasing the Luminosity to +10, while reducing the overall contrast in the image, made the area around the sunset look unrealistic and strange. So, Luminosity was set to +4 instead. Sometimes, it's okay to blow out the sunset a little. After all, the sun is incredibly bright and people expect it to look that way.

Micro-smoothing was reduced from the normal setting of +10 to +3. This helped bring out more detail in the sky and clouds without increasing the noise too much. Lastly, Gamma was increased to 0.75 to brighten the image.

While the HDR was brightened using the gamma slider and detail was brought out, it doesn't mean that the final version needs to look that way. The tone-mapped image (see 6-20) is lighter than the final image (see 6-21) due to an increase in contrast in 6-21. It's better to make these adjustments in a dedicated image editor rather than Photomatix because you have more control over the end result. The nice reflective sculpture picks up on the deep blue sky behind the camera and the sunset makes for a lovely backdrop for this scene. One of the keys to this photo was finding something reflective to make it stand out.

ABOUT THIS PHOTO
Millennium Bridge in Southport, United Kingdom. Unprocessed HDR from three bracketed exposures at -2/0/+2 EV. (ISO 100, f/8.0, 1/80 second, Sigma 10-20mm f/4.0-5.6 at 10mm) © Pete Carr

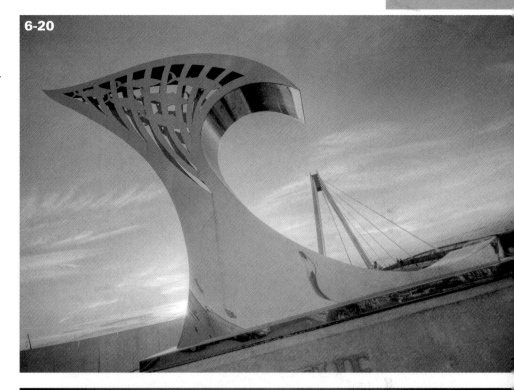

ABOUT THIS PHOTO
Millennium Bridge in Southport, United Kingdom. HDR from three bracketed exposures at -2/0/+2 EV. (ISO 100, f/8.0, 1/80 second, Sigma 10-20mm f/4.0-5.6 at 10mm) © Pete Carr

LINES AND ANGLES

There are various types of buildings that all sit differently in a landscape. Unique architectural styles include Georgian, Edwardian, modern, art deco, postmodern, Gothic, classical, Blobitecture, and deconstructivist, to name a few. The techniques you use (framing, distance, angle, time) can often be suggested by the style of the building you are photographing.

note Buildings are sometimes designed for the landscape around them. It's your job as a photographer to find the perfect angle to reflect this.

To begin analyzing a scene, look at the lines that make up the building. Some are straight and others are curved. Lines and the shapes they bound form powerful visual objects that must fit within the scene. Modern architecture can often be clean and minimal with lovely crisp lines. Use these lines to create interesting, abstract photographs that lead people around buildings, or to create beautifully composed photographs.

The lines that compose the buildings in 6-22 stand out clearly and lead you around the image. There is balance between the lower left and the upper right of the photo because it was composed with the Rule of Thirds in mind. There is also a

6-22

ABOUT THIS PHOTO *The lines of these shops in Liverpool lead you around the photo. HDR from five camera raw exposures bracketed at -2/-1/0/+1/+2 EV. (ISO 200, f/11, 1/160 second, Nikon 24-70 f/2.8 at 24mm) © Pete Carr*

sort of symmetry to the image. The empty sky contrasts with the detailed shape of the building on the bottom left. The edges of the building nicely frame the sky and help guide you from one building to the next. Carefully, well-placed elements make this sort of photo work. You can go for something abstract like this or something that shows off the entire building.

The image in 6-22 was produced using five standard bracketed exposures at -2/-1/0/+1/+2 EV. As usual, they were exported to Photomatix and the standard settings from Chapter 4 were applied. No major changes were needed for this image (it's great when tone mapping works this way). The Strength was reduced from 75

to 50 percent as the interior of the building came out looking a little too gritty for what was ultimately quite a clean, abstract photograph. Enough detail in the shadows and highlights was retained and, in the end, this is a major goal of HDR. The photo was later polished in Adobe Lightroom.

You may look at 6-22 and wonder if it really needed HDR. The sun is clearly shining on the building. How bad could the original scene have been? To be honest, it wasn't a bad scene to start with. The sun wasn't too high or too harsh. By comparing 6-22 to 6-23, you can clearly see that more detail has been brought out in the scene by bracketing and tone mapping the HDR image.

6-23

ABOUT THIS PHOTO *The lines of these shops in Liverpool lead you around the photo, 0 EV exposure. (ISO 200, f/11, 1/160 second, Nikon 24-70 f/2.8 at 24mm) © Pete Carr*

There is a lot more detail inside the building that wasn't very clear before. The orange cladding is softer and warmer, too.

Finally, the sky is much nicer in 6-22. Of course, you are comparing an unprocessed image to one that has been merged into an HDR image, tone mapped, and tweaked in Adobe Lightroom. There is going to be a noticeable difference between the two, just as there would be if you compared the unprocessed photograph to a processed non-HDR version. That said, you should be able to get an idea of how different HDR merging can make a photo. It has the potential to bring detail out of a scene that you simply might not be able to get from a single shot or RAW file editing.

USING THE SUN TO YOUR ADVANTAGE

Traditionally speaking, the best way to photograph a stunning building is to wait for the perfect light to strike it so that it shines and inspires you from every angle. This is true for traditional photography and it is also very true for HDR. Shooting in good light and with the right composition are the keys to getting good shots. The thing is, HDR lets you bend the rules a little. You can't shoot in bad light and badly compose your photos, but you don't always have to shoot in perfect conditions.

Take 6-24 for example. Shooting on the side of the building opposite the sun goes against most tried-and-true rules of photography. Normally,

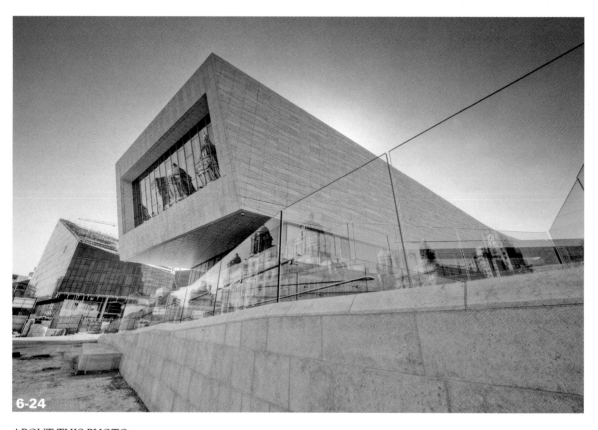

6-24

ABOUT THIS PHOTO *The Museum of Liverpool construction site. HDR from three raw exposures bracketed at -2/0/+2 EV. (ISO 100, f/5.0, 1/2000 second, Sigma 10-20mm f/4.0-5.6 at 10mm)* © Pete Carr

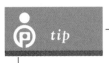

you would be around the corner, utilizing the amazing early morning sun shining on the building to capture amazing scenes.

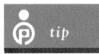

> *tip*
>
> Take some traditional shots first just to be safe and then start playing with the light.

In this example, the sun is backlighting the building, creating an interesting effect with the architecture. To achieve this, Pete used a very wide-angle lens and got close to the building so the sun was squarely behind it. The lens was a Nikon 14-24mm f/2.8 at 14mm on a full-frame sensor, so the shot is very wide. Using such wide angles allows you to get close to buildings while fitting a lot into the frame.

> *tip*
>
> Try to avoid standing too close to buildings and other structures as it can cause a fair bit of distortion.

Image 6-25 shows the issue you normally face. It's the +1 EV exposure picked out of the nine exposures bracketed for HDR. The building is nicely exposed, but to get enough light and detail from it, the sky is completely lost. Filters are an option, but they may cause the top of the building to be a little too dark compared with the rest.

Pete wanted to achieve a natural look without adding sky from another photograph in Photoshop (which is what a lot of commercial

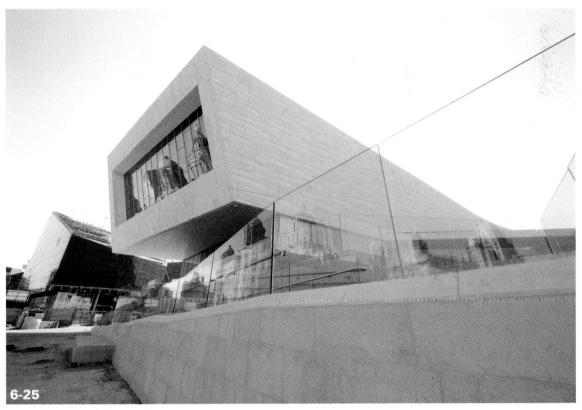

6-25

ABOUT THIS PHOTO *The Museum of Liverpool construction site. HDR from three raw exposures bracketed at -2/0/+2 EV. (ISO 100, f/5.0, 1/2000 second, Sigma 10-20mm f/4.0-5.6 at 10mm) © Pete Carr*

photographers do). In bad weather, using Photoshop to replace the sky may be the only option.

In this case, the standard settings for Photomatix Pro shown in Chapter 4 were used to get started. This produced a great result, but it had one key issue: the blue sky was quite dark around the edges and almost black at the extreme edges, which was unacceptable. To create a lovely soft blue gradient, the Strength slider was reduced from 75 to 50 percent. This cleared up the problem nicely.

If you find yourself faced with a situation in which the sky is quite dark or looks too heavily processed, see if reducing the Strength slider helps. Increasing the Luminosity to +10 certainly reduced the contrast in the image and that reduced the backlit glow from the sun. Although you may prefer that look, in this instance, the goal was to provide a hint of the sun backlighting the building for artistic effect.

When doing this style of HDR photography, you must remember not to process it so much that you cause massive haloes around the buildings. It's a common issue among HDR photographers. Quite often this is caused by setting Lighting Adjustments to Surreal+ and Luminosity to a negative number. Remember to keep those high.

URBAN CONSTRUCTION IN HDR

Construction is a great subject for HDR. While normal building photos focus on lines, angles, details, and composition, construction photos capture a scene in an unfinished state. Contrary to our normal experience, the focus is on visually interesting material, details, color, and exposed structures. Cranes and other construction gear often stand out, or are at odd angles to the rest of the scene.

Image 6-26 was taken in Liverpool at the largest (at the time) construction site in Europe. This is another great example of how to use HDR. It was an overcast day and the sun was behind the building. Metering for the sky resulted in the building being completely lost in shadow. Metering for the building resulted in the opposite effect — the sky was totally blown out and unusable (see 6-27).

HDR allows you to work around this problem and capture detail in shadow while not blowing out highlights. Three shots were taken, and at just the right moment the clouds broke and let the sun shine through, enhancing the sky. Everything — clouds, building, dirt, crane, pipes — benefited.

There are a variety of ways this photo could have turned out. The Luminosity and Strength settings could have been turned up to maximum to bring out all the detail in the clouds and create a dramatic hyper-real, almost painterly look to the image. Some people really like that look, but others heavily criticize it precisely because it looks so unreal. At the end of the day, it's up to you and what you are trying to say in your work that dictates how you process your photos. If you want a dramatic, hyper-realistic look, then increase the Luminosity and Strength while keeping Micro-smoothing low.

In this case, Pete went for a dramatic black-and-white look but didn't push it into the realm of hyper-realism. There's a gritty quality to the image in 6-26 and a nice dramatic sky overhead. Even the noise, which is sometimes an issue with HDR, falls nicely into place with the image being in black and white. This was achieved using the standard settings from Chapter 4.

ABOUT THIS PHOTO

The Liverpool One construction site, Liverpool. HDR from three raw exposures bracketed at -2/0/+2 EV. (ISO 100, f/5.0, 1/2000 second, Sigma 10-20mm f/4.0-5.6 at 10mm) © Pete Carr

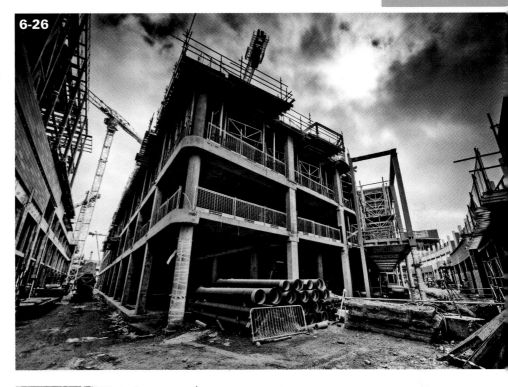

ABOUT THIS PHOTO

The Liverpool One construction site, Liverpool. This is the 0 EV exposure. (ISO 100, f/5.0, 1/2000 second, Sigma 10-20mm f/4.0-5.6 at 10mm) © Pete Carr

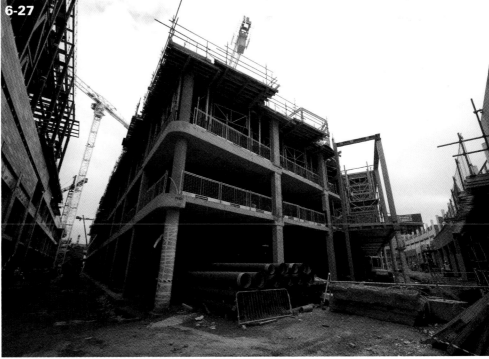

Notice the very bright area caused by the sun peaking through the clouds on the right side of the shot. The Luminosity was increased to try to correct this, but it didn't work. There was no extra detail to claw back from the area so the Luminosity setting was left at +5. It's good to try and see if you can get detail back in blown-out areas, but sometimes you just can't. After all, the sun is the brightest object you encounter in photography.

However, the last thing you should do is push processing too far when trying to recover detail. What happens is that white areas turn gray and look very strange indeed. Try your best to avoid this by bracketing more exposures or by reducing the processing so whites do not turn gray. If your image is in color, you may also be able to tweak the White Balance in a camera raw image (as you convert the RAW files to TIFFs) or Color Temperature in Photomatix Pro.

DEALING WITH CITY LIGHTS

One of the major problems you encounter in urban areas is the uncontrollable light sources, including streetlights, office and housing lights, car lights, and so on. Basically, if you shoot at night or dusk, you may find one or more buildings brighter than the rest. You may discover that the inside of one building is overexposed while the outside of another is overexposed due to flood-lights. This is sometimes a problem when taking long exposures at dusk while trying to capture that nice, deep blue sky. Situations like these can be deeply frustrating. During the day, you only have to worry about one light source.

Unfortunately, there's no "city lights" button in Photomatix to fix this. You have to play with the settings until it looks right to you, whether that means increasing the Luminosity to reduce the contrast in the image or adjusting the Gamma for the brightness — it's up to you. With 6-28, it took quite a while to find the right settings due to the complexity of the light sources.

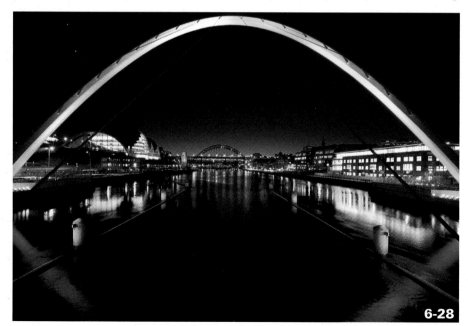

6-28

ABOUT THIS PHOTO
Millennium Bridge in Newcastle, United Kingdom. Single exposure at 0 EV. (ISO 800, f/11, 2.5 seconds, Nikon 14-24mm f/2.8 at 14mm) © Pete Carr

Like the Tower Bridge photograph earlier in the chapter (see 6-1), the blue light of dusk was fading too fast to show up nicely in one photo (although 6-28 does stand out as a study in contrast between a black sky and city lighting). Even if the light was perfect, the building on the right would have been overexposed because of its brightness.

Advances in camera raw editing mean you can potentially rescue the building on the right with the Recovery option and the addition of the Fill Light option to bring out the blue in the sky. However, this is not always a perfect solution because it increases the noise in the image. It's better to bracket at the scene to start with — you can't create new bracketed exposures when you get home. In most cases, you never know when

you might be back to a location. Even if you can return later, framing the shot identically or taking it at the exact same time is virtually impossible.

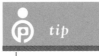

> **tip**
>
> It's best to get as much data as you can from a scene before leaving. Bracket it!

Once the images were loaded into Photomatix, the standard settings from Chapter 4 were applied. Right away, it was clear that these settings weren't working. While it did bring out more detail in the sky, it also brought out too much noise. The image was far too bright and oversaturated (see 6-29).

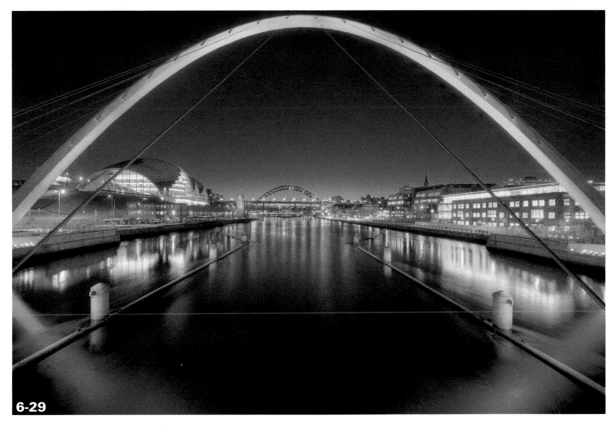

6-29

ABOUT THIS PHOTO *Millennium Bridge in Newcastle, United Kingdom. Tone-mapped from seven exposures at -3/-2/-1/0/+1/+2/+3 EV. (ISO 800, f/11, 2.5 seconds, Nikon 14-24mm f/2.8 at 14mm) © Pete Carr*

6-31

ABOUT THIS PHOTO *A barn in Indiana. Unprocessed 0 EV bracket. (ISO 50, f/8.0, 1/160 second, Canon A75 at 5.4mm, 35mm equivalent: 35mm) © Robert Correll*

The final, tone-mapped image is shown in 6-32. Here again, you can see general photography principles and HDR working together, no matter what model of camera is used. It should be obvious that this was taken during the evening golden hour. The light is hitting the barn directly from the side rather than the top, and that gorgeous light brings it to life. Shadows cast from trees to

the west fall on the surface of the barn, and create contrasting light and dark areas. Dramatic clouds are moving past, also lit from the side.

It's not perfect. The main problem here is that the clouds were moving fast enough between the manual brackets to be noticeable. When that happens, use the Photomatrix Pro Selective Deghosting routine in the Preprocessing Options to select and mark the moving clouds (see Chapter 5), which is

ABOUT THIS PHOTO *A barn in Indiana. HDR is, indeed, possible with a compact digital camera. HDR from five bracketed photos, -2/-1/0/+1/+2 EV. (ISO 50, f/8.0, 1/160 second, Canon A75 at 5.4mm, 35mm equivalent: 35mm) © Robert Correll*

what was done with 6-32. You may also find a better angle from which to shoot, so the clouds move toward you rather than across the frame.

The next example was taken with an old 5-megapixel camera with a Kodak Z740 zoom lens. Robert used Manual mode to take nine shots. Images 6-33 and 6-34 show the difference between two different bracketing combinations. Both were processed identically.

When using a compact digital camera, the more brackets, the better. If you can shoot a lot of brackets separated by a small EV difference, there will be less noise and more detail. The nine-bracket image (+/- 0.5 EV), 6-33, is clearly the better of the two. In this instance, three brackets separated by a large exposure difference (+/- 2 EV) bring out the worst in the smaller sensor, as you can see in 6-34, which is noticeably grittier and noisy.

6-33

ABOUT THIS PHOTO *Classic, small American church in the evening Golden Hour. HDR from nine exposures +/- 0.5 EV. (ISO 80, f/8.0, 1/180 second, Kodak Z740 at 6.3mm, 35mm equivalent: 38mm) © Robert Correll*

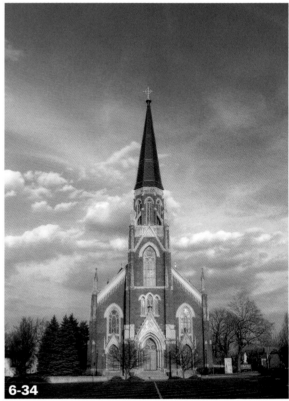

6-34

ABOUT THIS PHOTO *Classic, small American church in the evening Golden Hour. HDR from three exposures +/- 2 EV. (ISO 80, f/8.0, 1/180 second, Kodak Z740 at 6.3mm, 35mm equivalent: 38mm) © Robert Correll*

The tone mapping settings for this pair emphasized Lighting Adjustments, which was set to 8.1 and Micro-smoothing was raised to 14.3. This helped minimize cloud movement between frames by sort of smearing them together. Detail Contrast, however, was raised to 10 in order to make the clouds stand out from the rest of the sky.

To show you a direct comparison, neither 6-33 nor 6-34 has been processed after being tone mapped in Photomatix Pro. When zoomed out, 6-34 is nice and dramatic. However, 6-33 is smoother and has less noise. You could, in fact, use either of these images, and load them into Photoshop or Lightroom and finish them.

The final structure is Robert's favorite local suspension bridge. He photographed this series while it was under construction using an 8-megapixel compact. As is the case with most compact digital cameras, Robert had to get creative to set up for HDR. In this case, he used Program AE mode and the AEB feature to capture three brackets +/- 1 EV. This isn't ideal, of course, but it's better than nothing

Image 6-35 shows the unprocessed central bracket. It is a standard JPEG taken from the camera. It illustrates the classic exposure problem when shooting in the evening, especially toward the sun. The sun is not blown out and the sky is

well lit, but the foreground, bridge, and far bank are in shadow. It's not horrible, but not that memorable, either.

Compare it with 6-36, which is the finished HDR image. Tone mapping enhanced the color, vibrancy, brightness, contrast, and details of the photo, and — most importantly — without the telltale signs of overprocessing. Although many photographers think they can achieve results close to HDR using their camera raw processing skills, it is very hard to pull this off with JPEGs. There is very little room to work with as you push and pull exposure, contrast, and saturation of a JPEG. On the other hand, you can edit your

images far more effectively, even when using JPEGs as source images, if you tone map an HDR image.

In the examples involving the barn and the church, moving clouds presented a bit of a problem. If you must use a compact digital camera, try shooting on a calm day, or when clouds are either very high and distant or nonexistent. Stabilizing a compact digital camera on a tripod is necessary, but not a problem. However, operating the controls on a small camera — if it has any — can be harder than operating those on a larger dSLR, especially when you're in a hurry because the light is changing. Having to use a touch screen or

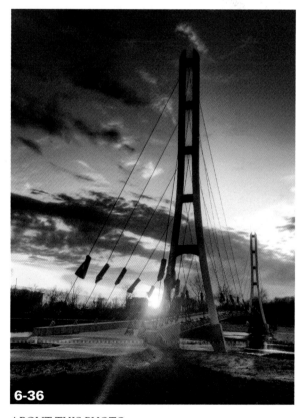

6-35

ABOUT THIS PHOTO *A footbridge under construction. A JPEG from the camera. (ISO 100, f/4.0, 1/200 second, Panasonic DMC-LZ8 at 5.2mm, 35mm equivalent: 32mm)* © Robert Correll

6-36

ABOUT THIS PHOTO *A footbridge under construction. Tone mapped from an HDR image. HDR from three bracketed photos at +/- 1 EV. (ISO 100, f/4.0, 1/200 second, Panasonic DMC-LZ8 at 5.2mm, 35mm equivalent: 32mm)* © Robert Correll

doing everything via the menu system jostles the camera and slows you down. Being unable to use a remote shutter release also contributes to some camera movement. In all of these cases, JPEGs are the only option. As such, camera raw editing is not possible, which limits white balance and other adjustments. However, you can make most corrections in Photomatix Pro or afterward in a photo editor with very little trouble. After you save the tone-mapped image as a 16-bit TIFF, you have much more room to work with than the original JPEG.

Although there are many practical and aesthetic reasons not to use compact digital cameras, it's very rewarding to be able to capture a scene using this type of gear, not to mention the fact that it's easier to get into and costs less. It's the perfect solution to introduce HDR to anyone who's interested. You can capture your own brackets and get used to using the same software as a professional photographer with a $2,500 camera. If you want more flexibility and quality, you should, of course, progress to using a dSLR. However, you don't have to have the best, most expensive gear to create something beautiful.

Assignment

Shoot at Dusk

Find a structure or building worth photographing and shoot it at dusk. Make it interesting. It can be new, old, classical, Gothic, minimal, avant-garde, or any other style that captures your attention. It can even be under construction or in the process of being removed. Find an interesting angle that tells a story. It could be about depth, height, angles, texture, or color.

The catch is to capture the scene without blowing the highlights due to tricky city lighting.

Pete shot this photo of the Liver Building in Liverpool, on a beautiful summer evening. HDR processing brought out details in the sunset and controlled the city lights with the Luminosity slider. There is a fantastic amount to look at in this image. HDR created from five camera raw exposures bracketed at -2/-1/0/+1/+2 EV. Taken at ISO 200, f/22, 5 seconds, Nikon 14-24 f/2.8 at 16mm.

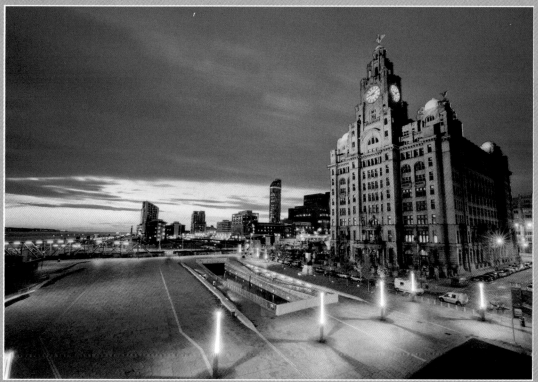

© Pete Carr

 Remember to visit www.pwassignments.com after you complete this assignment and share your favorite photo! It's a community of enthusiastic photographers and a great place to view what other readers have created. You can also post comments, read encouraging suggestions, and get feedback.

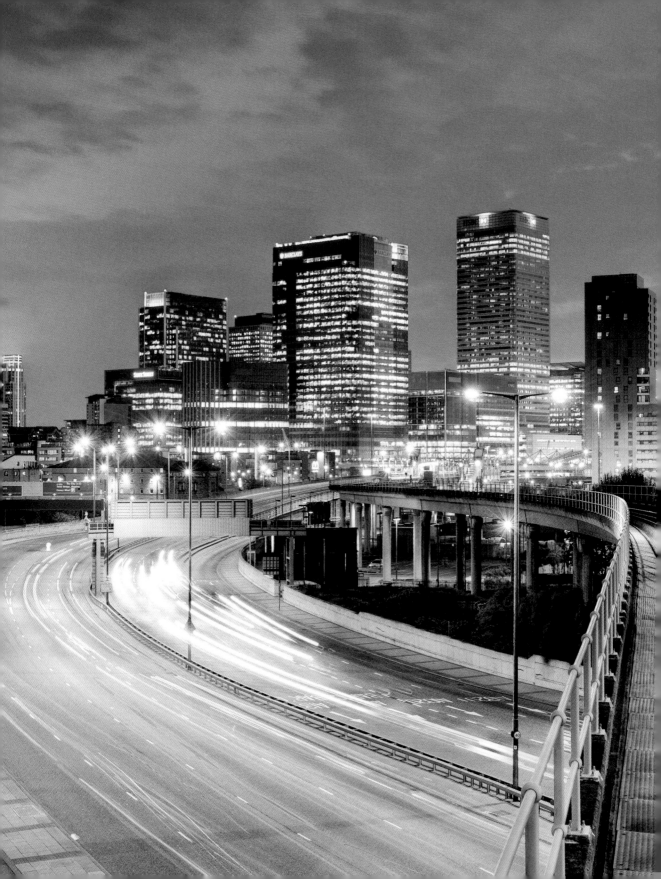

THE WIDER PICTURE

FINDING THE RIGHT VANTAGE POINT

© Pete Carr

When you photograph buildings and other structures, your focus is on the immediate object at hand, including the surroundings that you might include in the frame. When photographing cityscapes, on the other hand, your focus is on a collection of buildings and other objects that blend together to create something larger than any one structure.

Photographing cityscapes and processing the results as HDR is a different proposition than working with a single building, or detail of a building. Instead of zeroing in on the materials and details of a specific building, you are looking at how many buildings sit together to form a cohesive, or perhaps disjointed, whole. The scope is much larger and your techniques shift to take this into account. Many of these techniques are the same as those found in landscape photography.

THE WIDER PICTURE

A good wide-angle lens is indispensible when shooting cityscapes. Wide-angle lenses work wonders with cityscapes because you can fit so much more in every photo than you can with an everyday zoom lens — the sky, buildings, streets, the city — everything you need and then some.

Pay attention to "and then some." You may be tempted to include too much in a scene. Ease off on the field of view if you find yourself constantly cropping your photos to improve their composition.

CORRECTING DISTORTION AND PERSPECTIVE

One drawback of wide-angle lenses is that they are particularly prone to barrel or mustache distortion, and cityscapes and buildings are keen on showing even small amounts of perspective problems.

Distortion is the fault of the lens. Lines that should be straight aren't. They can bulge out from the center (barrel distortion), push inward at the center (pincushion distortion), or be a combination of barrel distortion at the center and pincushion distortion near the edges of the photo (mustache distortion). The way to deal with lens distortion is to either ignore it (a quite acceptable option given that most subjects hide much of it) or correct it in Photoshop or Photoshop Elements.

Perspective problems are caused by the photographer. Lines that should be vertical or horizontal aren't. Vertical perspective problems are caused by tilting the camera up or down. This causes buildings to lean away or toward you, respectively. When you look at a cityscape, this can often be a problem. Horizontal perspective problems arise when lines that should be horizontal lean to the left or right. This is caused by approaching the lines from an oblique angle instead of head-on. Horizontal distortion is a less obvious problem when shooting cityscapes.

To prevent buildings from tilting toward or away from you, move farther away from the building and zoom in. Alternatively, you can try and get higher up so you are face to face with the building. This way you don't have to point the camera up at the building. You can use the Lens Distortion filter to correct this in Photoshop Elements, but you may also want to leave some distortion in as an artistic effect. Removing horizontal or vertical perspective sacrifices part of the image and can create other distortion in the process.

For example, the cityscape photo of Liverpool in 7-1 reveals a particularly dramatic evening but has a serious vertical perspective problem. It was shot with an ultrawide-angle lens in order to capture more than a single building, as well as the

7-1

ABOUT THIS PHOTO *The Liver Building with Liverpool in the background. (ISO 100, f/11, 1/13 second, Sigma 10-20mm f/4-5.6 at 10mm)* © Pete Carr

bold colors in the sky and the fantastic clouds. It would have been impossible to capture this scene without an ultrawide-angle lens. Notice the composition and light. Even though the center of attention is on the Liver building on the right, the sky prominently shows off the clouds while the setting sun bathes the skyline in golden light.

You can see the vertical perspective issue quite clearly, as the Liver building is leaning badly to the left. This was caused by pointing the camera up at the building and sky.

 x-ref

See Chapter 2 for more information on lenses in general and wide-angle lenses in particular.

To correct perspective problems in photos like this, always start with the HDR process and apply other processing afterwards. Among other benefits, this saves time. It's possible to make the corrections to each bracket before loading them into Photomatix Pro, but you have to do this at least

three times. If you bracket nine exposures, you have to make the changes nine times. If you make these changes after HDR processing, you only have to do it once. Remember, HDR first and then correct for lens distortion and perspective problems — that's the key.

Starting with the settings from Chapter 4, this image was brightened a little by adjusting the Gamma from 0.9 to 0.75. Strength was reduced from 75 to 50 percent so that the sky wouldn't be too dark around the edges. Finally, Saturation was reduced from 50 to 40 percent because of the intense sunlight. That's not a huge amount, but

enough to reduce the heavy orange tint in the photo. Everything else was kept the same. The photo with the standard settings applied is shown in 7-2.

If you want a more dramatic look, you can reduce the Micro-smoothing to 0 and fine-tune the Strength until you get the desired effect. Remember not to automatically max it to 100 percent. Find the look that gets your message across. In 7-3, Strength was set to 60 percent. By comparison, 7-2 has a more natural look. You could say that 7-2 has been processed simply to get around issues with the camera's sensor, while

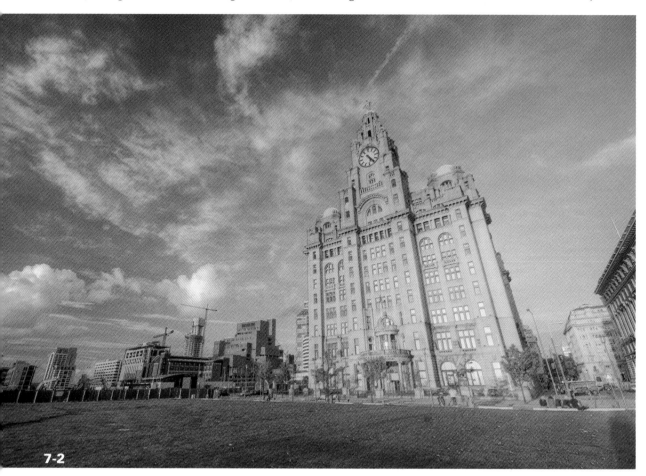

7-2

ABOUT THIS PHOTO *The Liver Building with Liverpool in the background. HDR from three camera raw exposures, -2/0/+2 EV. (ISO 100, f/11, 1/13 second, Sigma 10-20mm f/4-5.6 at 10mm) © Pete Carr*

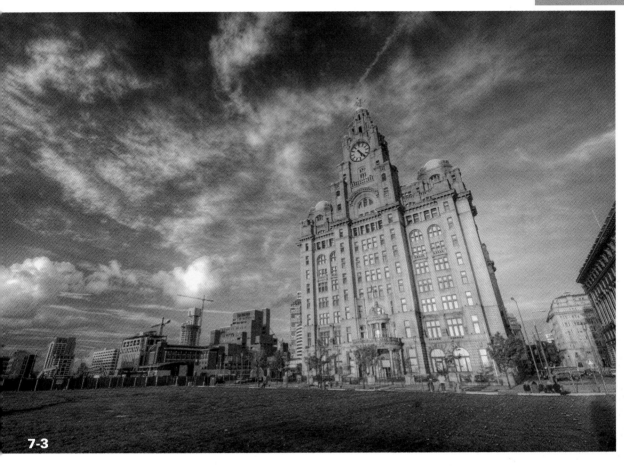

7-3

ABOUT THIS PHOTO *The Liver Building with Liverpool in the background. HDR from three camera raw exposures, -2/0/+2 EV, with Micro-smoothing reduced. (ISO 100, f/11, 1/13 second, Sigma 10-20mm f/4-5.6 at 10mm) © Pete Carr*

7-3 has been processed for the look. Image 7-3 is grittier, more dramatic, and also has more detail in the clouds around the buildings. As usual, you decide which settings you like based on the effect you're after, whether that's realistic or artistic.

The next step is to finalize the image in another image editor. In this case, the levels and curves were adjusted to add contrast back into the image. HDR is great for bringing out detail but sometimes flattens the contrast of the image too much. If you want to add punch back into your image, increase the contrast after tone mapping.

This is the dilemma of Lighting Adjustments during tone mapping. Lighting Adjustments keeps the image looking more realistic, but reduces contrast. Lowering Lighting Adjustments increases the contrast but tends to produce unrealistic (or artistic) results. If you want a more realistic final result with good contrast (people do expect shadows where there should be shadows, after all), the best method is to add it after tone mapping. If you're after something more artistic, you can lower the Lighting Adjustments in Photomatix and enjoy the effect.

The result is shown in 7-4. It's a nice, natural-looking tone-mapped image with a decent amount of contrast and punch to give it some wow factor. Detail was brought out in the grass, which was in shadow in 7-1. Detail has also been brought out of the sides of some buildings. It's not something that was obviously wrong with the original exposure, but it's nice to be able to use HDR to bring out clean, noise-free detail in the shadows.

With the tone mapping finished and other editing completed, finish the image by fixing distortion and perspective problems. Adobe Photoshop, Photoshop Elements, and Lightroom all have good lens-correction tools. At first glance (see 7-5), they may seem complicated. However, if you keep the types of distortion and perspective correction in mind, you'll be breezing through this dialog box in no time.

The first thing to do is adjust the Remove Distortion slider. Increasing it removes barrel distortion and sucks the image inward. Decreasing it does the opposite, which corrects for pincushion distortion. In this instance, the slider was set to -5. To help remove the leaning issue the vertical slider was decreased almost to 100 percent and set to 85 percent. This tilts the image along the vertical plane.

Afterward, you need to crop the image because these adjustments create a sort of trapezium-shaped image — it is wider at one end. After the crop and save, the result is shown in 7-6. You can see that you do have to crop a fair bit when reducing lens distortion. This is a little annoying, but if the image really needs the distortion to be removed then it is worth doing.

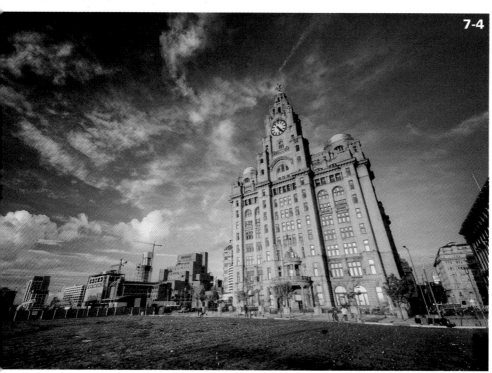

7-4

ABOUT THIS PHOTO
The Liver Building with Liverpool in the background. HDR from three camera raw exposures, -2/0/+2 EV, with Micro-smoothing reduced to bring out contrast. (ISO 100, f/11, 1/13 second, Sigma 10-20mm f/4-5.6 at 10mm) © Pete Carr

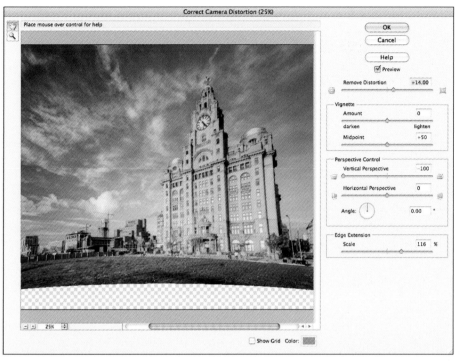

ABOUT THIS FIGURE
The lens distortion correction tool in Photoshop Elements. Image © Pete Carr

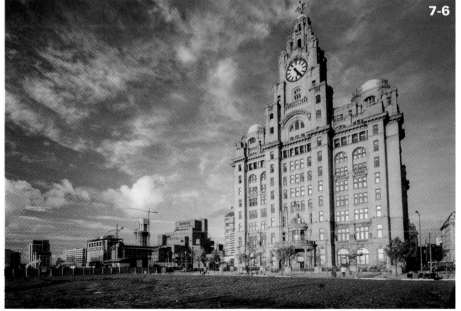

7-6

ABOUT THIS PHOTO
The Liver Building, Liverpool. The final image with lens distortion corrected. HDR from three camera raw exposures, -2/0/+2 EV. (ISO 100, f/11, 1/13 second, Sigma 10-20mm f/4-5.6 at 10mm) © Pete Carr

REPLACING FILTERS WITH BRACKETS

Traditional landscape photographers use filters to get around the dynamic range issue. They might use one or more ND graduated filters in front of the lens, in order to get the foreground and sky correctly exposed. This is great for getting long exposures at sunset to create those photos of lovely, wispy, smoky smooth seas. Landscape photographers doing these types of shots have an advantage over cityscape photographers. Landscape horizons tend to be straighter than cityscapes. If you have a lovely sunset over the horizon and a nice sea gently washing up against some rocks, you can easily compose the shot using a filter to darken the top half of the horizon, allowing you to get a longer exposure on the bottom half.

For cityscape photographers, there are many times when you simply cannot do this. If you are shooting a relatively flat skyline and a sunset then you might be able to use filters to your advantage. However, if you are in the middle of a collection of tall buildings, all of them jutting out at varying heights, then you probably won't be able to use a filter. The problem is that it wouldn't just darken the sky; it would also darken the tops of the buildings. You need something else to give you the extra dynamic range you need that won't darken the tops of the buildings.

That something is HDR. Bracket for the buildings and the sky using multiple exposures and merge them into HDR in Photomatix. Shoot three or more exposures: One for the sky (-2 EV), one for the buildings (+2 EV), and one in the middle (0 EV) to smooth the transition.

Image 7-7 perfectly shows this issue. The building on the left (Tower Building in Liverpool) is very brightly lit by a sunset, while the one on the right (the Liver Building) is in shadow. The sky isn't too badly exposed, but it could be better. The light was fading fast and with no filters or tripod available, the only option was to shoot handheld

7-7

ABOUT THIS PHOTO
The 0 EV exposure of the Liverpool cityscape. (ISO 100, f/6.3, 1/80 second, Sigma 10-20mm f/4-5.6 at 10mm) © Pete Carr

exposure brackets at 5 frames per second. Remember that in order to shoot handheld HDR, you need a camera that can shoot quickly (5 frames per second is a reasonable, practical minimum for handheld HDR).

You can see why you need to take at least three exposures in situations like this. Image 7-7 was shot at 0 EV, 7-8 at -2 EV, and 7-9 at

7-8

ABOUT THIS PHOTO
The -2 EV exposure of the Liverpool cityscape. (ISO 100, f/6.3, 1/80 second, Sigma 10-20mm f/4-5.6 at 10mm)
© Pete Carr

7-9

ABOUT THIS PHOTO
The +2 EV exposure of the Liverpool cityscape. (ISO 100, f/6.3, 1/80 second, Sigma 10-20mm f/4-5.6 at 10mm)
© Pete Carr

+2 EV. Taking more shots helps reduce noise, and smooth the transition between light and dark.

These photos were merged into HDR in Photomatix and the standard settings from Chapter 4 were used as the initial tone-mapping starting point. The reason to start here is that these settings tend to produce a clean, well-balanced photo that is suitable for further processing. However, you may want to do a little more with Photomatix before taking it to the next step. For example, Micro-smoothing was reduced from +10 to +3 in this case to increase the detail in the shot, mostly the sky. Pushing the Luminosity up from +5 to +10 helped compress the tones of the image, causing more detail to come out in the traffic lights. Other than that, no settings were changed.

The final result is shown in 7-10. The sky is more detailed, the building on the left is still brighter than most, but not to an excessive degree, and there is more detail in the building on the right. The image packs a punch without blowing any highlights and looks great. No filters or tripod were necessary — just great light and a great city to photograph by shooting handheld exposure brackets and processing the scene as an HDR image.

7-10

> **note** Great light and subjects are the key elements to getting good photographs, whether you use HDR or not. HDR expands the envelope in which you can shoot and gives you a flexible platform to express yourself, either realistically or artistically.

This example shows what you can achieve from a scene like this with HDR. Keep your eyes peeled for moments like the one captured in 7-10. You may not have a tripod with you, and you may not have filters in your bag, but you still might be able to create an extraordinary image with HDR.

ABOUT THIS PHOTO *The final HDR image of the Liverpool cityscape. HDR from three camera raw exposures, -2/0/+2. (ISO 100, f/6.3, 1/80 second, Sigma 10-20mm f/4-5.6 at 10mm)* © Pete Carr

FINDING THE RIGHT VANTAGE POINT

If the key to getting a great cityscape shot in HDR is great light and a great view, the real question is how do you find that? What should you look for?

These can be difficult questions to answer, because much of photography is about showing the world what you find interesting. Obviously, in order to do that, you have to know what you find interesting. What elements do you want to show people? Take the time to think through your answers. Round them up from the area of your brain that is a primitive, instinctual artist and examine them so you can take compelling photos on purpose. Taking prize-winning photos by accident is one thing, but being able to repeat it is far more rewarding.

So, as you are walking around a city, take time to stop and look around. If something catches your eye, it probably did so for a reason. How can you use that to your advantage? If the light isn't great at the time, make a note of the location and come back when it is.

LEADING LINES

While photography may be, in part, a personal adventure or a way of showing the world the things you find interesting, there are elements for which you should be on the lookout. As discussed in Chapter 5, leading lines are important, and they can easily be applied to cityscapes because buildings are filled with angles and lines. Leading lines can literally lead you through an image toward something else, like a stunning sunset or another bit of architecture. Streets are a perfect example of leading lines. Look for a street that leads your eyes toward something else interesting.

Don't forget to compose your photos using the Rule of Thirds, but also don't be afraid to try and break the rules.

The example shown in 7-11 is of Toronto City Hall. In this case (as in many others), leading lines direct you to the real subject of the image. The road on the right takes you up into the image and then to the left to Toronto City Hall.

The image, which is straight out of the camera, lacks impact. The sky is bland and the buildings are underexposed. The weather wasn't the greatest, but because this photo was taken during a holiday in Toronto, it was the best (and only) opportunity to get the shot. It is annoying when that happens, of course, but not a completely wasted photo opportunity, especially if you use HDR.

This is another handheld example. Three bracketed photos were taken at -2/0/+2 EV. This was a brief trip around the city and there was no time for a tripod. Thankfully, the camera was quick and Photomatix Pro does a fantastic job of aligning images.

The tone-mapped image is shown in 7-12. This, again, is the result of using the standard settings from Chapter 4 in Photomatix Pro. The photo looks much better because the sky is more detailed and the buildings are now better exposed. It's also a more interesting photo, which is good, but it's still not quite finished. Remember that Photomatix isn't the end of your image processing — it is but a step along the way.

> **note** It's good to get things looking right in Photomatix Pro, even if you plan on continuing with your edits afterward. Photomatix is unique in that it has options for adjusting images that other editors do not.

ABOUT THIS PHOTO
Toronto City Hall. Single 0 EV exposure. (ISO 100, f/8.0, 1/320 second, Sigma 10-20mm f/4-5.6 at 10mm) © Pete Carr

ABOUT THIS PHOTO
Toronto City Hall. HDR from three camera raw exposures, -2/0/+2 EV. (ISO 100, f/8.0, 1/320 second, Sigma 10-20mm f/4-5.6 at 10mm) © Pete Carr

The final image is shown in 7-13. Although there is not an immense amount of detail in the clouds, there is enough. The style of this image doesn't require overly dramatic clouds. Realize, though, the benefits of processing these brackets into HDR and producing a tone-mapped result. If this style of processing had been applied to the original 0 EV exposure, there would be no clouds in the image — they would be completely blown out. Sometimes you need HDR just to give you that extra amount of detail, so when you process the image further, you won't lose too much of it.

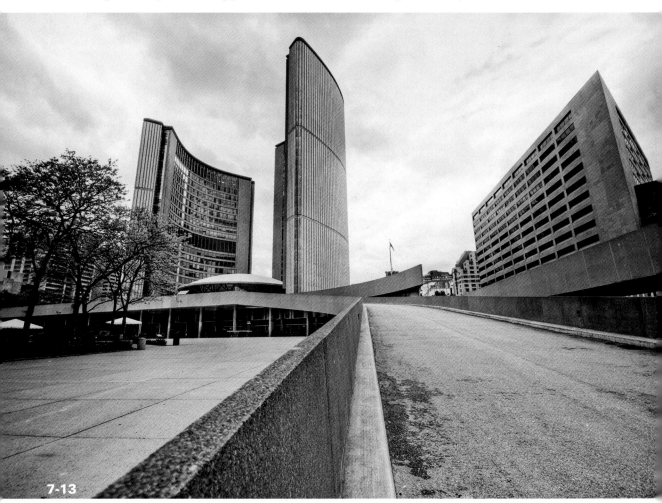

7-13

ABOUT THIS PHOTO *Final processed image of Toronto City Hall. HDR from three camera raw exposures, -2/0/+2 EV. (ISO 100, f/8.0, 1/320 second, Sigma 10-20mm f/4-5.6 at 10mm)* © *Pete Carr*

REFLECTIONS

Another great vantage point is by the side of a lake or dock. These areas produce great reflections that allow you to produce stunning symmetrical photographs of cityscapes. Find a reflecting location where the sunset or sunrise reflects in the water toward you. The colors in this type of photo are stunning and you get double the usual amount due to the reflection. Remember to compose with the Rule of Thirds, at least as a starting point.

Image 7-14 of Canning Dock in Liverpool illustrates this concept perfectly. As a cityscape, it combines elements of a beautiful sunset, dramatic sky, still water, and picturesque buildings in a dramatic fashion. Unfortunately, the camera wasn't able to pick up all those details and combine them into one photo. The original scene was far more intense and dramatic than it seems in the photo, and that's the problem with digital sensors and dynamic range at the moment.

Until digital cameras have the dynamic range to include all of these details in one exposure (and they are getting better), you must use techniques like HDR to properly capture the scene. Image 7-14 shows the original 0 EV exposure. It is a fairly standard sunset image. The camera produces a nice silhouetted cityscape by metering for the sun. There are lovely silhouettes and colors in the clouds. However, the details have been lost in the rest of the scene.

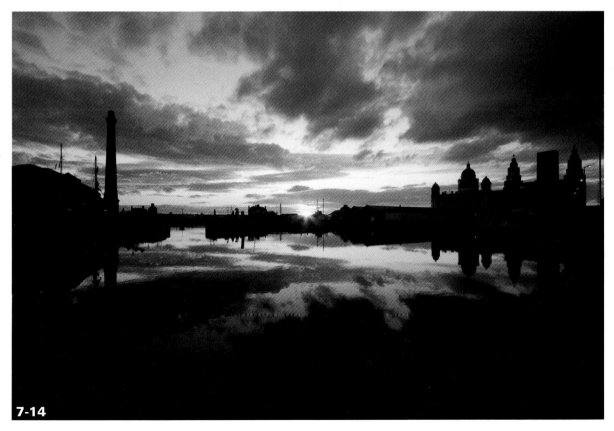

7-14

ABOUT THIS PHOTO *Canning Dock, Liverpool. Single 0 EV exposure. (ISO 400, f/9.0, 1/100 second, Sigma 10-20mm f/4-5.6 at 10mm) © Pete Carr*

Of course, exposure brackets bring out different details in different parts of the scene. Image 7-15, the -2 EV exposure, is so important because to get the detail in 7-16, the sky has been blown out. Three exposures are ideally required — two to capture either end of the spectrum and one to bridge them both (-2 EV, +2 EV, and 0 EV).

The result of tone mapping the HDR image with the standard settings from Chapter 4 is shown in 7-17. There are plenty of details in the clouds, the reflection, and the buildings. It's a huge contrast to 7-14, which has blown highlights and very dark shadow areas. This is the great thing about HDR. Shoot three quick photos at the scene and, after a bit of processing, you get amazing results.

7-15

ABOUT THIS PHOTO *Canning Dock, Liverpool. The -2 EV exposure. (ISO 400, f/9.0, 1/500 second, Sigma 10-20mm f/4-5.6 at 10mm)*
© *Pete Carr*

ABOUT THIS PHOTO *Canning Dock, Liverpool. The +2 EV exposure. (ISO 400, f/9.0, 1/25 second, Sigma 10-20mm f/4-5.6 at 10mm) © Pete Carr*

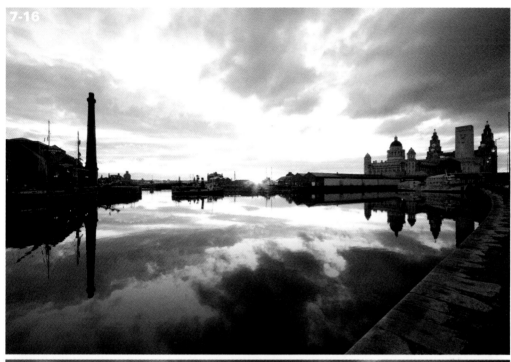

7-16

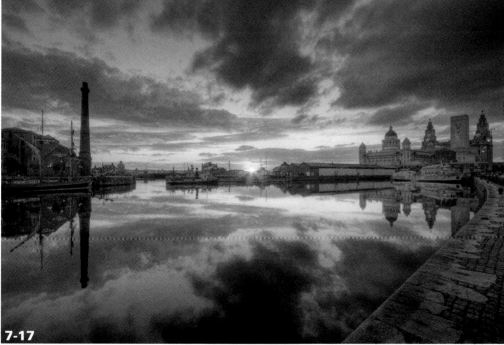

7-17

ABOUT THIS PHOTO *Initial HDR of Canning Dock, Liverpool. HDR from three camera raw exposures, -2/0/+2 EV. (ISO 400, f/9.0, 1/100 second, Sigma 10-20mm f/4-5.6 at 10mm) © Pete Carr*

There is a reason why the images produced by your camera are aesthetically appealing. They strike a chord with the viewer. Simply put, they look pretty. So while HDR gives you the ability to extract all the detail you need from a scene, it doesn't mean you need it all. Even though the image in 7-18 is a nice example of HDR with a lot of detail, it doesn't look completely right. It seems unnatural because it's too light for a sunset.

To correct the brightness problem, the image was darkened in Photoshop and the contrast was increased to give it a punchy feel. Image 7-19 looks more like a proper sunset. It is darker, moodier, more dramatic, yet with just enough detail in the buildings to allow you to see them. This gives you the best of both worlds. Detail, drama, atmosphere, mood — they all make for a stunning cityscape.

7-18

ABOUT THIS PHOTO *Processed image of Canning Dock, Liverpool. HDR from three camera raw exposures, -2/0/+2 EV. (ISO 400, f/9.0, 1/100 second, Sigma 10-20mm f/4-5.6 at 10mm)* © Pete Carr

7-19

ABOUT THIS PHOTO *Final processed image of Canning Dock, Liverpool. HDR from three camera raw exposures, -2/0/+2 EV. (ISO 400, f/9.0, 1/100 second, Sigma 10-20mm f/4-5.6 at 10mm)* © Pete Carr

note

Get the balance right between light and dark, detail and smoothness, or your photos will look unrealistic and people won't accept them.

FINDING ANGLES

You never know what a city looks like from different angles until you get out and travel around. Drive, walk, or ride around the city you plan to

photograph. Experiment with different shots from different distances and angles. Although it's the same city, you will surely find that each angle evokes a different feeling. What's more, you don't have to process everything the same way. You may, of course, especially if you're building a portfolio and want the photos to be in the same style. But you can also have fun and really shake things up.

Image 7-20 illustrates a serene winter scene in Fort Wayne, Indiana. Three bracketed exposures were taken from a bridge over the frozen river, looking southwest during the Golden Hour. The skyline is apparent, although it doesn't dominate this photo.

7-20

ABOUT THIS PHOTO *A wintry scene in Fort Wayne, Indiana. HDR from three camera raw exposures at -2/0/+2 EV. (ISO 100, f/8.0, 1/125 second, Sigma 10-20mm f/4-5.6 at 10mm) © Robert Correll*

The brackets were processed using the standard tone-mapping settings from Chapter 4 in order to minimize drama and emphasize the calm and quiet. A few settings were changed — Luminosity was lowered to 0 to smooth the photo and Gamma was set to 0.7 to brighten things up. Finally, the Temperature was lowered to -2 to bring out the blue in the sky and water.

On the other hand, 7-21 is an HDR image of the same town, but from a different angle and processed differently to evoke different feelings. Not all cities have been planned out with a strong sense of aesthetics. In fact, many are downright messy — poles, power lines, billboards, and other haphazard signs of civilization spring up seemingly randomly. Buildings — some pretty, some ugly — sit in front of each other, blocking the view. The idea for this shot (realized after processing it more or less normally) was to emphasize the grittiness of the skyline and then put it over the top by replicating a tilt-shift lens effect.

This was done in 7-22, using much more dramatic settings in Photomatix Pro than those presented in Chapter 4. Strength was set to 100 percent, Color Saturation at 80, Luminosity at 19, and Detail Contrast at 7.7. Lighting Adjustments was lowered to 4.4. The White Point was raised and the Black Point lowered. The Temperature was lowered to -1.5 and Micro-smoothing set to 2.

7-21

ABOUT THIS PHOTO *A crazy, tilt-shift scene of Fort Wayne, Indiana. HDR from three camera raw exposures at -0.7/0/+0.7 EV. (ISO 100, f/8.0, 1/80 second, Sigma 10-20mm f/4-5.6 at 20mm) © Robert Correll*

To create the even crazier tilt-shift effect shown in 7-22, a lens blur was applied to the upper and lower reaches of the photo and the saturation and contrast were both increased. Finally, the photo was cropped to achieve a more concentrated focus.

SHOOTING HIGH

Two great ways to show off a city are to shoot from up high and down low. Shooting from a high vantage point gives you a unique and fresh perspective of a city, while shooting from ground level can show the scale and height of a city. They both have their own distinct look and unique way of telling a story about the city you are in.

7-22

ABOUT THIS PHOTO *Fort Wayne, Indiana. The initial, dramatically tone-mapped image. HDR from three camera raw exposures at -0.7/0/+0.7 EV. (ISO 100, f/8.0, 1/80 second, Sigma 10-20mm f/4-5.6 at 20mm) © Robert Correll*

Shooting from up high and looking down on a city is a tricky thing to do because getting access to good locations from which to shoot can be challenging (although, you might be able to rent a helicopter or ride in an airplane). Some cities have great vantage spots, like the Empire State Building in New York, the CN Tower in Toronto, and the London Eye in London. All of these provide fantastic views and epic cityscapes for you to capture.

Whether you can take a tripod and set up to shoot stabilized brackets is another question though. You may need to hold your breath and shoot a handheld set of exposures, or perhaps invest in a GorillaPod (see Chapter 2) which would be small enough to mount on a railing.

 caution Know the applicable laws and restrictions wherever you plan to shoot and, for your own good, follow them.

If you can find a great vantage point from which to shoot, take a good look around. Soak in the city and decide what you want to show. Remember that sometimes you can have too wide a field of view. On an overcast day, a photo that is 65 percent cloudy sky and 35 percent ultrawide cityscape might not look that great. Try reversing that ratio. However, on a stunning evening with a fantastic sunset filling the sky, a 65/35 split might be perfect. Think of the Rule of Thirds as you compose the shot and place the most interesting elements of the scene in the dominant field of view. If it's not working due to the clouds, the sky, the light, or some other factor, shoot anyway. Examine your shots later and see what you have. If necessary, go back another day when the scene is more striking.

For example, 7-23 shows a nice view over Liverpool. It was shot at 10mm on a cropped sensor, so it's a very wide photograph. However, it doesn't feel too wide due to the proximity of the buildings. In other words, it's not a thin strip of a skyline among gray clouds. There's a decent collection of buildings in the photo and there's also a decent enough sky over the cityscape so that it complements the buildings instead of drawing the attention away. It's a nicely balanced cityscape of about 50 percent city and 50 percent sky.

It wasn't really possible to have less sky and more city in this image as composing the scene differently resulted in an unrealistic, distorted look. Shooting head-on provided the best shot of the buildings with a minimum amount of distortion or perspective problems. This is one of the advantages of shooting from higher up. Perspective problems are reduced because you are face to face with the city, rather than looking up from down below.

Image 7-23 is the 0 EV exposure straight out of the camera. It's not a bad shot and could probably be quite nice without HDR. However, HDR can bring out more detail in the clouds and shadow areas around the buildings to create a more dramatic image. Not every image needs a big heavy dramatic look, and this won't be pushed too far, but the sky looks like it would be good for adding a bit of drama. The park area looks to be about 2 stops underexposed, but compensating for that causes the sky to be at least 2 stops overexposed. This is why exposure brackets and HDR work so well.

The standard settings from Chapter 4 were again applied in Photomatix Pro. This immediately produced a more balanced set of tones. However, the image was a bit dark overall, so the Gamma was adjusted from 0.9 to 0.6 to brighten the photo. The park area was brighter without losing

7-23

detail in the sky. For some reason, the reds in the image were very saturated, so the shadows saturation was reduced by -2.0. Don't overdo that setting, as it may affect more of the image than you want. Luminosity was reduced from +5 to 0 to add a touch of contrast back into the image. The tones were compressed at the original setting and looked too flat.

Watch out for situations like this, and don't be afraid to dial back the Luminosity. If you go too far (close to -10) you may end up with an image no different from your original 0 EV exposure.

The result is shown in 7-24. When, compared to the original 0 EV exposure (see 7-23), the changes are easy to see. The park is brighter without losing detail in the sky. The final polished version can be seen in 7-25. It's a clean, noise-free image from three bracketed exposures. To top it off, the brackets were taken without a tripod. The fact that it lines up so perfectly is a testament to how good Photomatix Pro is for aligning images.

ABOUT THIS PHOTO
Initial HDR of Liverpool One, Liverpool. HDR from three camera raw exposures, -2/0/+2 EV. (ISO 100, f/6.3, 1/800 second, Sigma 10-20mm f/4-5.6 at 10mm) © Pete Carr

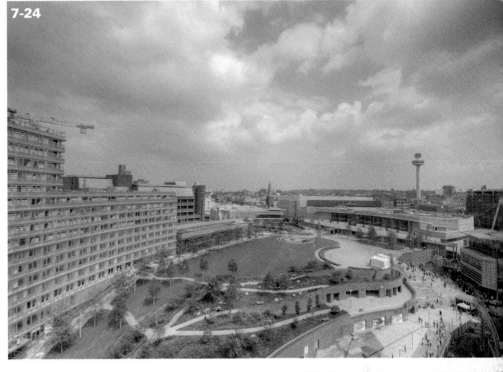

ABOUT THIS PHOTO
Final processed image of Liverpool One, Liverpool. (ISO 100, f/6.3, 1/800 second, Sigma 10-20mm f/4-5.6 at 10mm) © Pete Carr

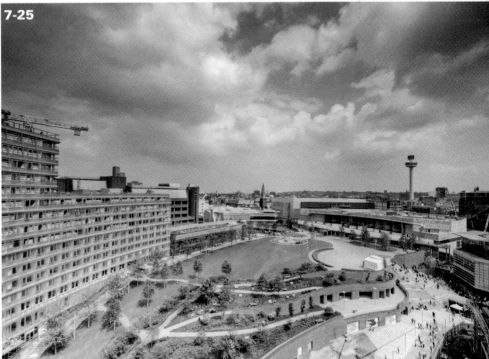

If you want to push things further, start by reducing the Micro-smoothing and increasing the Strength. Image 7-26 shows the result of increasing the Strength to +100 and reducing the Micro-smoothing to 0. Otherwise, the same processing used on 7-25 was applied.

There are a number of issues with 7-26. The key thing to remember is not to push the sliders to the maximum. Find a balance somewhere between 7-25 and 7-26 if you want a more dramatic image. The clouds here look more dramatic and detailed, but there are a number of random darker areas in the image. The top-right, top–left, and bottom-right corners in particular are all very

dark while, oddly the bottom left is fine. No vignette has been applied and there doesn't appear to be any pattern to the darker areas. There's another large one just to the right of the middle covering the building.

This is the kind of thing you want to avoid in your images. It is more dramatic, yes, but also more problematic, and it doesn't exactly represent the scene as it is. Even from a fine-art perspective, this is perhaps a bit too overprocessed. A better option would be to set Micro-smoothing to +2 and leave the Strength between 75 and 80 percent. This would give you a more dramatic look without over-processing.

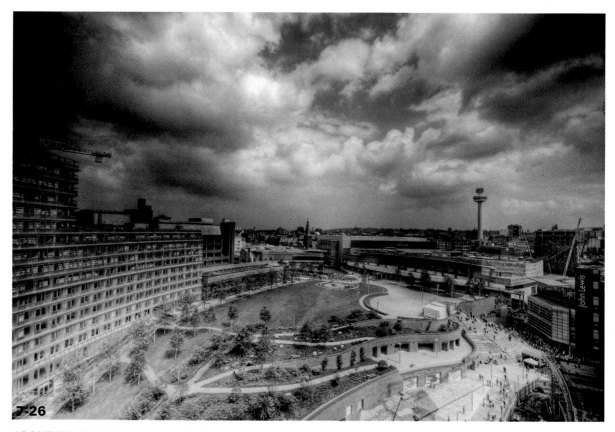

ABOUT THIS PHOTO *Overprocessed image of Liverpool One, Liverpool. (ISO 100, f/6.3, 1/800 second, Sigma 10-20mm f/4-5.6 at 10mm) © Pete Carr*

SHOOTING LOW

The easiest, most accessible way to photograph a cityscape is from the ground. There are many ways to shoot a city from this angle. You can get up close to the buildings, as shown previously in 7-10, which makes them look larger than life. They command a presence on the street and tower over the general public in the photo. Alternatively, you can find a vantage point away from the city that gives you a wide field of view. The latter method is a fantastic way to encapsulate the city in one go. However, some cities are impossible to shoot this way. Not every city has a great skyline that you can capture like this, but some larger cities, such as Toronto, New York, Shanghai, and Liverpool, do.

You probably want to shoot with a wide-angle lens for low shots, but watch that you don't go too wide. Image 7-27 is on the verge of being too wide. The rainbow keeps it from being so. Without it, the small skyline would be the sole focal point of the scene, and you can hardly see it. Thankfully, the rainbow adds scale to the photo and seems like a bubble trying to hold the menacing clouds off from the city.

7-27

ABOUT THIS PHOTO *Ultrawide-angle photo of the Liverpool skyline. (ISO 450, f/13, 1/200 second, Nikon 14-24 f/2.8 at 14mm) © Pete Carr*

In this example, five exposures were taken, ranging from -1 2/3 to +2 1/3 EV. Although they aren't centered on 0 EV, the brackets were still shot with a 2-stop range, similar to many images in this book. They were merged to HDR in Photomatix and the settings from Chapter 4 were applied.

Although those settings work most of the time (they tend to produce lovely, smooth, clean, noise-free tone-mapped images), in this instance, they didn't look as good. The rainbow lacked punch and was flat. The tones had been compressed too much by setting the Luminosity to +5. After Luminosity was reduced to 0, the rainbow looked great. The image was also too bright,

so the Gamma was reduced to 1.0 from 0.9. Although that doesn't sound like a lot, it was enough to fix the issue. Lastly, the Strength was increased to 80 percent to add more contrast and drama to the clouds. All these settings created the HDR photo in 7-28.

The difference between 7-27 and 7-28 is quite noticeable. The clouds have more detail and are better exposed in 7-28 — they look more dramatic. The buildings are also better exposed, and the foreground rocks and wall are clearer.

This is another example of handheld bracketing. In addition, although the horizon is relatively flat, a filter couldn't be used on this lens because

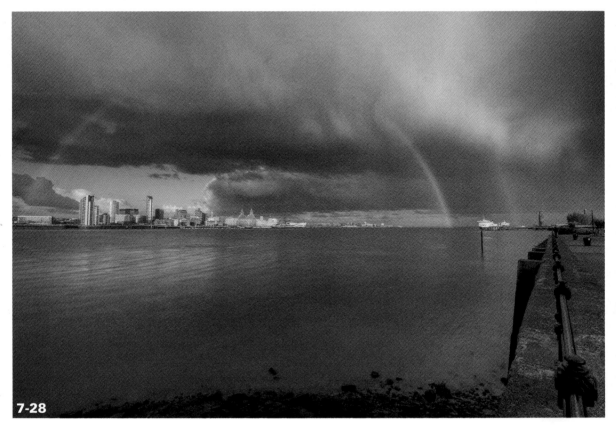

7-28

ABOUT THIS PHOTO *Initial HDR photo of the Liverpool skyline. HDR from five exposures, -2/-1/0/+1/+2 EV. (ISO 450, f/13, 1/200 second, Nikon 14-24 f/2.8 at 14mm) © Pete Carr*

the Nikon 14-24 f/2.8 only recently had an adapter developed for it (which is about 1/4 the price of the lens). In most ways it was simply easier to take exposure brackets, create an HDR image and tone map it, especially when you see such fleeting moments as this. It's very rare that you are in a position to get a fantastic rainbow over a cityscape, so make the most of it — and quickly.

Image 7-29 shows the photo after some final touches were added in Photoshop.

The previous example, 7-29, was shot low, and from very far away. You can also shoot fantastic photos if you move in a bit closer. For example, the image in 7-30 was taken using a fixed focal length of 50mm instead of the more wide-angle 14mm. It was taken from the same place as 7-27, which illustrates how much of a difference focal length can make. In 7-30, the cityscape resolves into individual buildings that you can properly see. In 7-27, the line of buildings is too small to

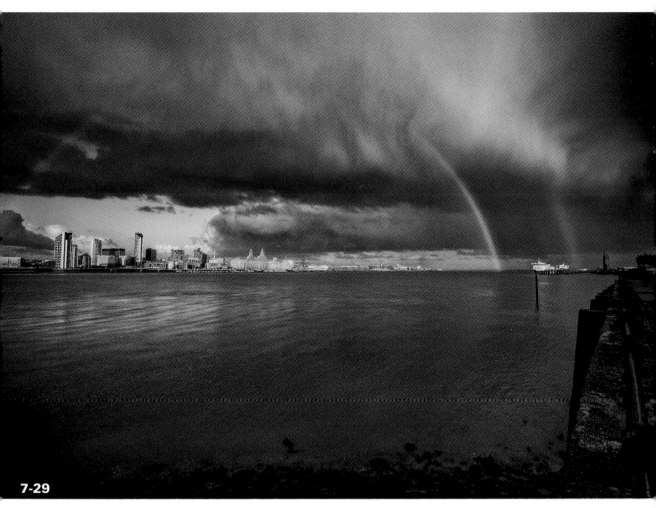

7-29

ABOUT THIS PHOTO *Processed HDR photo of the Liverpool skyline. HDR from five exposures, -2/-1/0/+1/+2 EV. (ISO 450, f/13, 1/200 second, Nikon 14-24 f/2.8 at 14mm)* © Pete Carr

really enjoy (the rainbow and bright flash of city are the centerpieces), but in 7-30, you can appreciate each structure.

Both ways of photographing cityscapes are perfectly acceptable, of course. It's up to you to find out and choose the vantage points and focal lengths you prefer. Really wide lenses let you capture the city and the drama around it, like a storm or a sunset. Closer shots (whether physically or by increasing the focal length) let you focus on just the city and its architecture. This way you can show off the multitude of buildings and the different styles of architecture.

You really need to nail the exposure when shooting this close, and working at dusk or nighttime can be very tricky. This is due to uncontrollable variations in city lighting. Some buildings may be brighter than others. At least one building in 7-30 has a spotlight on it, causing a large area to be blown out in the 0 EV exposure. The clock face on another building is also a bit overexposed. The minor issues in this image could probably be fixed with raw adjustments in Photoshop. To be safe, though, it's often better to bracket the scene so you know you have as much detail as you can get. It's hard to travel back in time and reshoot a moment.

7-30

ABOUT THIS PHOTO *The 0 EV exposure of the Liverpool skyline at dusk. (ISO 200, f/13, 13 seconds, Nikon 50mm f/1.8)*
© Pete Carr

Five exposures were taken to capture all the detail for this HDR image. As with 7-27, they were 2 stops apart, or -2/-1/0/+1/+2 EV. The images were loaded into Photomatix and the standard Chapter 4 settings were applied.

Image 7-31 shows what happened. It's not much of an improvement on the original. Technically, Photomatix did the right thing and brought out more detail. However, that isn't always a good

thing. The settings from Chapter 4 haven't corrected the issue of the spotlight on the building. This photo required alternative settings. To fix these issues, the White Point was reduced from 1.2 to 0.276. This reduced the bright highlights, including the large white spot on the building to the right. The Gamma was also reduced from 0.9 to 1.2 in order to darken the whole image. Lastly, the Strength was reduced from 75 to 50 percent to give a more natural look.

7-31

ABOUT THIS PHOTO *Processed HDR photo of the Liverpool skyline. HDR from five exposures, -2/-1/0/+1/+2 EV. (ISO 200, f/13, 13 seconds, Nikon 50mm f/1.8) © Pete Carr*

The finished image can be seen in 7-32. Like 7-18 and 7-19, the problem with the tone-mapped image was that the scene was too bright and had too much detail. It needed to be darker to appear realistic and believable. That was handled afterward in Photoshop.

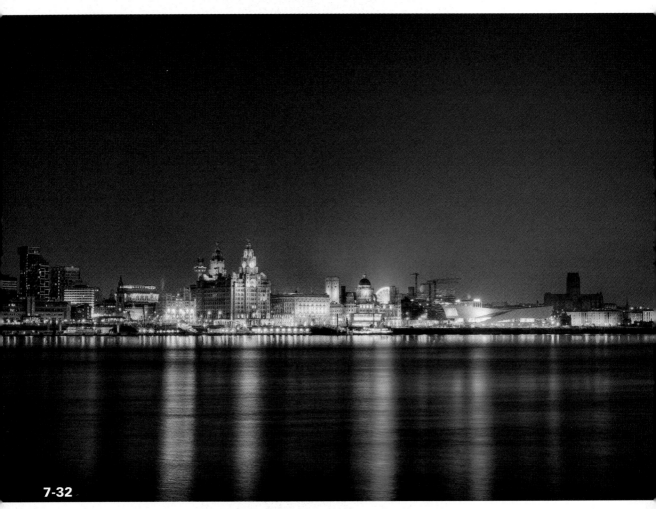

7-32

ABOUT THIS PHOTO *Final processed HDR photo of the Liverpool skyline. HDR from five exposures, -2/-1/0/+1/+2 EV. (ISO 200, f/13, 13 seconds, Nikon 50mm f/1.8) © Pete Carr*

Assignment

Photograph a Cityscape

In this chapter, you've seen cityscapes from high and low, wide and near. Using the ideas presented here, go out and find something great in a city and photograph it. Don't just photograph a building but look for the wider picture. How do those buildings all sit together? Do they look better in the morning, afternoon, or evening?

The image here is of the London skyline from across the Thames. The clouds really create a dramatic photo adding to the power of the architecture. HDR was created from three raw exposures. Taken at ISO 200, f/8.0, 1/200 second with a Sigma 10-20mm f/4-5.6 at 14mm.

© Pete Carr

Remember to visit www.pwassignments.com after you complete this assignment and share your favorite photo! It's a community of enthusiastic photographers and a great place to view what other readers have created. You can also post comments, read encouraging suggestions, and get feedback.

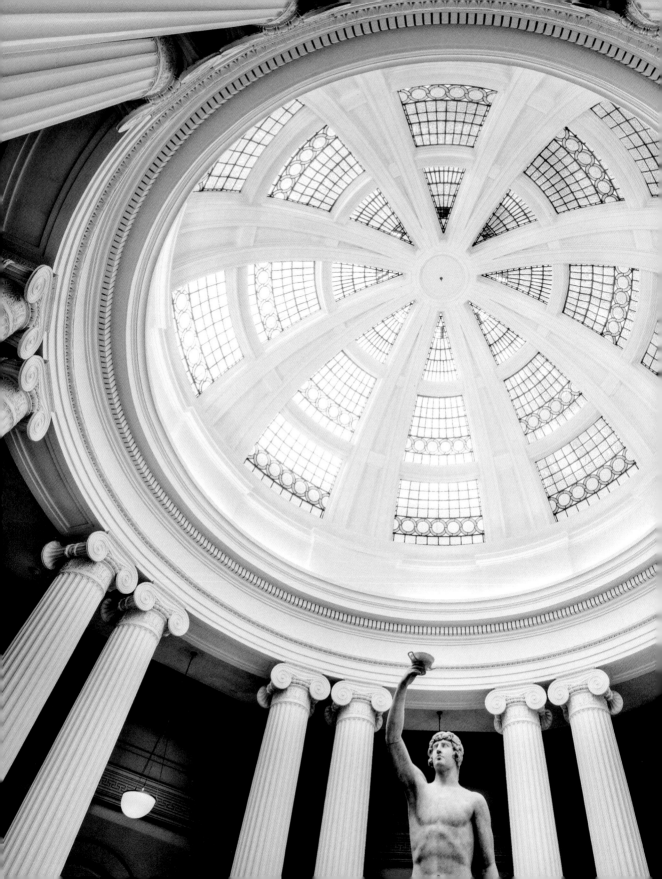

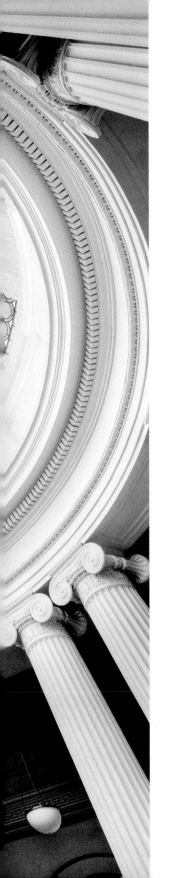

© Pete Carr

In this chapter, you take the information you've learned and the skills you've practiced and learn to shoot interiors in HDR. You don't have to worry as much about the Golden Hour, clouds, the time, or the weather. From that perspective, shooting inside is a lot easier and often more comfortable than waiting for the perfect conditions outside.

However, it's still a challenging endeavor. The variety of sizes, shapes, colors, and types of interior spaces is staggering. Man-made environments, both large and small, demand the most from your creativity and test your use of space and the existing lighting.

The most common post-processing challenges are related to white balance because different interior lights have different color temperatures — each one potentially throwing your photo's color off (that's called a *colorcast*). Interior lighting is also darker than you might think when compared to natural light. This becomes a problem when you try to balance indoor and outdoor light in the same scene.

UNDERSTANDING INTERIOR SPACES

By their very nature, interior spaces are constrained by walls, ceilings, and floors that serve as boundaries. You also have to contend with interior lighting replacing the sun as the primary light source. You may use diffused sunlight as a light source. In some buildings, there are competing sources of man-made and natural lighting at different intensities, which greatly complicates exposure. All of these differences have tremendous implications for your photographs.

SIZE, SHAPE, AND SPACE

Interiors come in many sizes and shapes. They can be square, rectangular, cubes, have curved walls, be oddly shaped, have vaulted or curved ceilings, staircases that break up the scene, and contain furnishings of all sorts.

When you look at an interior scene, you must decide what story you want to tell. It may be about the size, scale, color, shape, or interior details. Look at the scene and describe what you see in your head. What is there that you want to pick up and show to others? Is it the scale? If so, position yourself low and aim high. Is it the sheer volume of the place? In that case, shoot with a very wide-angle lens (but not a fish eye, as it would cause too much distortion). Combine the two by getting low and using a wide field of view to make it appear as if you're a child looking up at an epic interior. Alternatively, get up high and shoot down into the space, again with a wide-angle lens, to create a sense of space.

Use people or objects to create a sense of scale. If viewers can relate to something in the photo, then they can better imagine just how big the interior is. How you do this is all up to you, of course. Just take it slow. Look around and think about what you see. Break the scene down into keywords and go from there.

For example, the Lady Lever Art Gallery, shown in 8-1, is a stunning venue. In the center of the gallery, there is a dome that allows natural light into the room. A series of columns surround the central dome-covered area. Some keywords that this room generates are: Symmetrical, round, wide, tall, vast, stunning, bright, dark. Using keywords focuses your efforts. In this case, your goal would be to capture a wide shot that shows off the stunning interior, captures the skylight, and shows off the symmetry of the room.

ABOUT THIS PHOTO *Interior of the Lady Lever Art Gallery in Wirral, United Kingdom. Single 0 EV exposure. (ISO 200, f/11, 1/3 second, Nikon 14-24mm f/2.8 at 14mm) © Pete Carr*

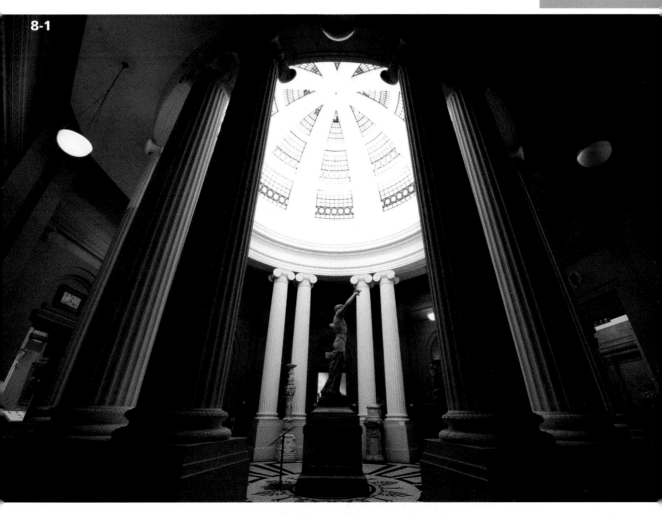

8-1

The problem with using a single exposure to do that in this space is that you can't possibly cover the dynamic range of the scene — the light from the dome is far too bright and the shadows in the room are too dark.

For this example, nine exposures were bracketed, each 1 stop apart. This ensured that all of the detail in the scene would be captured. The exposures were loaded into Photomatix and the settings from Chapter 4 were applied. The result was a natural-looking image, as shown in 8-2 (which is good), with a couple of issues (which is bad).

First, it was too dark, so Gamma was increased from 0.9 to 0.7. Because the outside of the circle of columns was darker than the inside, Strength was reduced from 75 to 50 percent, which made it brighter. Finally, the Temperature and Saturation highlights were reduced to -2 because the image was a little too yellow. It would be possible to decrease Micro-smoothing to make the image a little grittier and bring out even more detail, but the thing is, this is a very clean, crisp gallery — it doesn't need that look.

The final image, which incorporates all of those corrections, can be seen in 8-3. The white balance was further tweaked in Photoshop and more contrast was added to make the image pop. It's amazing how much of a positive difference a few changes can have on the final outcome. In particular, pay attention to white balance when shooting inside.

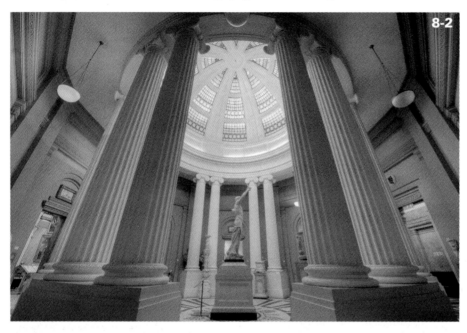

ABOUT THIS PHOTO
Straight from Photomatix HDR of the Lady Lever Art Gallery in Wirral, United Kingdom. HDR from nine exposures, -4/-3/-2/-1/0/+1/+2/+3/+4 EV. (ISO 200, f/11, 1/3 second, Nikon 14-24mm f/2.8 at 14mm) © Pete Carr

ABOUT THIS PHOTO
Final HDR of the Lady Lever Art Gallery in Wirral, United Kingdom. HDR from nine exposures, -4/-3/-2/-1/0/+1/+2/+3/+4 EV. (ISO 200, f/11, 1/3 second, Nikon 14-24mm f/2.8 at 14mm) © Pete Carr

NATURAL LIGHT AND SHADOW

You may find yourself using natural light as the primary light source, even indoors. Light coming in from windows, skylights, and doors, however, is generally not adequate to light interior spaces to the level required for good exposures. You might find yourself either overexposing the exterior to see details inside or underexposing the interior to avoid blowing out details outside. Image 8-4 illustrates this point. The skylight detail has been lost in exchange for interior detail.

To capture any detail in the skylight, the exposure had to be dialed down by 2 stops, which, of course, meant a massive loss in interior detail, as shown in 8-5.

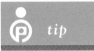 *tip*

Artificial lighting has a different color temperature than sunlight. Most cameras have white balance settings that can be used to account for the predominant lighting of a scene. If your photo looks too yellow, try changing the white balance to tungsten or fluorescent. Shooting RAW files enables you to correct this in software. For more information on color temperature and white balance, see Chapter 4.

There are ways around this issue, but none as attractive as HDR. The most obvious solution might be to use a flash to light the interior. However, you may be in a location where a flash would be too disruptive to the other visitors (as was the case with this art installation).

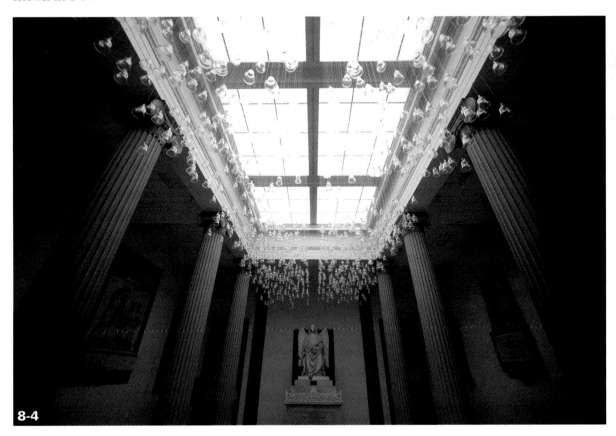

8-4

ABOUT THIS PHOTO *Interior of the Temple of 1000 Bells in Liverpool. Single, 0 EV exposure. (ISO 800, f/2.8, 1/100 second, Nikon 14-24mm f/2.8 at 14mm) © Pete Carr*

ABOUT THIS PHOTO *Interior of the Temple of 1000 Bells in Liverpool. Single -2 EV exposure. (ISO 800, f/2.8, 1/100 second, Nikon 14-24mm f/2.8 at 14mm) © Pete Carr*

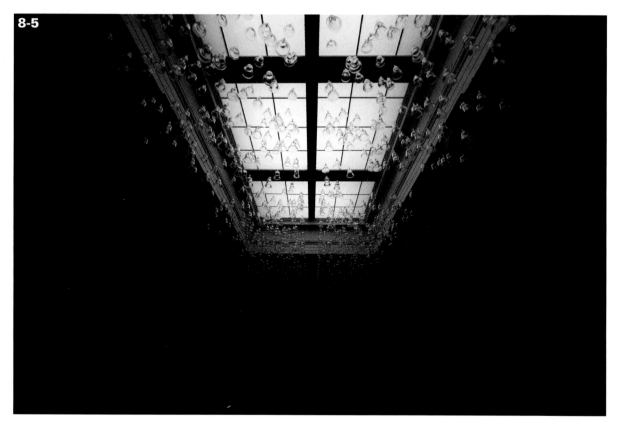

8-5

Alternatively, you could try to set up additional lighting in the space but, in addition to the cost and time required, you may not be able to secure permission to do so. More than likely, unless you're on a commercial shoot for the building or space in question, the answer will be no.

You could also try to increase Fill Light in your RAW file editor, but that often brings out a good deal of noise in the shadows. The easiest way to take advantage of natural light to light a room — and get a good exposure in the dark and light areas of the room — is to use HDR. It's quick, cheap, and gives you all the light you need to get a well-balanced image.

In this case, five images were enough to capture the details in the skylight and in the shadows. The images were loaded into Photomatix and the standard settings from Chapter 4 were applied. Initially,

the image was a little dark, so the Gamma was adjusted from 0.9 to 0.7. The skylight went quite gray. It was an overcast day outside, so there was little detail to bring back even in a well-exposed skylight. To reduce the gray, Luminosity was reduced from +5 to 0 and Strength from 75 to 50 percent. Finally, the Temperature was reduced from 0 to -2.5 as the interior looked a little too yellow. The result is shown in 8-6.

You can see that the bells hanging from the skylight are no longer completely blown out by the exterior light. They are clear and easy to see. There are also plenty of details in the shadows. The entire interior is visible. A quick conversion to black and white is shown in 8-7. While it's technically a good photo, it lacks atmosphere. This was quite a dark room in places.

ABOUT THIS PHOTO
*Interior of the Temple of 1000
Bells in Liverpool. HDR from
five exposures, -2/-1/0/+1/+2 EV.
(ISO 800, f/2.8, 1/100 second,
Nikon 14-24mm f/2.8 at 14mm)
© Pete Carr*

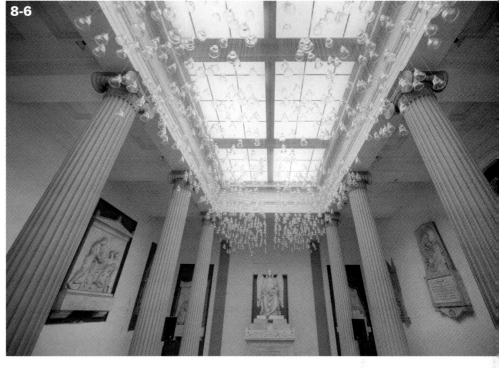

ABOUT THIS PHOTO
*Interior of the Temple of 1000
Bells in Liverpool. HDR from
five exposures, -2/-1/0/+1/+2 EV.
(ISO 800, f/2.8, 1/100 second,
Nikon 14-24mm f/2.8 at 14mm)
© Pete Carr*

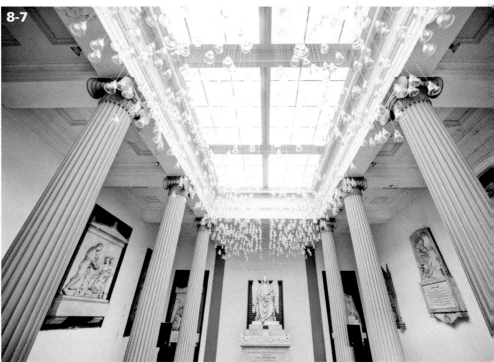

Bringing out all the detail is great but can sometimes feel wrong. Therefore, the image was darkened a little and a vignette was added around the edges of the frame to darken the sides. This version is shown in 8-8. It feels more natural — more like a dark temple.

EXTREME CONTRAST

You often find extreme contrast ratios when working with interiors, as shown in 8-9. This is Brookfield Place in Toronto, and the photo was taken from the underground pedestrian pathway system (PATH). The result is a scene with two interiors. One is underground with very little natural light, and the other is above ground with a vast amount of natural light. In scenes like this, as your eyes move up to the floor above, make sure that it's nicely exposed or it could look like people are taking a stairway to heaven.

The foreground is very dark and only gradually lightens toward the exit, which is so brightly lit that details have been washed out. To get any

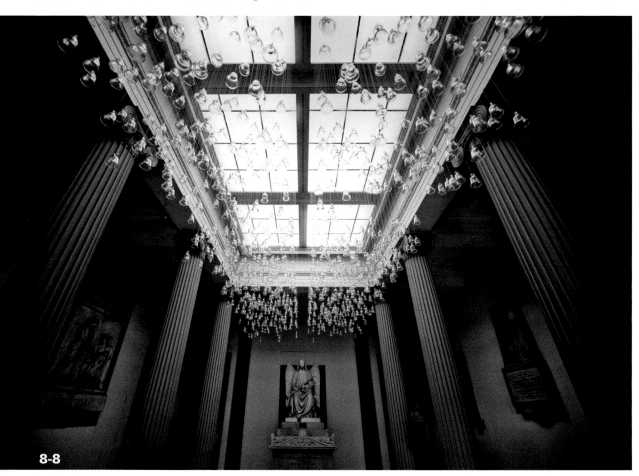

8-8

ABOUT THIS PHOTO *Interior of the Temple of 1000 Bells in Liverpool. HDR from five exposures, -2/-1/0/+1/+2 EV. (ISO 800, f/2.8, 1/100 second, Nikon 14-24mm f/2.8 at 14mm)* © Pete Carr

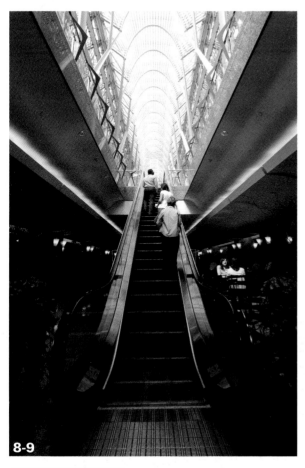

8-9

ABOUT THIS PHOTO *Underground view of Brookfield Place in Toronto. Single 0 EV exposure. (ISO 400, f/8.0, 1/60 second, Sigma 10-20mm f/4-5.6 at 10mm) © Pete Carr*

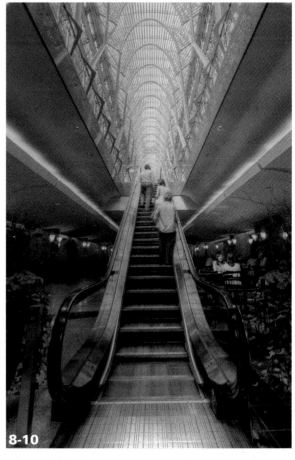

8-10

ABOUT THIS PHOTO *HDR of the underground view of Brookfield Place in Toronto straight from Photomatix, -2/0/+2 EV. (ISO 400, f/8.0, 1/60 second, Sigma 10-20mm f/4-5.6 at 10mm) © Pete Carr*

detail out of either extreme, HDR is required. In this instance, three photographs were taken 2 stops apart.

The three images were then loaded into Photomatix and the standard settings from Chapter 4 were applied. The tone-mapped result straight out of Photomatix is shown in 8-10. There is a lot more detail in the underground area and the floor above looks well exposed.

It's lacking a bit of contrast, though, and still needs to be lightened up. This was done afterward in Photoshop. The final result is shown in 8-11: a subtle blend of the two floors produce a natural-looking image.

Sometimes you may find yourself faced with high-contrast situations like this. Traditionally, you had to sacrifice one area for another, but HDR allows you to be creative in different ways.

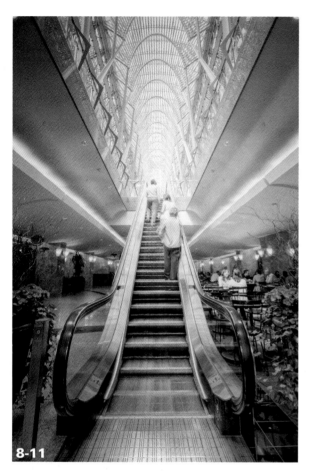

8-11

ABOUT THIS PHOTO *HDR of the underground view of Brookfield Place in Toronto straight from Photomatix, -2/0/+2 EV. (ISO 400, f/8.0, 1/60 second, Sigma 10-20mm f/4-5.6 at 10mm)* © Pete Carr

note

The point of HDR is not to remove all contrast — that leaves you with a flat, gray blob. The idea is to take too much contrast and intelligently map it to a lower level that you can work with and display. In many cases, you actually elevate the contrast of highly detailed areas of the photo. The point is to place that within the dynamic range of what you can see in an image file.

SHOOTING LARGE INTERIORS

The size and scale of large interiors evoke feelings similar to the awe generated by sweeping landscapes and cityscapes. Seek out impressive structures like Grand Central Station in New York City or The Natural History Museum in London to photograph. Tall ceilings are what you should be looking for and, if possible, grand vistas. Buildings with domes, arches, grand central staircases, or large interior gathering areas that are open to many levels qualify. Government buildings, cathedrals and other religious buildings, libraries, and even modern hotels may have very large, open interiors.

Larger spaces, though, can be hard to light evenly or at all, making traditional photography problematic. If you are a complete perfectionist with a lot of gear, it is possible to light an interior. Of course, you would need various lights, cables, and a lot of time to set it up. This is the nice thing about HDR — you don't need all of that. All it takes is you, a tripod, and your camera. Just bracket and process, and you can produce large interior scenes that rival anything else in HDR.

Be aware, though, that unless you ask permission first, you probably won't be allowed to set up a tripod in many of these locations. Also, commercial usage will most likely need to be approved. If you know you are going to be using the images commercially it would be best to get in touch with the manager or owner of the location and discuss it with him.

TRADITIONAL ARCHITECTURE

Traditional architecture comes in all shapes and sizes, but perhaps none more stunning than that of a cathedral. They include stunning stained-glass windows, incredibly high ceilings, and long aisles that act as the spine of the building. They are epic in detail, size, and scope — perfect for a great HDR image. The most important thing you want to do with a cathedral is capture the interior from the floor to the high ceiling while retaining the detail in the beautiful stained-glass windows.

While it probably is a good idea to have a wide-angle lens for such a scene, like a Nikon 14-24mm or a Sigma 10-20mm, it is not an absolute necessity. If you are creative, you could get away with using a 24mm or 35mm on a full-frame camera (roughly 18-24mm on most cropped bodies). Remember to use your feet. Walk around and find interesting angles. Take a step back or even go to the other end of the cathedral. Go up high. Get on your hands and knees, or lay down in the middle of the cathedral to compose your shot — do whatever it takes.

Pictured in 8-12 is Arundel Cathedral in Sussex, United Kingdom. It is a beautiful cathedral with lots of little stained-glass windows and a few very large ones. If you were shooting traditionally, you might choose to ignore the stained-glass windows and consider them casualties of war. Challenges are worth saving, though. Thankfully, HDR makes this challenge easy.

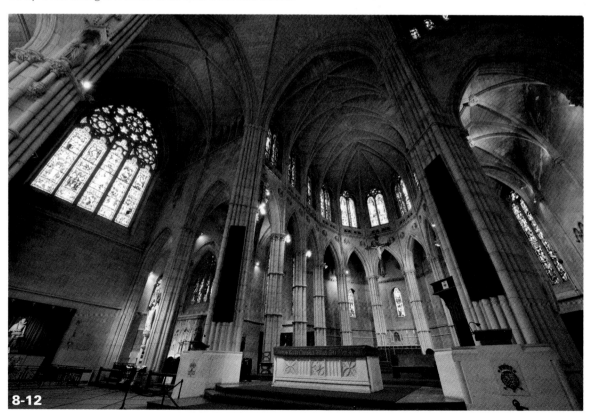

8-12

ABOUT THIS PHOTO Interior of Arundel Cathedral, West Sussex, United Kingdom. Single 0 EV exposure. (ISO 200, f/13, 1 second, Nikon 14-24mm f/2.8 at 14mm) © Pete Carr

For Arundel Cathedral, nine bracketed exposures were taken, 1 stop apart to ensure that enough details were captured. You don't want to get home and find out you didn't get enough to produce a decent HDR image, especially if the building is in another country. However, only five were really needed to create a well-exposed HDR. The addition of extra frames didn't add anything to the image.

Once loaded into Photomatix, the settings from Chapter 4 were applied. Aside from a white balance issue due to interior lighting, the image looked good. The Luminosity was set to +5 to balance the tones in the image. Strength was reduced from 75 to 50 percent, as the image was a bit dark in places. Lastly, the Gamma was increased to 0.7 from 0.9 to brighten the image. The HDR image that came out of Photomatix is shown in 8-13.

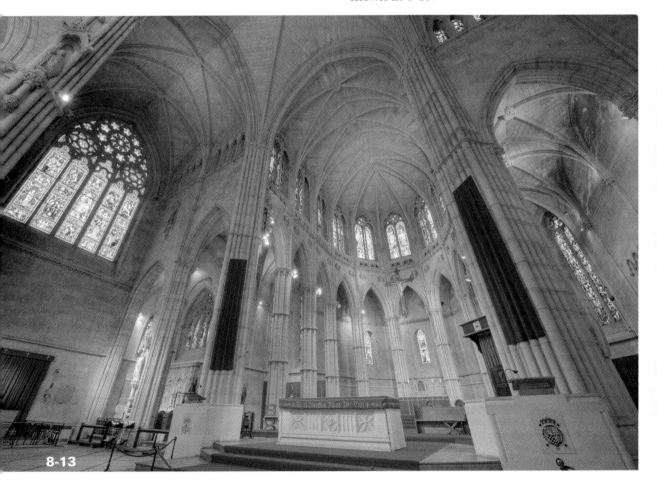

8-13

ABOUT THIS PHOTO *HDR straight from Photomatix of the interior of Arundel Cathedral in West Sussex, United Kingdom. HDR from five exposures, -2/-1/0/+1/+2 EV. (ISO 200, f/13, 1 second, Nikon 14-24mm f/2.8 at 14mm) © Pete Carr*

As mentioned, this image needed a white balance adjustment in Photoshop. Photomatix is okay for small adjustments, but this scene required more. The result, shown in 8-14, is beautiful, with a clear view of the stained-glass windows.

It is quite popular in HDR to bring out a lot of detail in cathedrals. Perhaps it is the stonework that emphasizes this effect. If you want to push the processing a bit more, you could keep the Strength at 75 percent and reduce Micro-smoothing to 0 or +2.

8-14

ABOUT THIS PHOTO *Final HDR of the interior of Arundel Cathedral in West Sussex, United Kingdom. HDR from five exposures, -2/-1/0/+1/+2 EV. (ISO 200, f/13, 1 second, Nikon 14-24mm f/2.8 at 14mm) © Pete Carr*

These adjustments are shown in 8-15. Be careful not to push it further, though, as this causes the image to look unnatural and computer generated. There's no point in visiting amazing places and taking the time to photograph them well if you could simply create it on a computer (unless you are a computer artist, of course).

Traditional architecture comes in other flavors besides cathedrals. The Tower Bank building in Fort Wayne, Indiana, shown in 8-16, is a gorgeous example of the Art Deco style of the 1920s and 1930s. This shot is overlooking the lobby from the second floor. The rounded lunch pail shape of the room is readily apparent

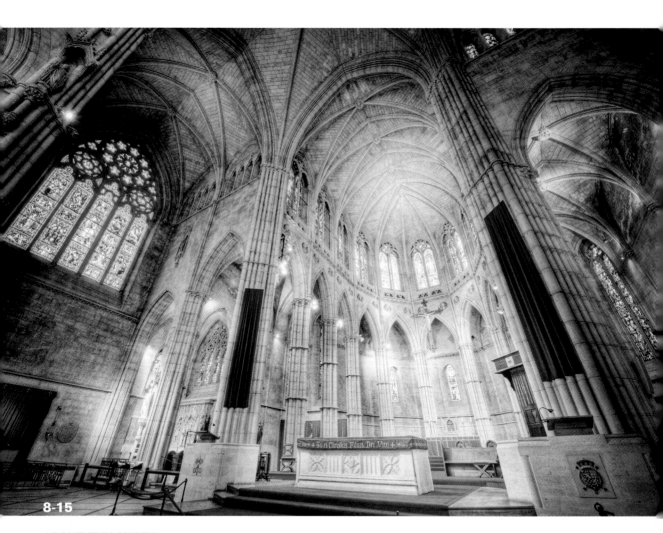

8-15

ABOUT THIS PHOTO *Heavily-processed HDR of the interior of Arundel Cathedral in West Sussex, United Kingdom. HDR from five exposures, -2/-1/0/+1/+2 EV. (ISO 200, f/13, 1 second, Nikon 14-24mm f/2.8 at 14mm)* © Pete Carr

from this vantage point, as well as its length. What doesn't show up well is the breathtaking beauty and color. The entrance, which faces north, is well lit by the bright daylight, which caused the camera to underexpose the rest of the scene. This exposure compromise is the worst of both worlds. The bright entrance is

still blown out, and the interior is too dark to appreciate.

Seven exposure brackets were taken, +/- 1 EV, to account for the large dynamic range in the scene. Image 8-17 shows the -3 EV photo. All you can see are the lights and windows, but those are well preserved.

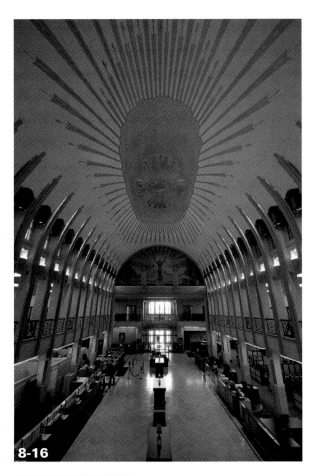

ABOUT THIS PHOTO *Muted beauty of the Art Deco style Tower Bank in Fort Wayne, Indiana. (ISO 100, f/8.0, 1/2 second, Sigma 10-20mm f/4-5.6 at 10mm) © Robert Correll*

ABOUT THIS PHOTO *Tower Bank, Fort Wayne, Indiana. The underexposed bracket shows the bright areas of the scene well. (ISO 100, f/8.0, 1/15 second, Sigma 10-20mm f/4-5.6 at 10mm) © Robert Correll*

Image 8-18 shows the final, tone-mapped result. The settings from Chapter 4 were loaded and only minor changes were needed. Strength was decreased to 70 percent to lighten the image. Color Saturation was increased to 80 percent to give the photo more pop. Luminosity was

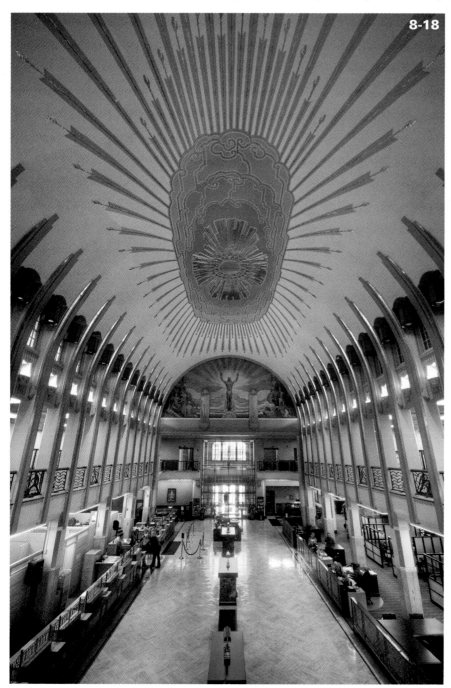

8-18

ABOUT THIS PHOTO
Tower Bank, Fort Wayne, Indiana. The final image reveals the colorful beauty of the lobby. HDR from seven bracketed exposures, -3/-2/-1/0/+1/+2/+3 EV. (ISO 100, f/22, 2 seconds, Sigma 10-20mm f/4-5.6 at 10mm) © Robert Correll

decreased to 0 to smooth the light gradient, while Detail Contrast was increased to 10 to give the details a bit more definition. Finally, the White and Black Point settings were increased.

CONTEMPORARY ARCHITECTURE

Contemporary architecture is all about large, open spaces with plenty of windows. This results in beautiful, cleanly designed interiors with stunning views. They can be quite clean and minimally designed, however, which means that there isn't a huge amount of detail to extract from the interior itself. Instead, it's all about creating a balanced image between the interior and exterior. Because the windows will probably be quite large, it's your job to capture the view in relation to the interior — that's the detail to retain. Obviously, the outside world is often brighter than the interior, which is why HDR can help you.

A good example of this issue is the interior of the newly constructed Museum of Liverpool. It is an absolutely stunning building — the perfect example of contemporary architecture, with big spaces, big windows, stunning views, and a joy to walk around. It's a little tricky to photograph, though, as those big windows are everywhere. You can see the issue in 8-19. Standard metering on the camera underexposes the interior while the exterior is overexposed. In fact, the exterior is overexposed by at least 3 stops (see 8-20) while the interior is underexposed by around 2 stops (see 8-21). It's a complicated shot.

To get the relevant detail for HDR, nine photographs were taken, each one 1 stop apart. This ensured a smooth merge. Depending on the time of day, you might find you can get away with less than nine shots if the light outside is softer or darker.

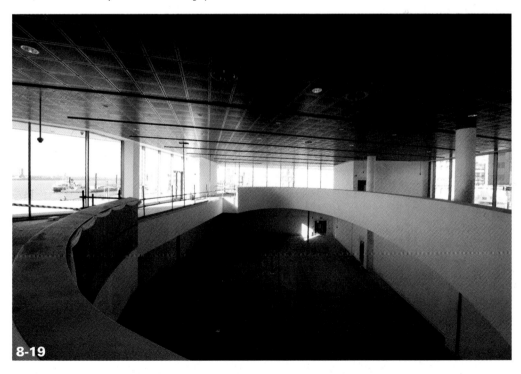

8-19

ABOUT THIS PHOTO *Single 0 EV exposure at the Museum of Liverpool. (ISO 200, f/13, 1/25 second, Nikon 14-24mm f/2.8 at 14mm) © Pete Carr*

8-20

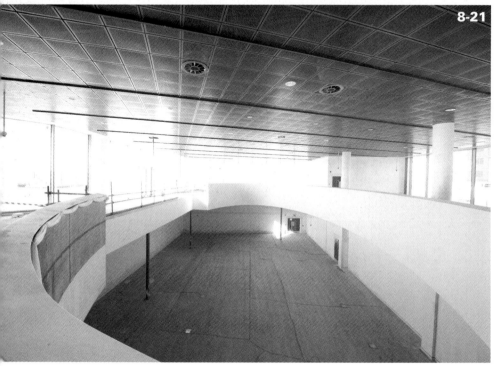

8-21

The nine images were then loaded into Photomatix and the standard settings from Chapter 4 were applied. The image looked good, but there were some overexposed areas that needed to be corrected. There are two ways of doing this: Increase the Luminosity to further compress the tonal range, or adjust the White Point levels. Adjusting the Luminosity can cause the image to look very low contrast and flat, while adjusting the White Point only changes how the highlights are clipped. It's up to you to find which works best on an image-by-image basis.

For this image, the White Points were decreased from 1.2 to 0.250. The Color Temperature was also reduced from 0 to -2, as the image seemed too warm. In addition, Saturation highlights were reduced from 0 to -2.5 as the blue sky was a little too saturated. The Strength setting was reduced from 75 to 50 percent to lessen the darkness around the edges of the frame. Lastly, the Gamma was increased from 0.9 to 0.7 just to help brighten the interior. The result is shown in 8-22.

Image 8-22 isn't the final one, however. As good as Photomatix is, it's not the final step. The image was loaded into Photoshop and contrast

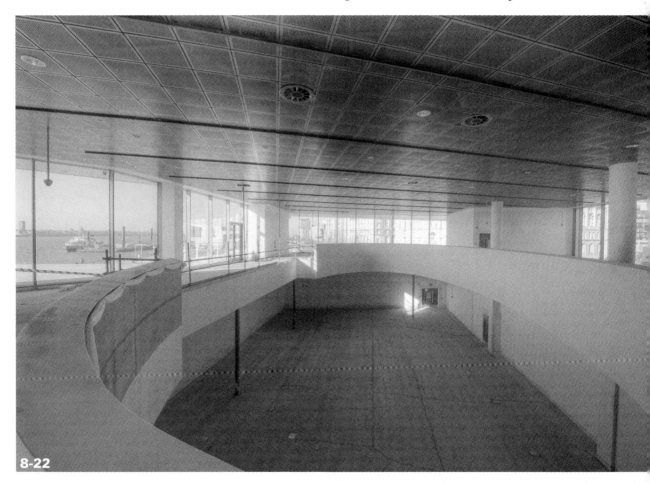

8-22

ABOUT THIS PHOTO *HDR of the Museum of Liverpool. Nine exposures, -4/-3/-2/-1/0/+1/+2/+3/+4 EV. (ISO 200, f/13, 1/25 second, Nikon 14-24mm f/2.8 at 14mm) © Pete Carr*

was enhanced to make the image pop. As a result, the brightness of the exterior view was increased, but not to the level found in 8-19. Rather, it felt natural. If it feels right, there's nothing wrong with creating an image that is slightly imperfect from a technical standpoint.

If you compare 8-23 to 8-19, you can see why HDR helps. Image 8-23 shows a nice, balanced interior, while also showing off the way contemporary architecture works best. It's a stunning interior with a fantastic view.

8-23

ABOUT THIS PHOTO *Final HDR of the Museum of Liverpool. Nine exposures, -4/-3/-2/-1/0/+1/+2/+3/+4 EV. (ISO 200, f/13, 1/25 second, Nikon 14-24mm f/2.8 at 14mm) © Pete Carr*

Remember that the settings in Chapter 4 are only a starting point — they won't apply to every photo. Some need extra tweaks and some look great without being polished.

Buildings such as those in this chapter do not really benefit from a gritty HDR style, like an urban scene with graffiti, for example. These buildings are clean, smart, minimal, and all about including the view. Remember not to push the processing too far.

Image 8-24 is another example of modern architecture in the form of a reasonably large contemporary American church. It is The Chapel, located in Fort Wayne, Indiana. The building is not quite as avant-garde as the last example, but some of the principles are similar. The sanctuary is large and open. There are several large skylights along both sides to let in natural light. Rather than a traditional pulpit, the center of attention is a stage, which has a drum kit set up and risers behind it for the choir. This 0 EV photo was taken on a sunny day with the lights on.

This vantage point illustrates how large rooms look when you can get higher up to take your brackets. This scene emphasizes the volume and the space.

Nine brackets were taken, each separated by 1 EV. Image 8-25 shows the +4 EV bracket. Although the white part of the ceiling is blown out, the dark tile work stands out very well, as do the pews and details at the far end of the sanctuary. This represents, oddly enough, the lower end of the dynamic range of light in this scene. The overexposed brackets let you see what would normally be underexposed.

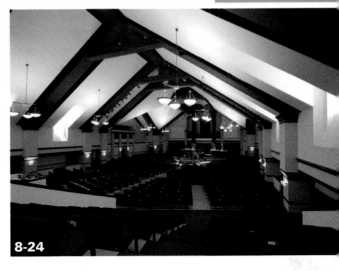

8-24

ABOUT THIS PHOTO *The Chapel, Fort Wayne, Indiana. Modern American church sanctuary taken from above, 0 EV. (ISO 100, f/8.0, 1/1.6 second, Sigma 10-20mm f/4-5.6 at 10mm) © Robert Correll*

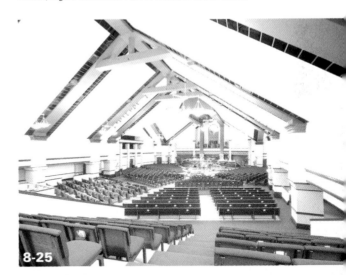

8-25

ABOUT THIS PHOTO *The Chapel, Fort Wayne, Indiana. The overexposed bracket (+4 EV) illustrates darker areas of the room and ceiling. Note the long exposure. (ISO 100, f/8.0, 10 seconds, Sigma 10-20mm f/4-5.6 at 10mm) © Robert Correll*

Image 8-26 shows the final image after processing in Photomatix. The settings from Chapter 4 were loaded and looked so good only a single change was made. To boost detail a bit, Detail Contrast was increased to +10. The photo was finalized in Photoshop by sharpening slightly and then adding a small amount of contrast using a Levels adjustment layer. The end result illustrates that you don't have to overdo it to enjoy HDR. Your photos can look very realistic if you use the right settings.

OTHER VENUES

You may not live near a cathedral or large commercial building, but even small towns can have interesting venues. For example, 8-27 shows the New Castle Fieldhouse located on the grounds of New Castle High School (Robert's alma mater) in New Castle, Indiana. It is the largest high school basketball gymnasium in the world (one might call it a cathedral to basketball).

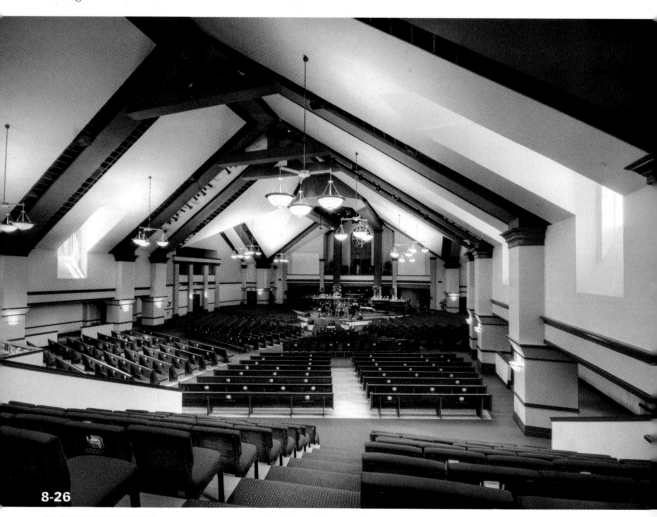

8-26

ABOUT THIS PHOTO *The Chapel, Fort Wayne, Indiana. Brilliant reds, whites, tans, and intricate detail stand out in this HDR image. HDR from nine exposures at -4/-3/-2/-1/0/+1/+2+/3/+4 EV. (ISO 100, f/8.0, 1/1.6 second, Sigma 10-20mm f/4-5.6 at 10mm) © Robert Correll*

This 0 EV shot was taken at center court looking toward the goal with the tunnel leading to the locker rooms behind it. On the far wall are photos of New Castle athletes and the banners they've won. As you can tell, this is a hard venue to shoot if all the lights aren't on. The court is well lit (to the point of blowing out) but the seats and ceiling are in shadow.

HDR provides the most practical way to turn an exposure nightmare into something worth using. Five brackets were shot, each separated by 1 EV. They were loaded into Photomatix Pro and the HDR image was generated and tone mapped using the base settings from Chapter 4. Only a few changes were needed: To strengthen details, Detail Contrast was increased to 5 and Gamma was changed to 0.8 to brighten the image, and Saturation Highlights was increased to 3.0 to

strengthen the color in the floor. The tone-mapped image is shown in 8-28, right out of Photomatix Pro.

The photo has promise, but needs more care and attention to finish it. The floor of this venue has a green tint. There is a white wall in the background and what should be neutral gray concrete supporting the seating planks. In addition, on the day Robert was there to shoot, there were temporary basketball goals on either side of the court. These and the lights on the ceiling are somewhat distracting.

The tone-mapped image was loaded into Photoshop and the colorcast removed by using Levels. The contrast was also enhanced slightly, and the entire image was reframed to effectively crop out the distractions. The result, shown in 8-29, is another very realistic HDR image.

ABOUT THIS PHOTO
New Castle Fieldhouse, New Castle, Indiana. This athletic venue has a large dynamic range due to the lighting and distance. (ISO 100, f/8.0, 1.3 seconds, Sigma 10-20mm f/4-5.6 at 10mm) © Robert Correll

8-27

8-28

ABOUT THIS PHOTO
New Castle Fieldhouse, New Castle, Indiana. The initial tone-mapped image from Photomatix Pro suffers from color balance problems. HDR from five exposures at -1/-2/0/+1/+2 EV. (ISO 100, f/8.0, 1.3 seconds, Sigma 10-20mm f/4-5.6 at 10mm) © Robert Correll

8-29

ABOUT THIS PHOTO
New Castle Fieldhouse, New Castle, Indiana. HDR images corrected in Photoshop. (ISO 100, f/8.0, 1.3 seconds, Sigma 10-20mm f/4-5.6 at 10mm) © Robert Correll

THE SMALLER PICTURE

There's no rule that says you must have a 10mm ultrawide-angle lens and only shoot landscapes, cityscapes, and impressively large interiors. At the opposite end of that spectrum, and no less a part of HDR photography, are smaller spaces. The key point for shooting in smaller spaces is the same as that for HDR in general: look for high-contrast scenes with details that can be brought out.

LESS DRAMA, MORE DETAIL

So far you've been looking at big, wide, dramatic interiors that capture lots of detail both inside and out, often resulting in stunning photographs. However, you can also capture details on a smaller scale when you want to get a bit more detail out of an image, instead of balancing the interior with the exterior. That is something with which HDR can really help.

Image 8-30 shows a large interior, but the scale of the space isn't important. What is important in this case is the sculpture in the center of the room rather than the room itself.

The artwork, in fact, is a little bit underexposed due to its color. Black objects require a longer exposure to bring out the detail. Unfortunately, the piece is in a large white room, which means that a longer exposure washes the detail out in the room behind it, as shown in 8-31.

Traditionally, you might use a flash to light the foreground and expose for the background. However, as mentioned earlier, there are times when you can't use a flash. This was taken inside a museum, many of which do not allow flash photography. Also, if you aren't allowed to bring a tripod, you have to stay very still when you auto bracket.

8-30

ABOUT THIS PHOTO *Artwork inside the Lady Lever Gallery, Wirral, United Kingdom. Single 0 EV exposure. (ISO 200, f/11, 1/8 second, Nikon 14-24mm f/2.8 at 14mm) © Pete Carr*

8-31

ABOUT THIS PHOTO *Artwork inside the Lady Lever Gallery, Wirral, United Kingdom. Single, +3 EV exposure. (ISO 200, f/11, 1 second, Nikon 14-24mm f/2.8 at 14mm) © Pete Carr*

To get enough detail for the foreground and background, nine exposure brackets were taken. However, after running some tests to evaluate the brackets, only five were needed in this situation.

tip You don't have to use every exposure bracket you took when generating the HDR image.

The images were loaded into Photomatix and the standard settings from Chapter 4 were applied. The interior lighting caused the image to come out tinted a little yellow. The Temperature was reduced to -2 along with the Saturation highlights, which were also set to -2. This cooled the image. Strength was reduced to 50 percent to lighten the edges. Luminosity was kept at +5 to help balance the light. Finally, Gamma was

increased to 0.7 to brighten the image. Image 8-32 shows the final result after a few tweaks to the contrast and white balance in Photoshop. There's plenty of detail in the artwork now — it looks stunning. There's no loss of detail in the room, either, which provides a fantastic background for the art.

PROBLEM SOLVING WITH HDR

At some point, you may find yourself faced with a normal-looking scene — one that isn't about capturing a grand view outside while retaining the stunning view inside when it isn't lit well. It may simply be something inside a building that you want to photograph without blowing the highlights in certain areas of the image. Use HDR to solve the exposure problem.

8-32

ABOUT THIS PHOTO *Artwork inside the Lady Lever Gallery, Wirral, United Kingdom. HDR from five exposures, -2/-1/0/+1/+2 EV. (ISO 200, f/11, 1/8 second, Nikon 14-24mm f/2.8 at 14mm) © Pete Carr*

238

The image in 8-33 shows the original dock wall of the first dock in Liverpool. It is the dock system that made the city a world-famous port. Unfortunately, there are some bright lights shining on the bottom area. This area could be cropped out, but in this instance, it was very important to keep it. The area at the bottom of the frame shows some liver-colored sand and rock, which is how Liverpool got its name — the Liver Pool. It was, therefore, incredibly important to show both the original dock wall and the liver-colored floor.

To make sure enough detail was captured, seven photographs were taken, each at 1 stop apart. They were loaded into Photomatix and the standard settings from Chapter 4 were applied. Although most of the image looked good, the really bright areas at the bottom were still overexposed. It required quite a few tweaks to get the best from this image. To start, the White and Black Points were reduced to 0.5 from 1.2. Luminosity was increased to +7, which reduced the brightness of the overexposed areas. Strength was set to 50 percent to brighten the rest of the image.

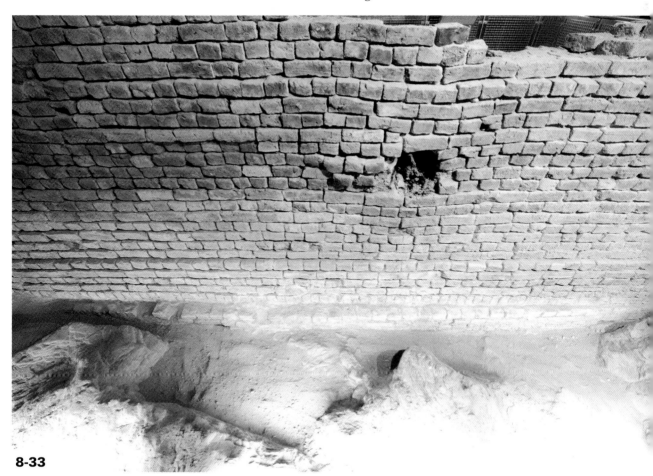

8-33

ABOUT THIS PHOTO *Interior of the Old Dock in Liverpool. Single 0 EV exposure. (ISO 200, f/8.0, 0.8 seconds, Nikon 14-24mm f/2.8 at 14mm)* © Pete Carr

The Temperature was reduced to -4 to ease the strong yellow colorcast (remember, interior lighting and, in this case, the subject can cause white balance problems), along with the Saturation shadows, which was reduced to -1. The end result is shown in 8-34. It's still quite yellow and the very bottom of the image is still a little overexposed, but it's a vast improvement over 8-33.

After a few adjustments to the white balance and contrast in Photoshop, the final image is shown in 8-35.

Alternatively, you could alter your tone-map settings to increase the detail in this image. This can be achieved by increasing the Strength to 100 percent and dropping Micro-smoothing to 0. This produces a more intense and gritty result, as shown in 8-36. There are one or two issues created by doing this, however. By reducing the Micro-smoothing, the image becomes unbalanced. There are darker areas on the left that were nicely

8-34

ABOUT THIS PHOTO *Interior of the Old Dock in Liverpool. HDR from seven exposures, -3/-2/-1/0/+1/+2/+3 EV. (ISO 200, f/8.0, 0.8 seconds, Nikon 14-24mm f/2.8 at 14mm) © Pete Carr*

balanced in 8-35. The other issue is that some of the rocks in that area feel more saturated than they should be.

It is, of course, up to you to decide how far you want to push things. Recognize the issues that arise if you choose to do so.

ABOUT THIS PHOTO
Processed interior of the Old Dock in Liverpool. HDR from seven EV exposures, -3/-2/-1/0/+1/+2/+3 EV. (ISO 200, f/8.0, 0.8 seconds, Nikon 14-24mm f/2.8 at 14mm)
© Pete Carr

ABOUT THIS PHOTO
Alternate processed interior of the Old Dock in Liverpool. HDR from seven exposures, -3/-2/-1/0/+1/+2/+3 EV. (ISO 200, f/8.0, 0.8 seconds, Nikon 14-24mm f/2.8 at 14mm)
© Pete Carr

FROM THE INSIDE OUT

Thus far, you've seen how to take photos inside large and small spaces. Now it's time to mix it up and shoot HDR in high-contrast scenes that capture interior and exterior details. With the right light and processing, you can capture a significant amount of detail both inside and out.

BUILDINGS

It's challenging to be inside a building and try to capture the outside at the same time. Image 8-37 shows what you might see when looking through a stall from inside a horse barn to the corral outside. Details in both areas are lost in this 0 EV shot.

HDR makes all the difference. In this case, five brackets were shot manually, separated by 2 EV. They were processed in Photomatix Pro with unique settings. Strength was set to 100 percent to bring out as much detail as possible. Color Saturation was raised to 70 percent to add sizzle to the image. Detail Contrast was raised to 5 to enhance the edges in the scene. The final image, shown in 8-38, was rotated slightly in Photoshop.

8-37

ABOUT THIS PHOTO *A horse barn in Indiana. This is pretty close to what your eyes would see before adjusting to the dark interior. (ISO 100, f/8.0, 1/8 second, Sigma 10-20mm f/4-5.6 at 20mm) © Robert Correll*

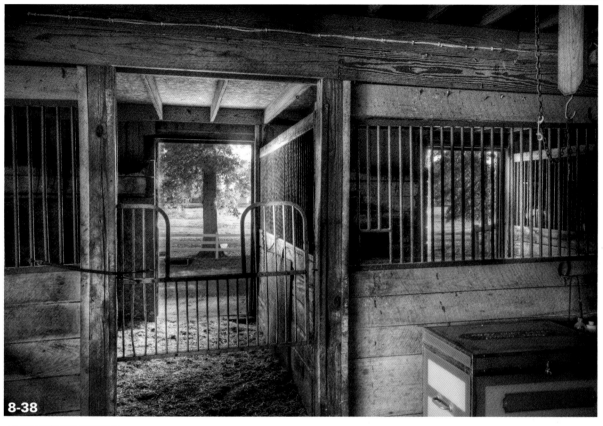

8-38

ABOUT THIS PHOTO *A horse barn in Indiana. The final HDR image looking outside at the fall foliage. HDR from three bracketed exposures at -2/0/+2 EV. (ISO 100, f/8.0, 1/8 second, Sigma 10-20mm f/4-5.6 at 20mm) © Robert Correll*

BRIDGES

Sometimes you have to outthink your camera. Some models bracket automatically by small steps, such as 0.3 or 0.7 EV. Three photos +/- 0.7 EV only give you a 1.4 EV range between the under- and overexposed brackets, which is not ideal if you are trying to capture a High Dynamic Range scene.

You can shoot the brackets manually, of course, but you can also shoot multiple bracketed sets. The key is to set your camera to Manual exposure mode so you can start the auto brackets when the exposure is under- and overexposed. One way to do it would be to set the shutter speed so your exposure index reads -2 EV for the first bracketed

set, and then shoot it. Change the shutter speed so your exposure index reads 0 for the second set, then +2 for the third. You end up with nine brackets total. This is if you are shooting AEB at +/- 0.7 EV. Set your bracketed set points to -0.7/0.0/+0.7 if you are shooting at +/- 0.3 EV. In the end, your bracketed set ranges from -2.8 EV to +2.8 EV.

Image 8-39 shows the 0 EV brackets taken within a covered walkway. Scenes like this are challenging because you're both inside (the dark walkway and supports show this) and outside. The brackets were taken very near sunset, so the sky is not too bright, but the sunset is visible in the lower-right center of the frame.

8-39

8-40

ABOUT THIS PHOTO *This scene presents tricky exposure problems due to the shadowed interior and bright sunset. (ISO 100, f/8.0, 1/40 second, Sigma 10-20mm f/4-5.6 at 17mm) © Robert Correll*

ABOUT THIS PHOTO *The initial HDR image from Photomatix Pro. HDR from three bracketed sets of three images (nine total), with two duplicates tossed. Seven brackets at -2.1/-1.4/-0.7/0/+0.7/+1.4/+2.1 EV. (ISO 100, f/8.0, 1/40 second, Sigma 10-20mm f/4-5.6 at 17mm) © Robert Correll*

Seven brackets were shot as part of three bracketed sets. Originally, the number was nine, but the sets overlapped and two photos weren't needed. Image 8-40 shows the tone-mapped result. The settings used were very close to those presented in Chapter 4. Color Saturation was increased to 75 percent and the Temperature was decreased to -2.0. These changes strengthened the color of the scene and pushed it toward blue.

The image was processed further in Photoshop, with an artistic goal. The idea was to make it look like an old-fashioned print with plenty of contrast. This was achieved by increasing the con-

trast with Curves. There was a good deal of chromatic aberrations in this image because Robert was shooting toward the sun, and the light was reflected by the bridge and the lens. Those areas were selectively desaturated to make them less obvious. The result is shown in 8-41.

AIRCRAFT

Taking photos out the window of an airplane in flight is a well-established tradition of tourists and other travelers. The view is amazing — you don't

get to see cities, clouds, mountains, oceans, and other scenery from above very often. You cannot set up lights, and flash photography may not be permitted. This presents a problem if you want to show the outside and inside of the plane at the same time. It's a dynamic range issue, and can be

8-41

ABOUT THIS PHOTO
Final HDR image tweaked in Photoshop to enhance contrast and color. Interior and exterior are both visible, and contribute to the overall effect. (ISO 100, f/8.0, 1/40 second, Sigma 10-20mm f/4-5.6 at 17mm) © Robert Correll

a real problem if you are flying over white clouds. They are exceptionally bright in comparison to the dimly lit interior of the plane.

To overcome this problem, take three bracketed photographs. If you are unable to auto bracket, it is very tricky to succeed at this because you must adjust the settings without moving the camera. Even with auto bracketing, you need a camera with a fast shooting speed because, most likely, you will be working without a tripod and have to support the camera by hand. The shorter the amount of time, the better.

Bracketing in this situation allows you to capture as much of the dynamic range of the scene and, therefore, detail, as possible. After generating the HDR, tone mapping the image should produce a balanced photo with details across the dynamic range of the scene.

The photo in 8-42 was taken on a flight to Toronto with a handheld dSLR using AEB. If you have a fast enough camera and can stabilize it with your hands, or by resting it on something,

you don't always need a tripod or monopod. In fact, in this instance, using one would be quite impractical.

Image 8-42 demonstrates the issue. The outside is a little blown out and the inside is very underexposed. Normally, you would just put the camera to the window and photograph the outside, but it's fun to be creative. As mentioned previously, you need to take a few photographs using AEB to build a decent HDR for this scene. In this example, three shots were taken, as that was the limit of the camera.

The images were then loaded into Photomatix and the settings from Chapter 4 were applied. A few tweaks were needed for this image. First, the White Point was reduced from 1.2 to 0.2 because the exterior highlights were very bright. This brought them under control. The overall color Temperature was reduced to -2.4 because the image was a little too yellow from the interior lights. Also, the Saturation shadows was reduced to -2.4 for a similar reason. In the end, the result was a natural image showing off the best of both worlds (see 8-43).

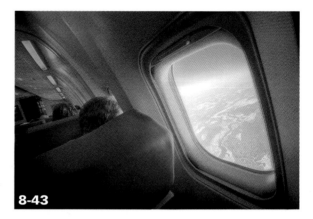

ABOUT THIS PHOTO *This single image was shot on a flight to Toronto. (ISO 100, f/8.0, 1/50 second, Sigma 10-20mm f/4-5.6 at 10mm) © Pete Carr*

ABOUT THIS PHOTO *HDR image shot on a flight to Toronto. HDR from three camera raw exposures, bracketed at -2/0/+2 EV. (ISO 100, f/8.0, 1/50 second, Sigma 10-20mm f/4-5.6 at 10mm) © Pete Carr*

Assignment

Capture an Interior Scene

This chapter covered a lot of different material connected to photographing interiors in HDR. You saw examples of common problems when shooting inside, and learned how to shoot large and small spaces from the inside out, as well as from the outside in.

For this chapter's assignment, put what you have learned into practice. Find a high-contrast interior that you want to shoot. It can be large or small. It can have details, drama, odd angles with finely crafted fixtures, or wild and crazy décor. Accept the challenge of shooting without a flash or any other lighting accessories. It's just you, the interior, and the exterior. Remember to compensate for white balance issues and other problems in camera or in post-processing.

Pete shot this photograph from within the new Museum of Liverpool. This is one of the main windows in the museum. It looks out over the World Heritage Site of the 3 Graces. It is a high-contrast scene. He used seven bracketed photos at -3/-2/-1/0/+1/+2/+3 EV. Taken at ISO 200, f/13, 1/40 second with a Nikon 14-24mm f/2.8 lens at 14mm.

See if you can find a similarly contrasted interior and use HDR to bring out the details in shadow and highlights. Post it to the website to share it with others.

© Pete Carr

Remember to visit www.pwassignments.com after you complete this assignment and share your favorite photo! It's a community of enthusiastic photographers and a great place to view what other readers have created. You can also post comments, read encouraging suggestions, and get feedback.

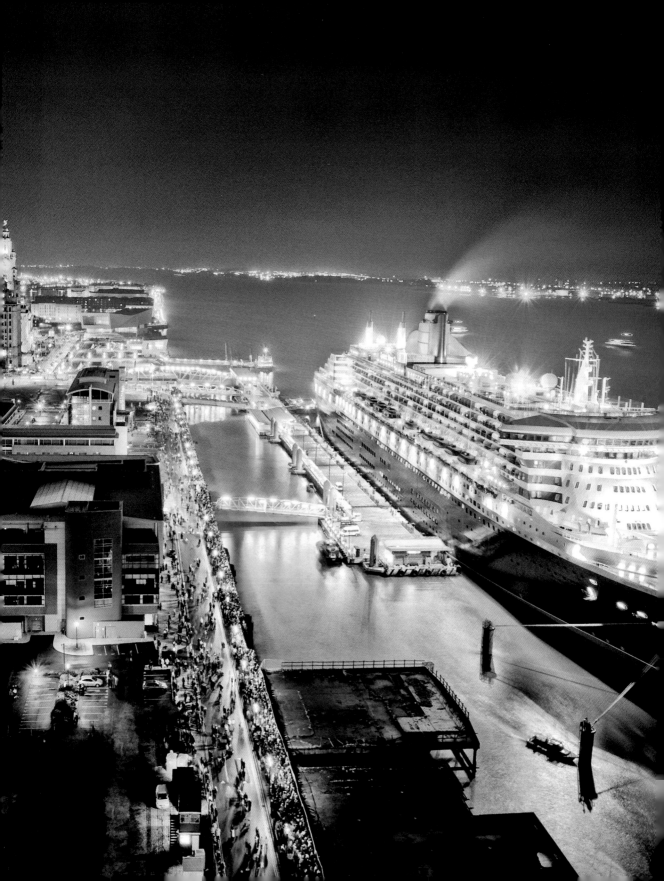

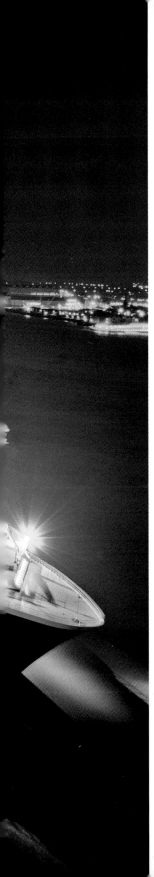

© Pete Carr

Although very popular, landscapes, buildings, cityscapes, and interiors aren't the only subjects that work with HDR. This chapter takes a quick look at some other creative possibilities within your reach. It also covers how to shoot and process panoramas using HDR techniques.

In the end, use your own insight and creativity to direct your efforts in HDR. Although not every scene or subject works as well as another, find the areas that suit your interests and talents and jump in.

CREATING PANORAMAS IN HDR

Landscapes and cityscapes present unique opportunities for creating magical scenes that don't always fit in a single frame, even if you're using an ultrawide-angle lens. Panoramas offer a challenging but rewarding solution to this problem.

In one sense, panoramas are simple. Digital technology enables you to stitch photos together in software far easier than in the darkroom. However, panoramas shot in HDR, like the one shown in 9-1, require a lot more work than standard HDR. All of the initial photographs must be lined up correctly and each panorama frame must be bracketed. You also have to shoot as many sets of brackets as you have panorama frames. This all

takes time, of course, and if clouds or other objects in your scene are moving, you have to be quick about it. In this example, a 5-frames-per-second (fps) camera and AEB helped speed things along.

The basic workflow when shooting panoramas in HDR is to bracket each frame of the panorama separately. In other words, don't shoot the complete panorama three or more times (once for each exposure in your bracketed set). Rather, complete the exposure bracket for each section of the panorama before moving on. That means taking three, five, seven, or more exposure bracketed shots per panorama frame. When you get to your computer, take care of the HDR first and then stitch the panorama together.

Image 9-2 shows the original 0 EV exposure of the second part of the panorama. Image 9-3 shows the tone-mapped HDR image created using the brackets of the frame shown in the 9-2 version. Three brackets shot at -2/0/+2 EV were used. To start with, the standard settings from Chapter 4 were applied. After altering some, it seemed that the standard settings were enough to bring out a decent amount of detail in the shadows. The clouds resisted and did not reveal much more detail than the original, but sometimes that's okay. When the sky isn't particularly dramatic, there is no point in forcing it to be so in processing.

9-1

ABOUT THIS PHOTO *This shot of the Mersey Viking was taken from Birkenhead, Wirral, United Kingdom. The panorama was created from four sets of bracketed images, each at -2/0/+2 EV. (ISO 100, f/8.0, 1/50second, Canon 24-70mm f/2.8 at 70mm) © Pete Carr*

ABOUT THIS PHOTO

The Liverpool Viking, taken from Birkenhead, Wirral, United Kingdom. The panorama was created from four sets of bracketed images, each at -2/0/+2 EV. (ISO 100, f/8.0, 1/50second, Canon 24-70mm f/2.8 at 70mm) © Pete Carr

ABOUT THIS PHOTO

The Liverpool Viking, taken from Birkenhead, Wirral, United Kingdom. The panorama was created from four sets of bracketed images, each at -2/0/+2 EV. (ISO 100, f/8.0, 1/50second, Canon 24-70mm f/2.8 at 70mm) © Pete Carr

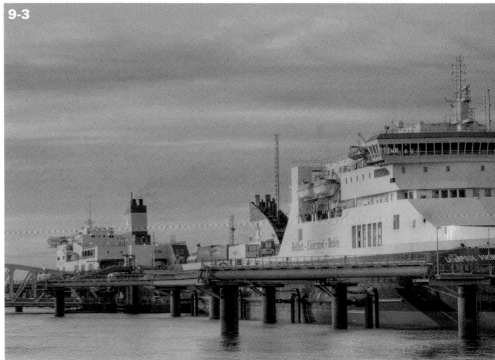

If you wanted to make the image a bit more dramatic, you could drop the Micro-smoothing down to 0. However, be aware that this massively increases the noise, as shown in 9-4.

TAKING PANORAMIC PHOTOGRAPHS

Although you may be able to hold your camera steady enough to shoot handheld brackets for a single HDR image, you should rely on a tripod when shooting panoramas in HDR. Likewise, a remote shutter release comes in very handy. If your compact digital camera or dSLR has a panorama feature, you may be able to use it in conjunction with AEB. Use the on-screen display to line up the next set of brackets with the previous one. Most dSLRs do not have this capability, however, so you have to line up the photos yourself. Ideally, you want an overlap of 20 to 30 percent between each set of images.

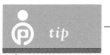

tip

Use the focus points in your camera to line up landmarks.

9-4

ABOUT THIS PHOTO *The Liverpool Viking, taken from Birkenhead, Wirral, United Kingdom. (ISO 100, f/8.0, 1/50 second, Canon 24-70mm f/2.8 at 70mm) © Pete Carr*

To get started in creating panorama photos, follow these steps:

1. **Set up your shot.** Get your gear out and get ready. Attach the camera to your tripod and attach the remote shutter release, if you have one. Some tripods have built-in spirit levels, which can be handy for getting your tripod level on uneven ground. If yours doesn't, you can buy a spirit level that goes in your flash hot shoe.

2. **Center and level the camera for the first set of bracketed images.** Frame the center of the scene.

3. **Pan your camera left and right to make sure it doesn't tilt too much.** Ideally, you want the camera level with the horizon as you pan.

4. **Align the camera where you want to start and shoot the first set of images.** Begin with the left or right side of the panorama. It doesn't really matter which. It helps to note your focus points and the objects you want to use to ensure overlapping coverage.

5. **Reposition the camera for the next set of images and continue.** After completing the first series of brackets, reposition the camera (remembering to overlap) and continue shooting bracketed photos along the panorama. Continue this step until you have all the bracketed coverage you want.

This is a fairly straightforward process once you get the hang of it. Shoot brackets, pan, shoot brackets, pan, shoot brackets, done.

CREATING THE HDR IMAGE

The next step is to convert each frame to an HDR image and complete tone mapping before proceeding to merge the left-to-right frames together as a panorama. Completing the HDR for each frame distills the large number of photos with different exposures with which you have to work, and ensures a level playing field for stitching the panorama together. This is opposed to creating panoramas from each layer of the bracket and then trying to push the entire bracketed panorama though Photomatix or another HDR application.

Follow these basic steps to create the HDR files that you can then stitch into a panorama:

1. **Convert RAW files to TIFF images.** This ensures the best results going into the HDR software.

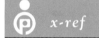

x-ref

Please refer to Chapter 3 for more information on generating HDR images. For more comprehensive information about tone mapping, see Chapter 4.

2. **Load a frame of bracketed images into Photomatix and decide on your HDR settings.** Image 9-5 shows the center frame of a series of shots for a panorama loaded into Photomatix with the Tone Mapping settings pane open. Initially, the settings from Chapter 4 were used, but they did not provide a decent result — the image was too flat and lacked contrast. To compensate for this, Luminosity was reduced to 0, which brought contrast back to the image. Strength was increased to 80 percent to add more punch. Gamma was set to 1.0, the Black Point to 0.01, and the White Point to 0.5. This helped bring out the detail in the shadows and highlights, and the image wasn't as dark as before.

3. **Process and save the result.** Make sure to save the tone mapping settings with the image so you can use them for the other parts of the panorama.

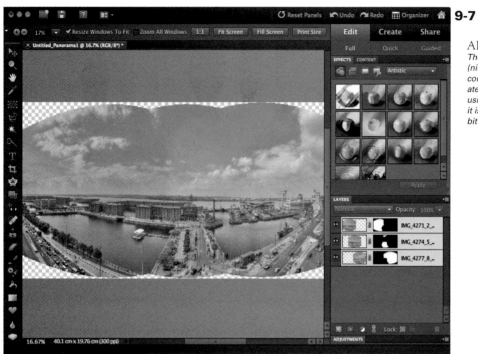

ABOUT THIS FIGURE
The result of three HDR images (nine original bracketed photos) combined into a panorama created in Photoshop Elements using Photomerge. Notice that it isn't perfect and still needs a bit of work. Image © Pete Carr

ABOUT THIS FIGURE
Hiding a layer allows you to see a merge point of the photos. Image © Pete Carr

As with any other image, you may need to eliminate some noise, clone dust away, make levels adjustments, and dodge or burn. You can convert the image to black and white or add some contrast to give it that final dramatic touch.

Image 9-9 sums everything up nicely: wide-angle skies, dramatic clouds, interesting scenery, shooting into the sun, and panoramic HDR. It shows how all of these elements combine to produce dramatic effects. While HDR didn't particularly help on the right side of the image (the light was shining on that area), it helped quite a bit with the left side as those frames were shot more directly into the sun. HDR helped bring out the detail in the clouds and created a balanced-looking panorama from a spot that isn't accessible to the public.

FUN STUFF

HDR is not a monolithic discipline where everyone has to take the same photos. Gathered here are more scenes and subjects that show the techniques and benefits of shooting and processing HDR photography, this time with various kinds of vehicles. They are very popular subjects. Studying and shooting them expands your creative horizons.

REFLECTIONS

Water and HDR mix exceedingly well. Water is often so interesting in HDR because HDR enables you to capture reflections while balancing

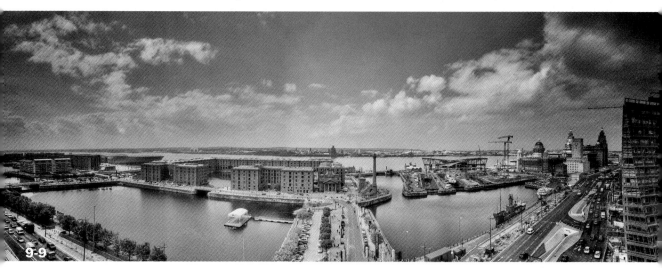

ABOUT THIS PHOTO *This panorama of the Albert Docks in Liverpool was created from six sets of bracketed images (18 total photos), each at -2/0/+2 EV. (ISO 100, f/8.0, 1/200 second, Canon 24-70mm f/2.8 at 24mm) © Pete Carr*

the brights and darks in the scene. Image 9-10 is the 0 EV bracket of a river scene. Notice that the camera metered for the brightness in the sky reflecting off the water. The clouds are darker, and the foliage in the foreground and at the top of the photo are darker still. The other brackets show similar exposure compromises. If you can see the leaves, the sky is blown out. When you can see the sky, everything else is too dark.

HDR photography offers the kind of exposure solution that enables you to capture the range of darks and lights in a scene like this without losing either end. The completed HDR image, created from nine bracketed exposures, is shown in 9-11.

It's a magical scene. The leaves in the foreground are real — they were near the bank of the river. Everything else, apart from the floating leaves, is a reflection. Those leaves call out the fact that what you're seeing is actually a reflection in water.

9-10

ABOUT THIS PHOTO *The 0 EV exposure of a reflection in a river. (ISO 100, f/8.0, 1/50 second, Canon EF-S 18-135mm f/3.5-5.6 IS at 18mm) © Robert Correll*

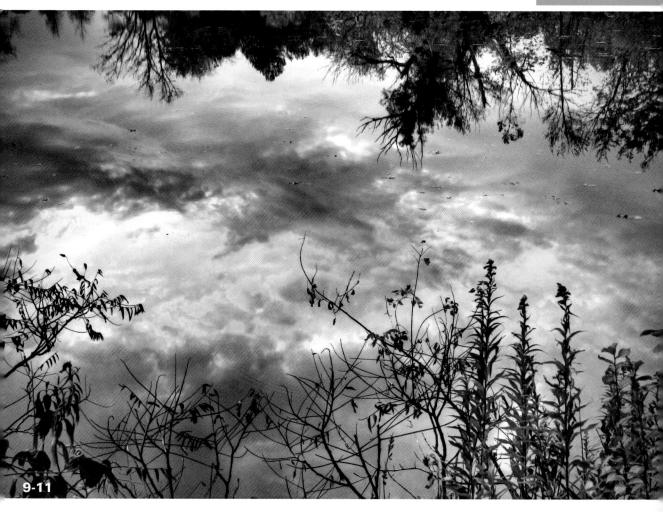

9-11

ABOUT THIS PHOTO *Reflections in HDR. HDR from three exposures, taken at -2/0/+2 EV. (ISO 100, f/8.0, 1/50 second, Canon EF-S 18-135mm f/3.5-5.6 IS at 18mm) © Robert Correll*

OUT FOR A WALK

You never really know what you might run into when you're out for a walk. HDR photography is at your fingertips if you have your camera with you, it shoots reasonably fast, and it has a decent AEB feature. You don't always need a tripod and remote shutter release, especially if you practice the art of holding your camera steady when shooting.

The key is to be on the lookout for scenes that touch you. Set your camera to Aperture priority mode, dial in your favorite f-number, and have the number of brackets and exposure distance set up in AEB beforehand. With everything set up, you can be ready for and shoot HDR almost as fast as traditional single exposures.

Image 9-12 shows a bench beside a tree just off a walkway. This is the 0 EV exposure. A pair of abandoned flip-flops sits in front of the bench. It's poignant and colorful. The blue sky beyond contrasts with the fall-colored foliage in the tree, the bushes, and on the ground. The problem is that the exposure is too great for a single shot to capture.

Image 9-13 shows the scene after three brackets were processed in Photomatix Pro and tweaked slightly in Photoshop. Light is much more balanced across the scene. The sky is darker and

bluer than the 0 EV exposure, while the foreground is much brighter. Details are clearer, cleaner, and the result is a much-improved photo.

The tone mapping settings were all over the place. Strength was set to 72 percent and Color Saturation to 70 percent. Luminosity was raised to 6.3 while Detail Contrast was left at 0. Lighting Adjustments was lowered to -4.9 (because there was so much texture to the photo, it wasn't necessary). White Point was raised to 4 to brighten the image. The Temperature was lowered to -10 to bring out the blue in the sky. Micro-smoothing

ABOUT THIS PHOTO *The 0 EV exposure of a scene noticed while on a walk. (ISO 250, f/8.0, 1/30 second, Canon EF-S 18-135mm f/3.5-5.6 IS at 18mm) © Robert Correll*

ABOUT THIS PHOTO *HDR brings out details in the foreground and keeps the sky from blowing out. HDR from three camera raw exposures, taken at -2/0/+2 EV. (ISO 250, f/8.0, 1/30 second, Canon EF-S 18-135mm f/3.5-5.6 IS at 18mm) © Robert Correll*

was lowered to 2. In Photoshop, Curves was used to strengthen the contrast and the entire image was desaturated because the colors were overpowering out of Photomatix.

SHIPS

Ships are stunning subjects to photograph. They are majestic, stately, and larger than life. The water, sky, clouds, and skyline present fantastic scenery in which to capture a ship. If you plan to get close, though, ships do require a wide-angle lens.

Image 9-14 shows a creative attempt that was limited by the camera's dynamic range. The idea was to produce a beautifully symmetrical photograph by capturing the warship and its reflection. Unfortunately, the settings required to get a good exposure on the real ship (on the left side) blew out most details in the sky. Notice that the clouds in the reflection are exposed well and look a lot nicer than those on the left, but the reflected ship isn't as well exposed. An ND graduated filter would have helped, but it still would have left the

9-14

ABOUT THIS PHOTO *The HMS Daring docked in Liverpool. Original 0 EV exposure. (ISO 200, f/8.0, 1/200 second, Nikon 14-24mm f/2.8 at 24mm) © Pete Carr*

clouds on the other side of the image a bit over-exposed. Additionally, filters did not fit on the Nikon 14-24mm lens at that time — so, HDR to the rescue.

A tripod was used, and seven exposures were taken, ranging from -3 to +3 EV. This produced a great series of images with a broad dynamic range good enough for this scene. The settings from Chapter 4 were applied and the image started to come alive, as shown in 9-15. Suddenly, there were clouds on the left and the ship on the right looked great. It was a well-balanced exposure that fit with the creativity of the photo. However, it was a little dark, so the Gamma was increased from 0.9 to 0.7.

After some further processing, the result is shown in 9-16. The Saturation was reduced in the image to give it a more muted feel and a vignette was applied around the image to darken the clouds without darkening the ship.

If you can get the right angle, capture ships during sunset or sunrise, as shown in 9-17. This was a lovely, calm evening on the River Mersey. Compositionally, the sun was on the left with enough space between it and the boat to cause them to play off each other.

This is a classic high-contrast HDR scene, shot as five bracketed exposures, -2/-1/0/+1/+2 EV. Shooting with 1 stop between each bracket instead of 2 can sometimes result in a smoother transition.

Of course, that standard photo shows a lot of brightness from the sun and little detail in the ship. The problem is that the scene has too high of a contrast ratio. The darkest black points and brightest white points are simply too far apart for the camera to capture in a single exposure. This scene perfectly illustrates why exposure brackets are so important for HDR. You capture everything you need in little chunks and then put them together later.

9-15

ABOUT THIS PHOTO *The HMS Daring docked in Liverpool. HDR from seven camera raw files. (ISO 200, f/8.0, 1/200 second, Nikon 14-24mm f/2.8 at 24mm) © Pete Carr*

ABOUT THIS PHOTO
The HMS Daring docked in Liverpool. HDR from seven camera raw files. (ISO 200, f/8.0, 1/200 second, Nikon 14-24mm f/2.8 at 24mm)
© Pete Carr

9-16

ABOUT THIS PHOTO
The cruise ship Patricia docked in Liverpool. HDR from seven camera raw files. (ISO 200, f/16, 1/50 second, Nikon 85mm f/1.8)
© Pete Carr

9-17

This scene, for example, was shot in five brackets, which were then loaded into Photomatix Pro. The standard settings from Chapter 4 were used as a starting point. The only setting altered was the Gamma to make the scene a little brighter — it was changed from 0.9 to 0.7. Other than that, the image looked great. The scene was too serene to add dramatic, brooding skies or other enhancements. The result is shown in 9-18.

The final image, 9-19, was created with HDR and is more alive than the original. There are many details in the terminal and the ship, along with the sky, but this was done without losing detail in the sunset itself. There was one problem, though — the white balance was slightly off. This was probably due to the camera being affected by the golden sunset and adjusting the white balance for it. As the boat had a clearly visible yellow colorcast, the white balance was tweaked to make it look normal without destroying the sunset. A vignette was also added to darken the sunset around the ship.

9-18

ABOUT THIS PHOTO *The cruise ship Patricia docked in Liverpool. HDR from seven camera raw files. (ISO 200, f/16, 1/50 second, Nikon 85mm f/1.8) © Pete Carr*

9-19

ABOUT THIS PHOTO *The cruise ship Patricia docked in Liverpool. HDR from seven camera raw files. (ISO 200, f/16, 1/50 second, Nikon 85mm f/1.8) © Pete Carr*

CARS

People love taking photos of cars, especially their own freshly washed and waxed vehicles. Next time you get the itch, take your car out to a scenic location and treat it to an HDR photo shoot. With HDR, you don't have to be in advertising with a huge travel budget that takes you to the south of France or Austria with amazing mountain ranges, wonderful skies, and perfectly lit cars. You shouldn't turn that down if it comes your way, but with HDR, it's possible to achieve startling results on a more realistic budget.

First, find the right backdrop. You want something that complements the car — maybe a deep valley with mountains on both sides, or a rugged scene with woods and a lake. Industrial areas can also make great backdrops. You can also go the opposite route and shoot on a completely flat surface at sunset — be creative.

> *note*
>
> Remember the Rule of Thirds when composing shots with cars. Overly crazy angles don't work well here, even if the landscape is dramatic. It upsets the eye, and people wonder why the horizon is off. If your audience has to tilt its head too far, then something is off.

Image 9-20 shows a Honda S2000 at sunset after a quick drive. It was completely unplanned, and the strobes, reflectors, lamps, and other professional lighting equipment required for a traditional shoot wouldn't have fit in the car anyway. You can see the problem with this scene. The background is very bright and the foreground is too dark. The front of the car isn't lit.

The obvious way to fix this would be to set up a flash, adjust the camera for the sunset, and fill in the foreground with that flash. However, you don't always go out on a casual drive with all of your gear. If you have HDR knowledge, though, you don't always have to.

With HDR, it is possible to shoot directly toward the bright sunset without sacrificing details, using only a dSLR and a tripod (or just a fast dSLR). The trick is to hide the sun behind something, which in this case is a car. That prevents the sun from being a large blob of blown-out highlights that are too bright for HDR to rescue.

9-20

ABOUT THIS PHOTO *A Honda S2000 at sunset. This is the 0 EV exposure. (ISO 200, f/22, 1/50 second, Sigma 10-20mm f/4-5.6 at 20mm) © Pete Carr*

The standard settings from Chapter 4 were applied but the image didn't look quite right. Every image has different lighting conditions, and while the settings in Chapter 4 work for a lot of them, you have to be able to adjust them if they don't.

The main problem was that the image was too dark. Specifically, the car was dark while the sunset was nicely exposed. To correct this and brighten the image, the Gamma was increased from 0.9 to 0.7. The Black Point was decreased to reduce the strength of the blacks in the image. This also made the image appear brighter. Strength was reduced from 75 to 52 percent, again to make the image appear brighter and reduce the vignette around the edge.

By this point, the image looked brighter, but also tonally flatter. The contrast had been reduced. To correct the contrast problem, the Luminosity was reduced from +5 to +2.5 — just enough to add some contrast back into the image. Lastly, the Micro-smoothing was adjusted from +10 to +5 to darken the sky without drastically affecting the other changes. The processed HDR is shown in 9-21.

The image is a definite step up from the original 0 EV exposure, but it's still not quite polished. Remember, Photomatix isn't a full-fledged image editor like Photoshop Elements. Complete the HDR to the best of your ability in Photomatix and then export it to Photoshop for final

9-21

ABOUT THIS PHOTO *A Honda S2000 at sunset. Tone-mapped HDR from three camera raw exposures, -2/0/+2 EV. (ISO 200, f/22, 1/50 second, Sigma 10-20mm f/4-5.6 at 20mm) © Pete Carr*

adjustments. In this case, the white balance was tweaked and the tone curve adjusted to add a bit more contrast. The final image is shown in 9-22.

You don't have to shoot the entire vehicle. Often, something more narrowly focused captures your attention. Image 9-23 is a close shot of the hood ornament and grille of an old Duesenberg at the Kruse Automotive and Carriage Museum in Auburn, Indiana.

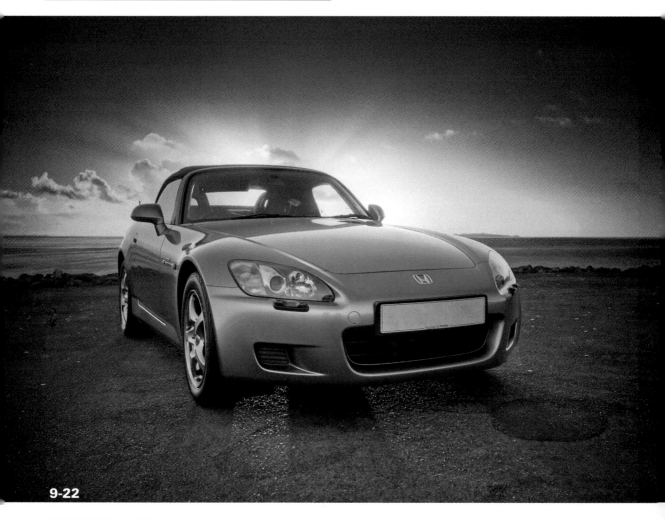

9-22

ABOUT THIS PHOTO *A Honda S2000 at sunset. The final image after Photoshop. Tone-mapped HDR from three raw exposures, -2/0/+2 EV. (ISO 200, f/22, 1/50 second, Sigma 10-20mm f/4-5.6 at 20mm) © Pete Carr*

You should immediately note that there is nothing wrong with this photo. The image was developed from the 0 EV camera raw exposure using Nikon Capture NX 2. It's bright, clear, clean, and colorful. You might think that there's no reason to process this as HDR. If so, you're both right and wrong.

Sometimes, HDR isn't just for solving exposure problems. There are times when you can get a fantastic shot from a single camera raw exposure like this one. However, if you never try, you won't realize that you can often achieve (subtly or not) *different* results from HDR.

9-23

ABOUT THIS PHOTO *Duesenberg hood ornament. Camera raw exposure processed in Nikon Capture NX 2. (ISO 100, f/4.0, 1/3 second, AF-S NIKKOR 50mm f/1.4G) © Robert Correll*

Image 9-24 shows the tone-mapped HDR image for comparison. It's not better, per se, than the single camera raw exposure, but it is different. Details in the chrome, which has a slightly different sheen to it, stand out more. The red of the hood is more vibrant, and the background is brighter and more colorful. To achieve this effect, five brackets were loaded into Photomatix Pro and the standard settings from Chapter 4 were used.

Old, worn-out vehicles have a tremendous amount of character that is wonderfully accentuated in HDR. They can be rusting, dented, banged up, falling apart — it doesn't matter. Rust in particular seems to show up beautifully in HDR. Image 9-25 shows the 0 EV bracket of an abandoned car and dump truck sitting in the grass beside a building. The lines created from this angle separate the photo into triangular regions.

As you can see, the sky is on the verge of blowing out and darker details under the car and truck are almost lost.

The truck bed on the left is streaked and spotted, having been aged with time and use. The Pontiac is pitted and worn out. If you look closely, you can see a large hole in the windshield on the driver's side. This was taken close-up in order to capture the small texture and surface variations. It was rendered in HDR using five bracketed exposures taken 1 EV apart.

As you can tell from 9-26, it is rendered dramatically. Strength was raised to 100 percent to make it appear more dramatic. Luminosity and Detail Contrast were both increased to 7.1 to enhance details and contrast. The final image was post-processed in Photoshop. Dust spots were removed, and small Levels and Curves adjustments balanced the colors and contrast a bit better.

9-24

ABOUT THIS PHOTO
Compare the processed camera raw image to this tone-mapped HDR image. The results are different, but arguably comparable. HDR from five camera raw exposures taken at -2/-1/0/+1/+2 EV. (ISO 100, f/4.0, 1/3 second, AF-S NIKKOR 50mm f/1.4G) © Robert Correll

ABOUT THIS PHOTO

An abandoned dump truck and car, 0 EV. (ISO 100, f/8.0, 1/60 second, Sigma 10-20mm f/4-5.6 at 11mm) © Robert Correll

ABOUT THIS PHOTO

A beautifully rusting, abandoned dump truck and car. HDR from five camera raw exposures, bracketed at -2/-1/0/+1/+2 EV. (ISO 100, f8.0, 1/60 second, Sigma 10-20mm f/4-5.6 at 11mm) © Robert Correll

tip

Return to your favorite scenes and keep photographing them. You learn a great deal by analyzing how your photos change and what contributes to how good they look. Choose different tone-mapping settings and closely track how they change the image. Note what works and what doesn't.

SHOOTING SMALL-SCALE HDR

HDR photography isn't just for sweeping panoramic land- and cityscapes. You can use it in a variety of circumstances, both large and small. Image 9-27 shows a nut and a bolt in a rusty piece of metal. The city was undertaking some heavy-duty storm drain improvements near Robert's home. He walked by and took some shots of the construction equipment and material.

While this scene doesn't scream HDR, it has more promise than you might think. HDR works wonders with textures and color. Robert shot three quick handheld brackets using AEB, mostly just to see what it would look like in HDR.

Image 9-28 shows the result. The tone-mapping settings, not surprisingly, were used to bring out the grit and texture of the rust and the bolt. Strength was 100 percent and Luminosity was 4.5. Detail Contrast was lowered to -4.0. Lighting Adjustments was lowered to High and the White

Point was raised to over 4. The Temperature was lowered to -1.0 to counter the very red scene, and Micro-smoothing was lowered from 10 to 5.

In the end, 9-28 is a great example of shooting a small subject in HDR and coming up with something very interesting. Image 9-29 is another example of HDR on a smaller scale. In this instance, Robert was shooting in the National Military History Center, also in Auburn, Indiana. The scene is a close-up of an M4 tank advancing down a snow-covered street during the winter of 1944. Because the scene is actually a diorama encased in glass, using a flash was impossible. The best way to capture this scene is with HDR.

The finished, tone-mapped image is shown in 9-30. It's obvious that the colors and lighting are much more vibrant. Although the tone mapping settings emphasize contrast and detail, it's not an outlandish result. Strength was set to 100 percent and Color Saturation to 80 percent. These are both high, and result in better detail and color. Luminosity was raised to 7.4 and Detail Contrast to 5.5. White Point was maximized. Notice that this was shot with a 50mm prime lens — not something you normally see with HDR. The lesson here is to use whatever you have with you.

9-27

9-28

ABOUT THIS PHOTO *Close-up shot of a nut and bolt in a rusty piece of metal. Single camera raw exposure. (ISO 250, f/8.0, 1/125 second, Canon EF-S 18-135mm f/3.5-5.6 IS at 79mm) © Robert Correll*

ABOUT THIS PHOTO *HDR brings out the texture and color of the rust, in addition to details in the nut and bolt. HDR from three camera raw exposures taken at -2/0/+2 EV. (ISO 250, f/8.0, 1/125 second, Canon EF-S 18-135mm f/3.5-5.6 IS at 79mm) © Robert Correll*

ABOUT THIS PHOTO *Close-up of a diorama taken indoors through glass without a flash. (ISO 100, f/4.0, 1/3 second, AF-S NIKKOR 50mm f/1.4G) © Robert Correll*

9-29

9-30

ABOUT THIS PHOTO *Close-up of a diorama taken indoors through glass without a flash. HDR brightens and evens the exposure, adding vibrancy to the shot. HDR from five camera raw exposures, taken at -2/-1/0/+1/+2 EV. (ISO 100, f/4.0, 1/3 second, AF-S NIKKOR 50mm f/1.4G) © Robert Correll*

WORKING WITH MOVEMENT

Moving objects and HDR generally do not go well together. The problem is quite simple. As you take multiple photographs of the same scene, some objects (like boats, planes, people, clouds, leaves, and cars) may move between frames. When it comes to merging them, you have the overexposed area in one photo, say, on the left, the middle 0 EV exposure in the center of the image, and the underexposed area on the right of the image. Photomatix cannot line up these three aspects to produce a clean HDR image. Instead, you get what is called ghosting across the image.

The easiest way to overcome this is to try to avoid it in the first place. That may sound obvious, but it's the best way. If you don't photograph moving objects, you don't have to worry much about ghosting. At other times, however, it is impossible to avoid capturing movement. If you can, time your shots to avoid movement. If you are shooting a cityscape, wait for the traffic lights to stop the traffic, and then take your photos. If there are people around, wait for a clear shot.

Another method to prevent or minimize ghosting is to take longer exposures. This makes objects in motion appear to disappear from the photo because they slip through and aren't there long enough to register much on the sensor. This may not work for the exposures on the dark end of the bracketed set, which have faster shutter speeds, but the moving objects might be too dark to see in those photos anyway. Try a few sequences with different speeds and check the results.

To get a longer exposure, set the ISO as low as possible and increase the f-number to f/22 (this decreases the aperture), or as narrow an aperture as you can get. This restricts the light and increases the exposure time. If that isn't enough,

try adding Neutral Density (ND) filters to the lens. These filters help reduce the amount of light that gets into the lens, thus increasing the exposure time. They also enable you to shoot in broad daylight and, hopefully, avoid capturing objects in motion.

The third method is to utilize the Photomatix Pro Selective Deghosting tool. This option is presented when you import your images to create the HDR image. It is very simple to use and works wonderfully. The automatic method works very well in most situations, but when you need to identify moving objects yourself, the selective option is the method to use.

When the first options appear (see Chapter 4 for a refresher on the Preprocessing Options dialog box), set Remove Ghosts to the with Selective Deghosting tool option. After a few moments, the Selective Deghosting window appears with a reasonably exposed preview of the photo. Draw a circle around any areas you want to fix, as shown in 9-31, right-click in the circle, and then select Mark selection as ghosted area.

After you've done a few, click Preview deghosting to see the results, as shown in 9-32. The ghosting should now be removed. If it isn't, you can adjust which exposure the deghosting uses for the object by right-clicking the selected area and choosing Set another photo for selection. Select another photo from the list. When you are happy with the results, click OK and continue with the HDR process.

tip

If you're sneaky, you can use the Photomatix Selective Deghosting tool to pull information from any bracket you want, regardless of whether you need to because of movement.

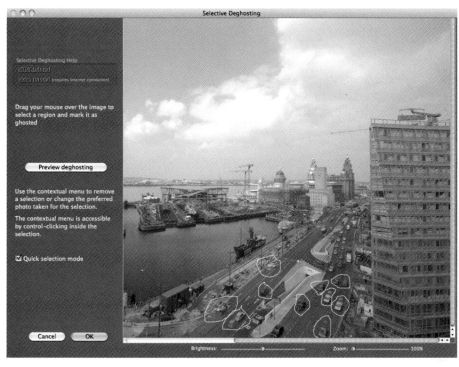

9-31

ABOUT THIS FIGURE
*Selective Deghosting in
Photomatix before it is applied.
Image © Pete Carr*

9-32

ABOUT THIS FIGURE
*Selective Deghosting in
Photomatix after it has been
applied. Image © Pete Carr*

GETTING CREATIVE WITH PSEUDO-HDR

While HDR involves shooting exposure brackets and combining those shots into an HDR image, it is possible to tone map a single camera raw exposure in Photomatix.

x-ref

For more information on using single camera raw exposures to create pseudo-HDR, see Chapter 4.

When possible, of course, you should try to shoot exposure brackets of a scene for HDR, regardless of whether you use a tripod. This allows you to capture more of the dynamic range of a scene than is possible with a single exposure. The problem is many subjects don't remain still long enough for you to shoot the brackets. You only get one chance, whether you like it or not.

You always have the choice of processing your single exposures normally. If you shoot raw, that means developing or converting the raw exposure to a TIFF or JPEG using an application such as Photoshop, Photoshop Elements, Lightroom, Aperture, or the software that comes with your camera. If you use JPEGs, you can use the same software to touch up your photos, but you are starting from already-converted data.

If you shoot camera raw images, however, you have another option: tone mapping the exposure (whether singly or creating your own exposure brackets from a single photo) in Photomatix Pro. While the rest of this book focuses on using proper exposure brackets for HDR, this section shows you a few examples of how you can be creative with single camera raw exposures and HDR software.

CREATIVE PROCESSING

It is possible to create HDR photographs of people. You have to be very careful, though, because people have an expectation of how someone

should look. If you push it too far, it looks strange and unreal. What you should aim for is more detail in the scene but not the person. People shouldn't look overprocessed.

The image in 9-33 was taken at a swimming pool in Indiana after this guy's lesson was over. The mid-morning sun was bright and the camera was on Shutter priority mode. The flash didn't

9-33

ABOUT THIS PHOTO
Swim lessons are over. The 0 EV exposure. (ISO 100, f/8.0, 1/400 second, Sony 18-70mm f/3.5-5.6 at 30mm)
© Robert Correll

automatically fire, which meant that nearby details of the subject were not captured as well as they could have been.

When you drop a RAW file into Photomatix, you are presented with a few options, as shown 9-34. All you need to do is make sure that White Balance is set to As Shot and Color space is set to sRGB, and then click OK. The RAW file then loads and you see the normal Photomatix tone map screen.

The image in 9-35 had the settings from Chapter 4 applied and looked very good. Initially, Luminosity was raised to 5 to balance the lighting on the subject's face and Detail Contrast was also

9-34

ABOUT THIS FIGURE *The Photomatix camera raw image import options.*

9-35

ABOUT THIS PHOTO *Swim lessons are over. HDR from a single camera raw exposure dropped into Photomatix. (ISO 100, f/8.0, 1/400 second, Sony 18-70mm f/3.5-5.6 at 30mm) © Robert Correll*

raised. However, a head-to-head comparison revealed that those changes didn't make the image any better. In the end, Color Saturation was increased from 50 to 60 to make the water, towels, and swimsuits stand out. Nothing else was changed.

The final result is shown in 9-36 after a few more tweaks in Photoshop.

Note that there is no need to convert a RAW file to a TIFF when working with pseudo-HDR — just drop it into Photomatix. In fact, the single TIFF often produces worse results.

9-36

ABOUT THIS PHOTO *Swim lessons are over. HDR from a single camera raw exposure dropped into Photomatix and tweaked in Photoshop. (ISO 100, f/8.0, 1/400 second, Sony 18-70mm f/3.5-5.6 at 30mm) © Robert Correll*

BALANCING EXPOSURE

It's also possible to use pseudo-HDR to balance lights and darks in certain photos. If you want to try this, use well-exposed photos without a lot of dark regions, as Photomatix pushes the exposure around and elevates noise. Image 9-37 shows a casual photo of Robert's youngest son smiling for the camera. This is the camera-processed JPEG and there's not much wrong with it. The photo could be more vibrant, though, and there are some minor shadow problems.

While you could certainly use normal photo editing or RAW file processing techniques to make this photo better, it's possible to even the exposure by using Photomatix, in essence, as a RAW file processor. The key is to try not to do too much in Photomatix. Let it balance the exposure — handle contrast and color afterward.

The single camera raw exposure was tone mapped in Photomatix Pro using the basic settings from Chapter 4. Only two changes were made. Light

9-37

ABOUT THIS PHOTO *This unprocessed JPEG from the camera isn't bad, but could be improved. (ISO 100, f/3.5, 1/1600 second, Canon EF-S 18-55mm f/3.5-5.6 IS at 18mm) © Robert Correll*

mode was unchecked and Lighting Adjustments was raised to 10. Also, Micro-smoothing was raised to 30. These changes kept the photo looking very realistic. This was not an exercise in artistry as much as straightforward image processing.

The photo was then opened in Photoshop and a curve was applied to enhance the contrast and color. Image 9-38 shows the result. When you compare it to 9-37, the photo looks more balanced and vibrant. Instead of a dark center and bright edges, it's reversed. The center of the photo is now the center of attention. While the sky is more vibrant, it is also darker than in the original. Photomatix was able to attenuate the brightness of the sky very well.

9-38

ABOUT THIS PHOTO *Single camera raw exposure processed as pseudo-HDR balances the exposure across the frame. (ISO 100, f/3.5, 1/1600 second, Canon EF-S 18-55mm f/3.5-5.6 IS at 18mm)* © Robert Correll

Assignment

Amaze Us with Your Creativity

Your assignment this time is to amaze us with your creativity. Find something outside the normal areas of architecture, city- and landscapes, and interiors. Perhaps a bit of public art, a run-down car, or even a plane if you can legally get access to one. If you feel adventurous, have a go at a panorama.

Generate the HDR, tone map the result and then post process it in Photoshop Elements or the tool of your choice.

Pictured here is the Liverpool One Wheel — a great tourist attraction. It was photographed just at the moment it stopped so there was no motion. Generated from seven camera raw exposures, bracketed at -3/-2/-1/0/+1/+2/+3 EV. Taken at ISO 3200, f/13, 1/40 second with a Nikon 14-24mm f/2.8 at 14mm.

© Pete Carr

Remember to visit www.pwassignments.com after you complete this assignment and share your favorite photo! It's a community of enthusiastic photographers and a great place to view what other readers have created. You can also post comments, read encouraging suggestions, and get feedback.

© Pete Carr

You don't have to create ultra-realistic HDR images with natural color tones if you don't want to. There's room for much more. In fact, HDR lends itself very well to the same sorts of artistic treatment that traditional photography has long enjoyed.

The most significant of these areas is black-and-white HDR photography. This topic is covered in depth in this chapter, including what to look for as you seek out opportunities to create black-and-white HDR images, as well as how to covert images from color to black and white.

Other creative possibilities include adding color tones to black-and-white HDR images and using cross-processing techniques to create other-worldly tinted photos.

Of course, it all starts with HDR. You follow the same techniques you've read about thus far: Shoot the exposure brackets, tone map them in Photomatix Pro, save the results, and then use your favorite photo editor to convert the color image to black and white. If you like, you can add other tints back in to the image.

THINKING IN BLACK AND WHITE

It takes training to see in black and white because humans are very consciously aware of color — the color of the subjects, background, light, and reflections. A black-and-white photographer should be able to see a scene differently — for example, the long, deep shadows, and rich contrast between the dark areas and highlights.

The beauty of black and white is a paradoxical combination of simplicity and complexity. With color information artfully removed, you are able to focus on tonal variations, and the play of light and shadow, texture, and contrast. Your eyes respond to different stimuli with black and white than they do with a color photograph — they soak up tones and details, such as those shown in 10-1.

You might think that 10-1 is from a single camera raw exposure because of the moving horses. It was actually created from three exposure brackets taken at the scene at -2/0/+2 EV. Thanks to the Photomatix ghost removal tool (see Chapter 9 for more information) the ghosting caused by the movement of the horses between frames was reduced. Before Photomatix had the Selective Deghosting option, the best approach was to take a single camera raw exposure and process it with (if anything) pseudo-HDR. However, that approach doesn't give you the same amount of dynamic range or noise control that you get from using three bracketed exposures.

The standard settings from Chapter 4 were applied to this image, but the whites in the clouds and horses turned gray. To fix that, the Luminosity was set to 0. This happens when Photomatix tries to bring back detail in white areas. There's no data there, so converting this image to black and white in the end was better than leaving those areas gray. The Luminosity adjustment overexposed some of the clouds, so the White Point was reduced and the Gamma increased from 0.9 to 0.8 to brighten the image.

You don't need to think in terms of black and white for every photo, obviously, but be open to the circumstances and recognize the possibilities for it.

WHAT TO LOOK FOR

Generally speaking, you should follow the same technical principles when shooting for black and white as you would for color HDR photography. Seek out high-contrast scenes. On a stunningly beautiful clear day, try to shoot during the Golden Hour as this is the best time to capture long shadows, which look striking in black and white.

The photograph in 10-2 is of an old boat on Heswall Beach. Due to the dynamic range limitations of the camera, you can see only the boat as

ABOUT THIS PHOTO
Horses in Storeton, United Kingdom. Created from three camera raw images. After HDR, it was converted to black and white. (ISO 320, f/8.0, 1/125 second, Sigma 10-20mm f/4-5.6 at 10mm) © Pete Carr

ABOUT THIS PHOTO
An old boat on Heswall Beach, United Kingdom. Single camera raw image, 0 EV. (ISO 200, f/22, 1/160 second, Nikon 14-24mm f/2.8 at 19mm) © Pete Carr

a silhouette. It's not a bad image — perhaps if the silhouette was more pronounced it would be more interesting. Unfortunately, the boat blends into the landscape too much. However, looking at it in black and white (see 10-3) reveals promise. There's a lovely contrast between the clouds and the sky, but not much else to it.

Shooting directly into the sun like this requires a good range of bracketed photographs. This scene required seven exposures ranging from -3 to +3 EV to ensure that the image would be noise free and have enough detail in the shadows while retaining the highlights.

The standard settings from Chapter 4 were applied to this photo. The image was okay and had plenty of detail in the foreground, but it was a bit dark. You can try changing the Gamma to lighten a photo. In this case, the Gamma was adjusted from 0.9 to 0.7, and the Strength was reduced from 75 to 50 percent. The result can be seen in 10-4.

10-3

ABOUT THIS PHOTO *An old boat on Heswall Beach, United Kingdom. Single camera raw image, 0 EV. (ISO 200, f/22, 1/160 second, Nikon 14-24mm f/2.8 at 19mm) © Pete Carr*

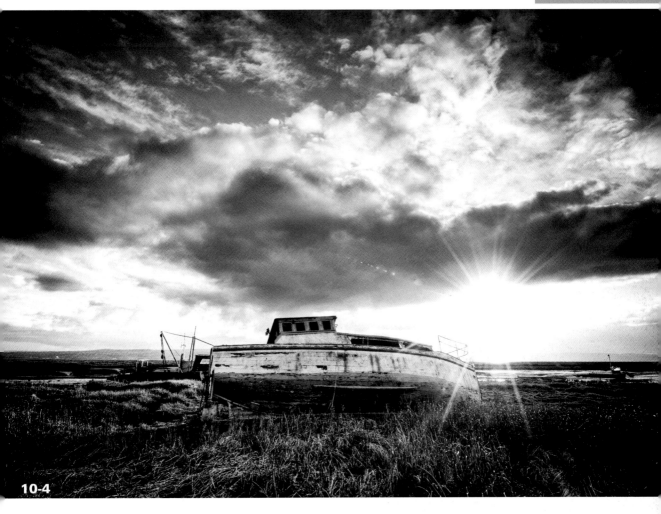

10-4

ABOUT THIS PHOTO *An old boat on Heswall Beach, United Kingdom. HDR from seven camera raw files, -3/-2/-1/0/+1/+2/+3. (ISO 200, f/22, 1/160 second, Nikon 14-24mm f/2.8 at 19mm)* © Pete Carr

THE FOCUS

A well-composed and processed black-and-white photo gets straight to the point without distraction. It does this through tone and contrast. The result is as if you were using depth of field to focus on someone or something specific in a photo. For example, 10-5 is an HDR image of The Sage in Gateshead, United Kingdom. You can instantly see the great contrast between the interior and exterior of the building. The black-and-white image draws your attention to that aspect, which is mirrored in the water, more than anything.

10-5

ABOUT THIS PHOTO *The Sage in Gateshead, United Kingdom. HDR created from five camera raw exposures, -2/-1/0/+1/+2. (ISO 640, f/11, 1.3 seconds, Nikon 24-70mm f/2.8 at 32mm) © Pete Carr*

The original 0 EV exposure is shown in 10-6. It's been metered for the inside of the building at the cost of the overall scene. The result of taking the brackets into Photomatix HDR and tone mapping the scene can be seen in 10-7. Details in the darkness have been brought out without sacrificing detail in the highlights. This gives you plenty of detail to work with when producing the black-and-white image.

SHOOTING ON OVERCAST DAYS

Another benefit of black and white is that it opens up more possibilities for you as a photographer than if you shoot with only color in mind. You can shoot on days when color would look dull, such as overcast days which are prone to flat colors, making color images appear lifeless. Blue skies with white, fluffy clouds are replaced with a blanket of gray.

ABOUT THIS PHOTO *The Sage in Gateshead, United Kingdom. Original 0 EV exposure. (ISO 640, f/11, 1.3 seconds, Nikon 24-70mm f/2.8 at 32mm) © Pete Carr*

10-6

10-7

ABOUT THIS PHOTO *The Sage in Gateshead, United Kingdom straight from Photomatix. HDR created from five camera raw exposures, -2/-1/0/+1/+2. (ISO 640, f/11, 1.3 seconds, Nikon 24-70mm f/2.8 at 32mm) © Pete Carr*

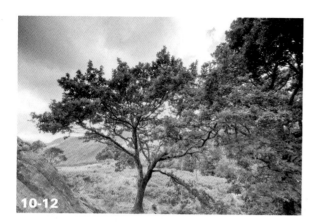

ABOUT THIS PHOTO *Red channel black-and-white image of 10-11. (ISO 320, f/8.0, 1/100 second, Sigma 10-20mm f/4-5.6 at 10mm).* © Pete Carr

- **Green.** Image 10-13 shows the Green channel, which is a close approximation to the lightness of the original color photo, although lighter.

- **Blue.** Image 10-14 shows the Blue channel. It looks the least like the actual scene. The trees, grass, and moss-covered rocks do not contain much blue, so they appear very dark in this channel. The sky, which is gray, is brighter. Interestingly, the distant hills look very natural.

Image 10-15 shows the completed conversion to black-and-white HDR. Can you tell what color channel was used more heavily than the others? If you guessed Blue, you're right.

This is why black-and-white photos are not simply color photos without the color, and why converting color HDR photos into black-and-white HDR images takes thoughtful attention. Each color channel has a different role to play in the color image, and information from different color channels impact the resulting black-and-white photo differently. What is light in the Red channel may be dark in the Green channel. Details preserved in the Blue channel may be lost in the Red channel. You should be thinking of how detail, contrast, tone, and luminosity are affected based on the blend of color channels that you use to, paradoxically, create black-and-white photos.

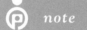 *note*

Photoshop has a nifty tool, actually an adjustment layer called Selective Color. In addition to a range of other colors, you can adjust white, black, and neutral areas of the image. If you want to emphasize contrast, deepen the blacks (carefully) and neutrals.

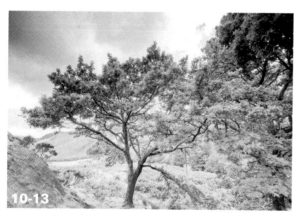

ABOUT THIS PHOTO *Green channel black-and-white image of 10-11. (ISO 320, f/8.0, 1/100 second, Sigma 10-20mm f/4-5.6 at 10mm).* © Pete Carr

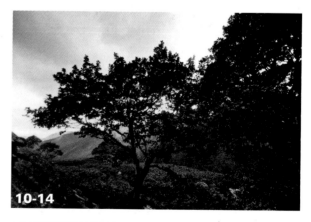

ABOUT THIS PHOTO *Blue channel black-and-white image of 10-11. (ISO 320, f/8.0, 1/100 second, Sigma 10-20mm f/4-5.6 at 10mm).* © Pete Carr

10-15

ABOUT THIS PHOTO *Final black-and-white image of 10-11. (ISO 320, f/8.0, 1/100 second, Sigma 10-20mm f/4-5.6 at 10mm).* © Pete Carr

CONVERTING HDR IMAGES TO BLACK AND WHITE

When you decide to try your hand at black-and-white HDR photography, workflow and process questions naturally arise. There are many ways to get to a final, processed black-and-white HDR photo. This section shows you an effective way to manage the process and produce fantastic results.

note
Everyone has a different method for converting color photos to black and white. You are encouraged to experiment with different ideas. Some won't make that much of a difference and some will look pretty bad. Others may be very complex and time consuming. The solutions presented in this section are a professionally proven balance between productivity and quality.

HDR FIRST, THEN BLACK AND WHITE

Although you are probably excited to process your photos into black and white as soon as you can, process the color exposures into HDR using your standard HDR procedure before converting the final image to black and white. The primary reason for this is because creating one black-and-white image out of a single HDR image is easier than creating an HDR image out of several black-and-white photos. The following list explains the challenges when working in different situations, pre-HDR conversion:

- **Bracketed camera raw exposures.** Converting the over- and underexposed bracketed images to black and white is based on guesswork. You have no way of knowing how to decide what anything should look like because it is not properly exposed. If you use the center exposure as a baseline, you must decide on the best settings, convert the image, then apply the same settings to the other bracketed images. This multiplies your workload by the number of brackets you shoot.

- **Single camera raw exposures.** After converting the single raw exposure to three 16-bit TIFFs, you are in the situation as before with bracketed exposures and a multiplied workload.

- **Converting camera raw exposures.** Depending on your RAW file editor, you might be able convert camera raw images to black and white as you save them as TIFFs. You might even have a fair degree of control over this process. Assuming you apply identical black-and-white settings to all exposures, this might work well enough and not overly add to your workload. However, you may not get the ideal results when the images are processed as HDR.

In the end, whether you are willing to assume a greater workload or not, the flexibility of having a finished color HDR image to work from is tremendous. You may or may not choose to convert it to black and white. If you do, you are able to experiment with different conversions without having to go back to the beginning and start over.

> **tip**
>
> Try to keep your source images as unprocessed as possible as you convert camera raw files to TIFFs and then process into HDR.

CONVERTING AN IMAGE IN PHOTOSHOP ELEMENTS

After you properly generate an HDR image that is tone mapped to your liking, it's time to convert it into black and white. Although you may be tempted to desaturate the photo in order to convert it to black and white — don't. Likewise, don't convert the image to grayscale. While it is true that both of these options remove color information from the file and convert it to black and white, you have no control over the process. You have to take what it gives you — good or bad. Your goal is not simply to remove color; it is to be creatively involved in the process of black-and-white photography.

To convert your image into black and white using Photoshop Elements, follow these steps:

1. **Open your tone-mapped photo in Photoshop Elements.** If it is 16-bit, you have to convert it to 8 bits per channel by choosing Image⇨Mode⇨8 Bits/Channel.

2. **Choose Enhance⇨Convert to Black and White.** This opens the Convert to Black and White dialog box with preview windows, preset styles, and channel sliders (see 10-16).

Most other applications have similar (or greater) capabilities than Photoshop Elements. You should look for a similar menu option or try mixing color channels.

3. **Select a Style from the list at the bottom left.** Investigate its effect by looking at the After window. Pay attention to tone and contrast. Select other presets to compare.

4. **Tweak the Adjustment Intensity sliders.** Many times you have to fine-tune the effect. Remember, the Red channel smooths and the Blue channel emphasizes details. If you are shooting portraits, these channels can be used very effectively for people as well.

Continue working to improve your black-and-white HDR photos with additional post-processing. You can make a tremendous

10-16

ABOUT THIS FIGURE *Image 10-11 is converted to black and white in Photoshop Elements using a preset in the Convert to Black and White dialog box. The image has already been converted to HDR, tone mapped, saved as a TIFF, and converted to 8 bits per channel. Image © Pete Carr*

difference in how the final image looks during this stage, as shown in 10-17. The final post-processing steps were completed in Lightroom and included increasing Fill Light and Black to bring out more detail, and enhance contrast. An s-shaped Curves adjustment increased contrast.

The original is shown in 10-18. HDR helped here by bringing back detail to the sky and also bringing it out in the shadow areas without increasing the noise. To achieve this effect, the standard settings from Chapter 4 were applied in Photomatix. Gamma was increased from 0.9 to 0.7 and Luminosity was set to 0.

Alternatively, you could increase the Luminosity to +10, Strength to 85 percent, and drop the Micro-smoothing to +2. This would create a more dramatic look, but also increase the noise (see 10-19).

The best way to learn is to experiment. Open your own graphics application, load a processed HDR file, and play with the settings found in the Convert to Black and White dialog box (or a suitable counterpart if you are using another application).

10-17

ABOUT THIS PHOTO *Debenhams in Liverpool One. HDR created from three camera raw exposures (-2/0/+2 EV), and then converted to black and white. (ISO 100, f/6.3, 1/250 second, Sigma 10-20mm f/4-5.6 at 10mm) © Pete Carr*

ABOUT THIS PHOTO
Debenhams in Liverpool One. The 0 EV exposure. (ISO 100, f/6.3, 1/250 second, Sigma 10-20mm f/4-5.6 at 10mm) © Pete Carr

ABOUT THIS PHOTO
Debenhams in Liverpool One. HDR created from three camera raw exposures, and then converted to black and white. (ISO 100, f/6.3, 1/250 second, Sigma 10-20mm f/4-5.6 at 10mm) © Pete Carr

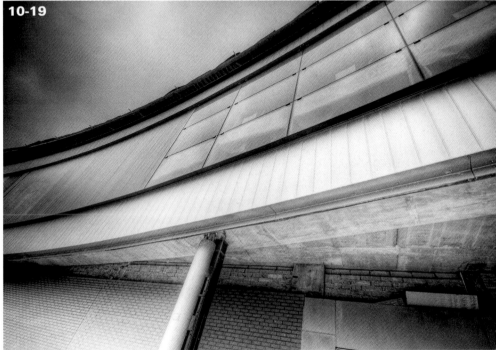

TONING IMAGES

While most black-and-white photos look fantastic, there's something to be said for toning your images with a little color, for example, with sepia. There are many ways to add a colorful tint to

black-and-white HDR photos, and they all boil down to adding at least one other color to the photo. Often, but not always, black is kept in the image.

ENHANCING WITH COLOR

Many people love toned (also called tinted) images for the feelings they evoke. The photo can be of a romantic scene, loved ones, or something nostalgic, like the tall ships in 10-20. This photograph was processed into HDR, converted to black and white, and then toned. A combination

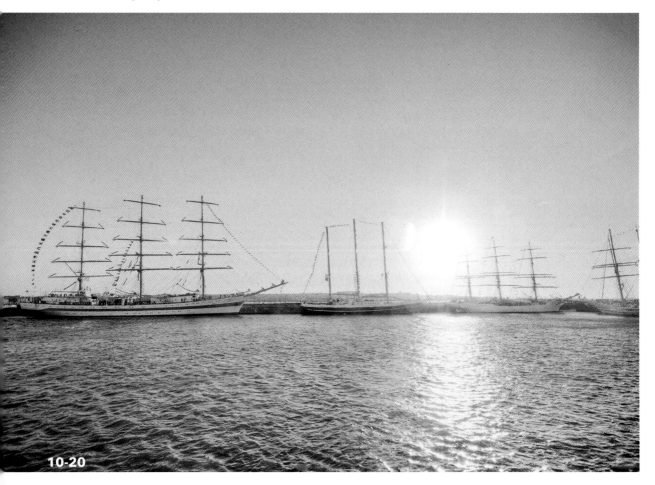

10-20

ABOUT THIS PHOTO *Ships docked at Liverpool. HDR created from three camera raw exposures, -2/0/+2 EV. (ISO 100, f/8.0, 1/1600 second, Sigma 10-20mm f/4-5.6 at 10mm) © Pete Carr*

of blue and yellow was used across the shadows and highlights. The standard Photomatix tone-mapping settings from Chapter 4 were used.

WARMING THINGS UP

Pure black-and-white photos can sometimes appear a bit harsh. Adding a hint of color to them can subtly warm them up and make them much more pleasing to look at. It's all in the eye of the beholder, of course, so the best technique to recommend is this: try it and see.

Image 10-21 is a completed, tone-mapped, color image of a tree and a park bench in Fort Wayne, Indiana. The shot was taken with a compact digital camera using its AEB feature, which was limited to +/- 1 EV. Although not ideal, gear becomes irrelevant when the picture turns out.

The tone-mapping settings were reasonably standard, but there were several changes. Strength was increased to 100 percent and Saturation was bumped up to 60 percent. This created a stronger,

10-21

ABOUT THIS PHOTO *A scenic tree and bench in color. HDR created from three camera raw exposures, -1/0/+1 EV. (ISO 100, f/3.3, 1/80 second, Panasonic Lumix DMC-LZ8 at 5.2mm, 35mm equivalent: 32mm) © Robert Correll*

more vibrant photo. Micro-smoothing was reduced from 10 to 2, to preserve the texture of the tree and grass.

While 10-21 is a good color image, it turns into something magical when converted to black and white, as shown in 10-22. Removing the color makes this a much more intimate setting. Your eyes focus on the tree, the bench, the grass, and the houses beyond much more than in the color photo, where the sky dominates because of its brightness.

10-22

ABOUT THIS PHOTO *Tree and bench converted to pure grayscale. HDR created from three camera raw exposures, -1/0/+1 EV. (ISO 100, f/3.3, 1/80 second, Panasonic Lumix DMC-LZ8 at 5.2mm, 35mm equivalent: 32mm)* © Robert Correll

By adding a single tint back into the photo (colorizing), the result is even better. The photo in 10-23 is warmer and more dramatic.

The tree and bench were colorized using a single tint, but you don't have to stop there. The next example uses four semitransparent color fill layers (set the blend mode to Color), each filled with different shades of warm brown and gray.

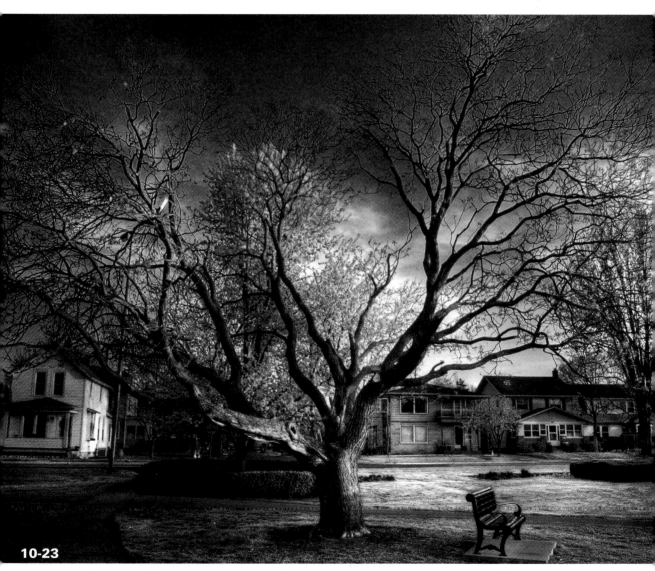

10-23

ABOUT THIS PHOTO *Tree and bench colorized with a single hue. HDR created from three camera raw exposures, -1/0/+1 EV. (ISO 100, f/3.3, 1/80 second, Panasonic Lumix DMC-LZ8 at 5.2mm, 35mm equivalent: 32mm) © Robert Correll*

Image 10-24 is a color HDR of the tunnel leading back to the locker rooms in the New Castle High School fieldhouse in Indiana. Much more dramatic settings were used for this image. Strength and Color Saturation were again increased to 100 and 80, respectively. The Luminosity was increased to 3.7 and Detail Contrast increased to 4.6. White Point was increased to 4.688 and Micro-smoothing decreased to 2. All these changes increased the drama, contrast, color, and punch. In the end, it's not noticeably unrealistic.

Image 10-25 shows the same photo after being converted to black and white. There are no color tones in this, it is a pure grayscale. It looks very clean and could be used without any trouble.

However, by adding four tones back into the photo, as shown in 10-26, it turns into something warm, aged, and pleasing. If you showed only this photo to someone, she might not guess that you've warmed it up that much, but when compared side-by-side with 10-15, it's obvious. The moral of the story is that you can add one or more color tints to pure black-and-white HDR images to warm them up.

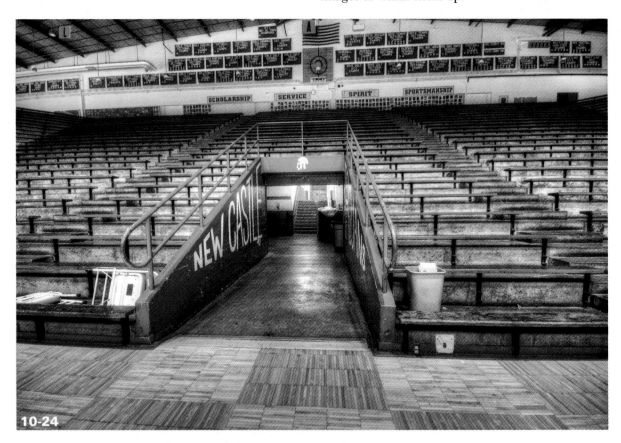

10-24

ABOUT THIS PHOTO *Interior color HDR image taken inside a basketball gymnasium. HDR created from five camera raw exposures, -2/-1/0/+1/+2 EV. (ISO 100, f/8.0, 2 seconds, Sigma 10-20mm f/4.5-5.6 at 10mm) © Robert Correll*

ABOUT THIS PHOTO *Color HDR image taken inside a basketball gymnasium converted to black and white. HDR created from five camera raw exposures, -2/-1/0/+1/+2 EV. (ISO 100, f/8.0, 2 seconds, Sigma 10-20mm f/4.5-5.6 at 10mm) © Robert Correll*

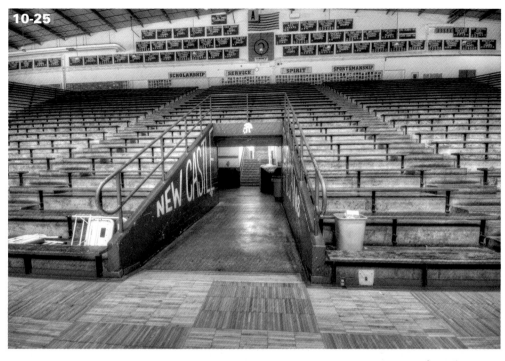

10-25

10-26

ABOUT THIS PHOTO *A basketball gymnasium tinted using four warm hues as color layers. HDR created from five camera raw exposures, -2/-1/0/+1/+2 EV. (ISO 100, f/8.0, 2 seconds, Sigma 10-20mm f/4.5-5.6 at 10mm) © Robert Correll*

CREATING TONED IMAGES IN PHOTOSHOP ELEMENTS

Toning your black-and-white HDR photos in Photoshop Elements is a pretty easy process using a feature called Variations. To create a toned image, follow these steps:

1. **Open an HDR image that you've converted to black and white.**

2. **Choose Enhance⇨Adjust Color⇨Color Variations.** The Color Variations dialog box appears, as shown in 10-27. You get a nice-

sized preview area, some controls to change how the effect is applied, and smaller thumbnails that correspond to different color variations.

note
As is often the case, there are more ways than one to accomplish a task in Photoshop Elements. Aside from Variations, you can create toned images by using tinted Solid Color Fill layers (set to Color blend mode and tweak opacity), the Colorize feature of the Hue/Saturation color adjustment, or even Hue/Saturation adjustment layers.

10-27

ABOUT THIS FIGURE *The Color Variations dialog box in Photoshop Elements. Image © Pete Carr*

3. **First, select an area of the image.** This is important because it limits changes to a range of tones: Midtones, Shadows, and Highlights. Ignore Saturation for this task.

4. **Click the color box that reflects the adjustment you want to make to your image.** You may increase or decrease the amount of Red, Green, or Blue in addition to lightening or darkening the photo. Each click increases or decreases the color by the intensity chosen on the small slider to the left.

5. **Mix and match the areas and color combinations.** Generally speaking, blue and green work well together, as do red and yellow.

They work because black and white is built on contrast. Cross-processing (which is covered later in this chapter) is produced with yellow and green. Experiment and have fun with your own combinations — make them truly your own.

6. **Click OK when you are happy with the result.**

In general, it's best to leave the midtones alone. Stick with adjusting the shadows and highlights. This preserves contrast across the photo. For a sepia look, increase yellows and reds a bit, as shown in 10-28, but not too much.

10-28

ABOUT THIS PHOTO *HDR image of the fountain outside the Walker Art Gallery in Liverpool. Created from three camera raw images, -2/0/+2 EV. (ISO 100, f/8.0, 1/25 second, Sigma 10-20mm f/4-5.6 at 10mm) © Pete Carr*

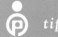
In 10-28, reds and yellows were used for the shadows, and blue was used to tint the highlights. This combination works well for this scene. Toning, when combined with the subject, produces an otherworldly, yet somehow subtle science-fiction feeling.

CROSS-PROCESSING

Cross-processing is an old film technique in which the film is processed in a chemical solution designed for a different type of film. The result is a photo that looks a bit unreal because the colors are off and contrast is greater than normal. In software, cross-processing adds the same green and yellow tints to photos, along with increasing the contrast. It doesn't work on everything, but it is worth trying — just be careful not to increase contrast so much that you blow out highlights.

The reasons to cross-process are primarily artistic, but sometimes practical. In the first instance, you may simply love the way the cross-processed style makes photos appear. From a practical perspective, though, cross-processing can help you rescue photos. For example, a tone-mapped photo that does not work in color or black and white may look stunning after cross-processing. It's hard to predict these situations beforehand, which is why a healthy sense of experimentation and an openness to go in different directions (often wherever the photo leads you) are important.

APPLYING THE TECHNIQUE

As with converting color HDR photos to black and white, apply cross-processing after you have generated the HDR file and tone

mapped it in Photomatix (or another HDR application). Cross-processing takes place in your image editor, ideally after you perform any other final adjustments, including noise and contrast.

Unfortunately, cross-processing is not well supported in Photoshop Elements. The main problem is that Elements does not have the ability to manipulate separate color channels with Curves. It is possible, however, to create the general feel of cross-processing in Elements by following this approach:

1. **Open Photoshop Elements and load the tone-mapped HDR image.** Cross-processing takes place after you generate the HDR from your bracketed photos and tone map the resulting image, as the one shown in 10-29. Here, settings emphasized details and ambience. Strength was maximized to accentuate detail in the building and grass. Luminosity was increased slightly to balance the light of the sky with the rest of the image. Detail Contrast was reduced to remove some of the halo effect. This image has had a few dust spots removed, and the snow and parts of the building were dodged to bring out highlights. Parts of the building and sky have been burned to emphasize drama and contrast of existing details.

2. **Choose Enhance⇨Adjust Color⇨Adjust Color Curves.** The Adjust Color Curves dialog box appears.

3. **Select the Increase Contrast preset, as shown in 10-30.** This alters the contrast curve to something approaching a true cross-processing adjustment.

4. **Click OK to apply the changes.**

ABOUT THIS PHOTO *Old warehouses in Liverpool. HDR created from three camera raw exposures, -2/0/+2 EV. (ISO 200, f/4.0, 1/125 second, Sigma 10-20mm f/4-5.6 at 10mm) © Pete Carr*

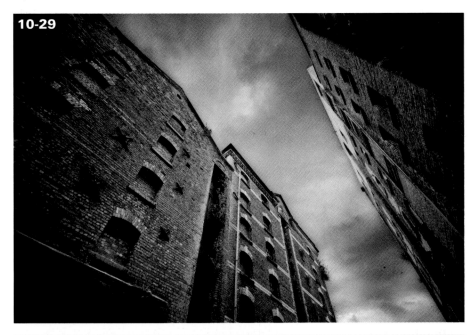

10-29

10-30

ABOUT THIS FIGURE *Increase the contrast in preparation for color tinting in Photoshop Elements. Image © Pete Carr*

5. **Choose Enhance⇨Adjust Color⇨Color Variations.** The Color Variations dialog box appears.

6. **Select Shadows and increase green.** This adds a subtle green tint to the shadows.

7. **Select Highlights, and then increase a combination of red and green.** Because you can't directly add yellow in the Color Variations dialog box in Photoshop Elements, you must add red and green, which combine to give the highlights a yellow tint.

8. **Finalize your adjustments.** You may need to increase contrast again or perform a final levels adjustment. The final image is shown in 10-31.

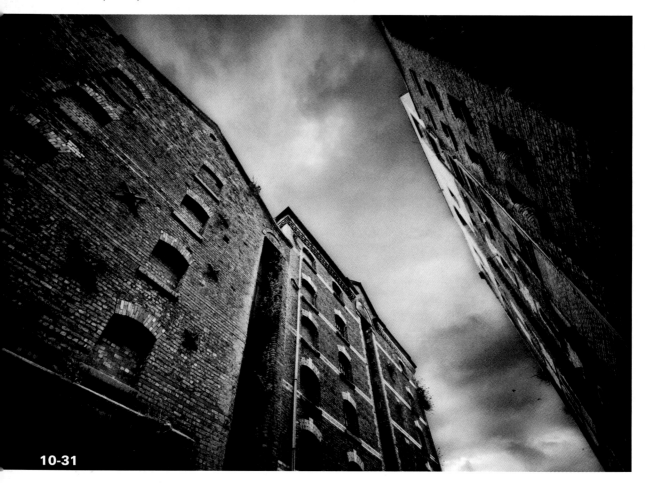

10-31

ABOUT THIS PHOTO *Old warehouses in Liverpool. HDR created from three camera raw exposures, -2/0/+2 EV. (ISO 200, f/4.0, 1/125 second, Sigma 10-20mm f/4-5.6 at 10mm)* © Pete Carr

If you compare 10-29 with 10-31, you see that both are good examples of HDR. The more traditional HDR file, 10-29, has good color, detail, and drama, while the cross-processed file (10-31) adds that characteristic otherworldliness.

EXAMPLES OF CROSS-PROCESSING

Cross-processing can work for any scene: Urban areas, land- and cityscapes, or wherever your imagination leads you. For urban shots, as shown in 10-32, HDR brings out the small details and

10-32

ABOUT THIS PHOTO *Statue of Captain Johnnie Walker, Liverpool. HDR created from three camera raw exposures, -2/0/+2 EV. (ISO 100, f/11, 1/13 second, Sigma 10-20mm f/4-5.6 at 14mm) © Pete Carr*

textures in a photo, while cross processing adds a slightly romantic feel and accentuates the red in the poppies. To achieve this look, three images were taken at -2/0/+2 EV. Later, the standard settings from Chapter 4 were applied in Photomatix. Because the moment wasn't overly dramatic, the image didn't suit an overly dramatic look, so nothing else was changed. However, if you wanted more drama, you could drop the Micro-smoothing down from +10 to +2 and increase the Strength from 75 to 85 percent.

In the original, 10-33, you can see how HDR helped. It brought out more detail in the sky and the statue without increasing the noise to a point where it doesn't add anything to the image.

This final example is a classic use of HDR when shooting directly into the sun. The original 0 EV exposure is shown in 10-34. The trees are mostly in shadow as there's no light on them. It could work quite nicely as a black and white due to the

10-33

ABOUT THIS PHOTO *Statue of Captain Johnnie Walker, Liverpool. Single 0 EV exposure. (ISO 100, f/11, 1/13 second, Sigma 10-20mm f/4-5.6 at 14mm) © Pete Carr*

10-34

ABOUT THIS PHOTO *Sunrise in Sefton Park, Liverpool. Single 0 EV exposure. (ISO 100, f/9.0, 1/60 second, Sigma 10-20mm f/4-5.6 at 10mm) © Pete Carr*

inherent contrast in the image. However, this book is about HDR, so we're looking to go beyond a simple black and white.

To get enough detail in the grass and trees, three photos were taken. As it was quite a high-contrast scene, more may have helped but the camera was limited to three at -2/0/+2 EV. The images were then loaded into Photomatix and the standard Chapter 4 settings were applied.

Afterward, the image was cross-processed using similar settings mentioned earlier in the chapter. The result is shown in 10-35. The effect works quite well here due to the natural colors of a sunrise over a green landscape.

10-35

ABOUT THIS PHOTO *Sunrise in Sefton Park, Liverpool. HDR created from three camera raw exposures, -2/0/+2 EV. (ISO 100, f/9.0, 1/60 second, Sigma 10-20mm f/4-5.6 at 10mm) © Pete Carr*

Assignment

Amaze Us with Your Creativity

Your final assignment is to take an interesting black-and-white photo. Find a car, ship, plane, landscape, or an incredible-looking abstract building. Review this and the other chapters for ideas of places and things that might be interesting for you to photograph.

Remember to shoot three or more bracketed, camera raw photos. Generate the HDR and then tone map the result. Continue to post-process in Photoshop Elements or the tool of your choice.

The final example is a simple study of how great black and white can be, even when capturing a sunset. There's a great contrast between the signpost, sky, and ground. It's what black and white is all about. No flash was used; no lighting at all other than natural light. It really shows what you can do with a camera, three photos, a bit of creativity, and HDR. Generated from three camera raw exposures, bracketed at -2/0/+2 EV. Taken at ISO 100, f/8.0, 1/100 second with a Sigma 10-20mm f/4-5.6 at 10mm.

© Pete Carr

 Remember to visit www.pwassignments.com after you complete this assignment and share your favorite photo! It's a community of enthusiastic photographers and a great place to view what other readers have created. You can also post comments, read encouraging suggestions, and get feedback.

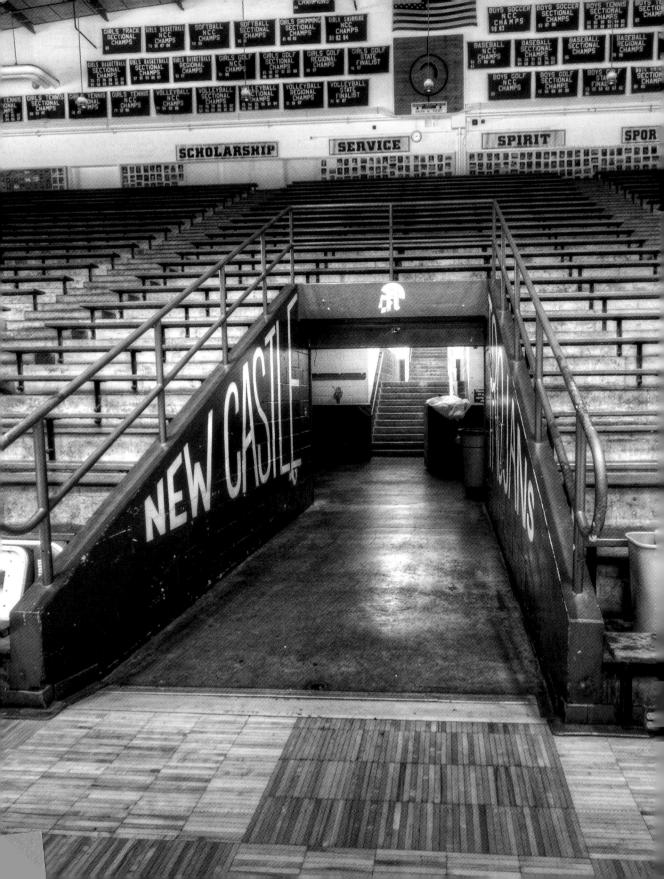

© Robert Correll

AEB (Auto Exposure Bracketing) A camera feature that automatically adjusts the exposure for a series of photos, resulting in a set of at least three photos. Cameras differ in how much exposure compensation they offer per bracket. Some change the exposure +/-2 EV per bracket (-2/0/+2 EV) while others change the exposure by a smaller degree.

aperture Aperture describes the size of the opening in the lens that lets light past the open shutter and onto the sensor inside the camera. A larger opening lets more light in and a smaller opening allows less. Aperture is expressed as an f-number, the number of which works opposite the aperture size. In other words, f/2.8 is a larger aperture than f/8. See also *bokeh* and *depth of field*.

Aperture Priority This mode locks the aperture to your chosen setting but enables the camera to modify shutter speed to get the best exposure.

bit depth A measure of how many binary digits (bits, which can be 0 or 1) are used to record or store data in a digital system or file. More bits allow larger numbers. For example, one 8-bit channel of an RGB image can store 256 values for color intensity, while a 16-bits-per-channel TIFF image can store 65,536 values per channel.

blown highs This happens when details are lost in white skies or highlights. The photo as a whole does not have to be overexposed.

Blue Hour The dawn hour before sunrise and the dusk hour after sunset. Precedes the Golden Hour in the morning and follows it in the evening.

bokeh The blurred area (most often perceived as behind the focal plane) that is not in the depth of field for a given lens and aperture, and therefore not in focus. Not all lenses produce equally aesthetic bokeh. Some produce double images while others are very pleasing. See also *aperture* and *depth of field*.

bracketed set The photos taken by bracketing, whether manually or using AEB. The number of photos varies and depends on the photographer's choice and the camera's capabilities. See also *bracketing* and *exposure bracket*.

bracketing Bracketing is the process by which you shoot at least three different photos, two of which are bracketed around the central exposure, which is most often shot at 0 EV. A good distance between the brackets is 2 EV, resulting in three exposures shot at -2/0/+2 EV. You can create brackets from a single camera raw photo by adjusting exposure in a RAW file editor (-2/0/+2 EV) and saving the processed files with different names. Bracketing can be done manually or with AEB. See also *bracketed set*.

burning A technique used to darken areas of a photo during image processing. Most photo-editing applications have a Burn tool or brush.

chromatic aberration Color fringing on borders and edges of objects. It is caused by the inability of the lens to focus all of the wavelengths of light onto one spot on the digital sensor.

circular polarizer These filters reduce the glare caused by reflected sunlight on non-metallic surfaces.

colorcast When the colors in a photo appear unintentionally tinted. This can be caused by having the wrong white balance setting, or when neutral or light-colored surfaces pick up color from their surroundings.

color temperature The temperature of the light source as measured in Kelvin. As the temperature increases, the color of the light transitions from red through white to blue. Confusingly, our perception of the light is described the opposite way: a blue tint is cool and a yellow/red tint is hot. Color temperature is used to help find the white balance of a photo.

compact digital cameras Small, light, digital cameras meant for the casual photographer. They normally have a decent built-in zoom lens, and a live view LCD screen to compose and review photos. You often have less control over modes and options, but this is not universal. These cameras are generally viewed as being at the opposite end of the camera spectrum as dSLRs.

contrast masking A software technique that evens the contrast of an image.

contrast ratio The ratio of the luminance of the brightest color (white) to that of the darkest color (black) that the system is capable of producing or viewing. Paper, monitors, cameras, LCDs, and your eyes have limited contrast ratios.

cross-processing Originally described the activity of using the wrong chemicals to process film, which generally imparts green and yellow tints to a photo. Today, similar effects are available using photo-editing software, such as Photoshop and Photoshop Elements.

depth of field The depth of the plane perceived as in focus. Large apertures create smaller depths of field, resulting in a great deal of blurring (called *bokeh*) in front of and behind the focal plane. Smaller apertures result in much larger depths of field, with little or no perceivable blurring throughout the depth of the photo. See also *aperture* and *bokeh*.

digital noise Signals from sources other than the light of the scene you are intending to measure detected by the digital camera sensor. They appear as pixels of random color in a photo. Greater sensor size and efficiency combat noise. Common sources of digital noise are heat from sustained camera operation and background activity. High ISOs do not generate digital noise; they simply amplify the noise that is already there.

digital single lens reflex (dSLR) Cameras that are the digital equivalent of the traditional 35mm SLR camera, which has a mirror within the body of the camera that reflects the view from the lens into the viewfinder. dSLRs range from entry level for the hobbyist to very expensive models for the consummate professional. A key feature of dSLRs is their ability to change lenses, making them a very versatile system.

distortion Distortion is apparent when lines that should be straight are not. Barrel distortion is when a photo appears to be bulging out from the center. Pincushion distortion is when the center pinches inward (or away from you). Mustache distortion is a complex combination of both. These types of distortion are caused by the lens. Perspective distortion is when vertical lines lean toward or away from you, or when horizontal lines are not parallel. Both types of perspective distortion are cause by holding the camera at an angle from the subject.

dodging A technique used to lighten areas of a photo during image processing. Most photo-editing applications have a Dodge tool or brush.

dynamic range The ratio between the smallest and largest possible values of a changeable quantity. In photography, it is the difference between the brightest and darkest values the camera can record. Dynamic range can be expressed as EV, stops, or as a contrast ratio.

EV (Exposure Value) The relationship between exposure, shutter speed, and f-number. EV is a working figure that allows the effects of altering shutter speed and aperture on exposure to be quickly and easily compared.

EXIF (Exchangeable Image File Format) EXIF data was created to store non-image data, such as time of exposure, shutter speed, ISO, and f-number, in the same file as a digital photograph. See also *JPEG*, *metadata*, and *TIFF*.

exposure A single photograph. Also, how much light is recorded by the camera sensor during a single photograph. Factors that affect non-flash exposure are aperture (how large an opening is into the camera) and shutter speed (how long the light is allowed to enter). ISO determines the sensor's sensitivity to the light. See also *bracketing* and *exposure bracket*.

exposure bracket A single image of a bracketed set. See also *bracketed set, bracketing,* and *exposure*.

exposure compensation A control on most cameras that enables you to push or pull the exposure that the camera has set. In the context of HDR, this allows you to indirectly set shutter speed and ISO, thereby enabling you to manually bracket on cameras without manual exposure controls.

filters Filters are usually mounted in front of a camera's lens to control exposure by filtering out light. Exactly how they do this depends on the type of filter. Some filter all wavelengths and others are very selective.

f-numbers Also known as f-stops or stops. F-numbers describe the ratio between the lens focal length and aperture diameter. For a given focal length, larger f-numbers have smaller apertures, letting less light into the camera, also deepening the depth of field. Smaller f-numbers have larger aperture diameters that let in more light, resulting in a shallower depth of field.

fps Frames per second. The rate at which a camera can take and store photos.

generating an HDR image The process of combining brackets in an HDR application to create a high bit depth, High Dynamic Range image. See also *HDR photography*.

ghosting Semi-transparent *ghost* objects in an HDR image caused by movement between brackets. Many HDR applications have automatic and semi-manual deghosting routines that identify moving objects and eliminate the ghosts.

Golden Hour The hour after sunrise or the hour before sunset, where the sun's light is less harsh and strikes scenery at a more forgiving angle. This is the best time to photograph landscapes and other outdoor subjects.

HDR files High Dynamic Range, 32-bit files generated from multiple camera exposures. To be of practical use, they must be tone mapped onto a lower bit range, such as 16 or 8 bits per channel.

HDR photography High Dynamic Range photography is a photographic discipline and software process that captures high-contrast scenes using exposure bracketing techniques and processes them in order to keep details from being lost in shadow or blown out in highlights. See also *bracketed set, bracketing, exposure bracket, generating an HDR image*.

high contrast Used to describe a scene with a great deal of difference between highlight and shadow luminosity. It does not automatically mean a bright scene, as an indoor scene with very deep shadows and limited light can also be high contrast.

ISO (International Organization for Standardization) ISO was originally used to describe film speed, but in the digital world it is used to describe sensor gain. Higher settings turn up the sensitivity of the sensor, often at the cost of noise.

JPEG (Joint Photographic Experts Group) A very common and compatible photo file format widely used on the Internet. It is capable of millions of colors, stores metadata as EXIF information, and has a variable but lossy compression scheme. They are generally limited to 8 bits per channel (12-bit JPEG images are possible, but rarely seen or supported outside of medical imaging). Best used as a final format for presentation on the web. See also *EXIF*, *lossy compression*, *metadata* and *TIFF*.

leading lines Lines that lead your eyes (and hence your attention) from one part of a scene to another.

light meter A device used to measure the intensity of light in order to guide photographic exposure settings. Incident meters measure light falling on a subject while spot meters measure reflected light. Digital cameras have built-in light meters, but you can also buy external, handheld light meters.

lossy compression Compression algorithms that do not preserve the original data as they reduce the size of an image. For example, you could compress the red color value of an image that has 100 pixels by averaging groups of two pixels together instead of saving each one. Each time through the process, data is irretrievably lost. See also *JPEG*.

low contrast A scene with very little difference between highlight and shadow luminosity. It does not automatically mean a dark scene, as even a bright but cloudy day can be low contrast. See also *luminosity*.

luminosity How bright something is. A scene with high luminance is brighter than one with low luminance. Raising the luminance in post-processing brightens the photo. See also *low contrast*.

Manual mode The camera mode where you make all exposure decisions based on the information at hand and adjust the camera settings (aperture, shutter speed, ISO) yourself.

metadata Non-image, descriptive data that is stored in an image file. Individual entries can range from shutter speed for camera files to bit depth. See also *EXIF*, *JPEG*, and *TIFF*.

metering A process where a camera or light meter measures the amount of incident or reflected (also called spot) light in a scene, which assists in determining what camera settings should be used to take the proper exposure. Cameras often have several metering modes. The most common are Evaluative, Average, Center-weighted, Matrix and Spot.

ND filter Neutral Density filters reduce the amount of light coming into the lens regardless of wavelength, which preserves the inherent colors of a scene while reducing exposure. See also *ND Grad filter*.

ND Grad filter Neutral Density filters with a graduated effect. Most often used to darken skies to keep them from being blown out while exposing other elements of a scene more brightly. See also *ND filter*.

panorama A panorama uses several individual exposures stitched together to create a very wide-angle finished photo.

post-processing Anything that occurs after you take a digital photo. HDR is a form of post-processing. Noise reduction, black-and-white conversion, dodging, burning, layer blending, and toning are examples of activities undertaken in the last stage of post-processing.

pseudo-HDR Tone mapping a single raw exposure in Photomatix Pro to create something that looks similar to a completed HDR image but was not created from exposure brackets.

raw Raw is a term used to generally describe proprietary camera file formats that store data direct from the camera sensor. The main advantages are that the sensor bit depth (generally 12 to 14 bits) is not truncated to 8 bits per channel and that the photos are stored in an unprocessed state. They are not directly editable and require a raw editor to process into JPEG, TIFF, or other formats for post-processing.

remote shutter release A wired or wireless control that enables you to trigger the camera shutter remotely. Very helpful for HDR as it reduces camera shake.

Rule of Thirds A technique used to compose photographs by dividing a scene into a 3×3-square grid like a tic-tac-toe board. The focal points of the image are ideally placed either along the lines or where the lines intersect for the most pleasing effect.

Saturation The purity of a color, ranging from gray to pure color. High saturation can make photos look unnatural and increase noise. Grayscale images are completely desaturated.

shutter speed How fast the camera shutter opens and closes. Shutter speed is measured in minutes, seconds, or fractions of a second. Longer times (slower speeds) let more light into the camera. Shorter times (faster speeds) let less light in.

single-exposure HDR HDR created from one camera raw file that is turned into three brackets (-2/0/+2 EV) using raw image-editing software. These brackets are used to generate HDR, which is then tone mapped. Although this method does not capture the same dynamic range as multiple bracketed exposures, it is sometimes the only way to create HDR due to the fps limitations of cameras and the movement of the subject.

TIFF (Tagged Image File Format) A high-quality photo file format that can (but is not required to) use lossless compression. TIFFs are not well supported in web browsers, but are powerful interim working files that can be viewed and printed in high quality. TIFFs can be 8 or 16 bits per channel. See also *EXIF*, *JPEG* and *metadata*.

tinting Tinting is a general name for applying color to a black-and-white photo. It can be duotoning (two colors), tritoning (three), or quadtoning (four). Sepia toning is another example of tinting. See also *toning*.

tone mapping The process of condensing the dynamic range of a 32-bit HDR file onto a lower dynamic range, 16-bit file that you can view, edit, and print from standard image-editing programs. Tone-mapping settings within HDR applications guide how the 32-bit data is condensed. These settings can be changed, resulting in many possible 16-bit interpretations of the same 32-bit source HDR file.

toning Purposely imparting a colorcast to an image. Options range from using one to several color tints. See also *tinting*.

workflow A term used to describe a work or processing order. An HDR workflow should promote creative flexibility and timeliness without unnecessarily compromising data integrity.

Develop your talent.

Go behind the lens with Wiley's Photo Workshop series, and learn how to shoot great photos from the start! Each full-color book provides clear instructions, sample photos, and end-of-chapter assignments that you can upload to pwassignments.com for input from others.

978-0-470-42193-2

978-1-1180-2454-6

978-0-470-53491-5

978-0-470-41299-2

978-1-1180-1411-0

978-0-470-14785-6

978-1-1180-2453-9

978-0-470-11876-4

978-0-470-11436-0

978-0-470-11433-9

978-0-470-40521-5

978-0-470-11955-6

For a complete list of Photo Workshop books, visit photoworkshop.com — the online resource committed to providing an education in photography, where the quest for knowledge is fueled by inspiration.